THE FRENCH IMPRESSIONISTS AND THEIR CENTURY

THE FRENCH IMPRESSIONISTS AND THEIR CENTURY

DIANE KELDER

A new text based on

Die Maler des grossen Lichtes

by Hans Platte

PALL MALL PRESS · LONDON

Pall Mall Press Limited
5 Cromwell Place, London SW 7

First published in Great Britain 1970
Original edition © 1967 by Georg Westermann Verlag, Brunswick, Germany

ISBN 0 269 02553 7

Printed in Germany by Georg Westermann Druckerei, Brunswick

CONTENTS

The nineteenth century was one of the most complex and exciting periods in the history of mankind. Important political and social institutions, traditional philosophic and scientific beliefs, and cherished artistic conventions fell by the wayside in the wake of revolutionary ideas. Justifiably, it has been termed the age of revolution, and the civil wars and wars of independence that swept the various parts of Europe and America throughout the century testify to the quickness with which political and philosophical concepts were put into action.

One arena in which significant change took place was the art world, particularly in painting. The appearance of different attitudes toward subject matter, materials, and techniques that marks the development of nineteenth-century painting may be regarded as a microcosm of what was happening in the world at large. The gradual industrialization of Europe, which prefigured our present-day technological society, presented new problems to artists wishing to respond to the spirit of their time, and many were prompted to react violently against their urban environments. Many painters, dissatisfied with the traditional subject matter and formulas that had gained public acceptance over hundreds of years, sought to break new artistic ground. They wished to move beyond the programs of an earlier age, to create new art works that would express more accurately their personal needs as well as the cultural aspirations of their time. The young artist's struggle to make a valid contribution on his own terms is nowhere more powerfully reflected than in the history of nineteenth-century French painting.

The political and social consequences of the French Revolution of 1789 were felt by many artists, who were no longer assured of the continuing patronage of the Church and the royal family. The Revolution initially attempted to democratize the artistic establishment of the old regime by abolishing the century-old Royal Academy of Painting, Sculpture, and Architecture, but the Academy was re-established later under a different name, and its rigid educational program was virtually unchanged. Many artists who had previously worked for the greater glory of God or of their king became citizens in the service of the Revolution. Chief among them was Jacques-Louis David (1748—1825), who saw the primary task of art as the creation of an appropriate visual language for the expression of the Revolutionary message and for the glorification of its martyrs.

David's style had developed in the intellectual climate of the Enlightenment, with its great emphasis on the reason prevalent in the Greco-Roman civilizations of the past. David, who can be considered the Revolution's official painter, had trained initially under François Boucher (1703—70), Louis XV's court painter, an exponent of the Rococo style whose art symbolized the decadent sensuality of the old regime. In the 1780's—under the impact of a general enthusiasm for the antiquities that had been rediscovered with the excavations of the Roman cities Pompeii

and Herculaneum—David's style changed drastically. He adopted the severe, linear clarity that characterized so much of the ancient painting and sculpture. With the advent of the Revolution, he became an ardent revolutionary, calling for the abolition of the Academy and reform of its system of art education. David also advocated the artist's direct involvement in the affairs of his time, declaring that the only worthy art was one that was socially useful." Art," he stated, "must be the sword of the revolution." The painter was a man who practiced what he preached. When Jean Paul Marat, one of the Revolution's most outspoken propagandists, was murdered by a young royalist, Charlotte Corday, David produced an eloquent tribute to the slain hero (p. 18), which would take its place beside the scenes of martyrdom that had inspired devout Christians for centuries. The clarity of his forms, the austere quality of his composition, which deals only with stark essentials, and, above all, the artist's masterful handling of light and dark make the painting almost a *tableau vivant*. The work is a curious blend of the seemingly natural or spontaneous and the ideal and predetermined. David constantly spoke to his students of the need to study nature. (Indeed, he made a sketch of the dead Marat shortly after his body was dicovered, and the artist's use of this sketch and of a death mask of the victim is well known.) But what he meant by nature was the careful examination of the human body. Like most earlier French artists, David considered history painting and portraiture vastly superior to the painting of landscapes. His compositions contain only a few landscape fragments, although there is one startling exception: a small view of the Luxembourg Gardens (p. 19), which he made in 1794, when he was imprisoned for his revolutionary activities by the government that succeeded Robespierre. In this work, the painter allowed himself to react quite directly to the sun-filled corner of the world visible from his prison cell.

Such fresh, charming landscapes were infrequent in early nineteenth-century France, where the declamatory manner of David's history painting was adopted as the official painting style of Napoleon's empire. This style dominated the *École des Beaux-Arts*—the name given to the reorganized Academy—and it achieved such general acceptance that it was difficult for any young painter to develop an independent manner in face of the great public demand for the works of David and his followers. History painting had been revered since the Italian Renaissance, but it became even more important in an era when national identities were emerging all over Europe. When the movement known as Romanticism developed in England and on the Continent, many artists began turning away from the sophisticated, rational worlds of Paris, London, or Potsdam to seek the peace and simplicity offered in the countryside or in such remote, uncivilized lands as America and the islands of the South Pacific. Enlightenment philosophers like Jean Jacques Rousseau had first turned men's thoughts to nature, and the Romantic movement, especially in England, produced a new responsiveness to nature—not grandiose and idealized, as in the past, but honest and direct—and this responsiveness was celebrated in poetry and painting.

Jacques-Louis David, "Death of Marat," p. 18

Jacques-Louis David, "View of the Luxembourg Gardens," p. 19

Jean Auguste Dominique
Ingres, *Madame Ingres*,
Pencil Drawing

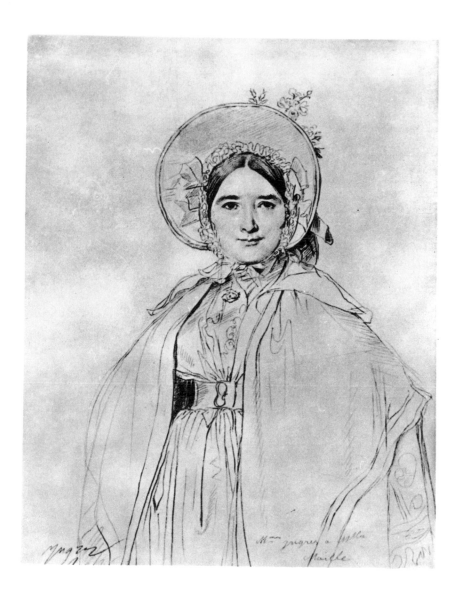

In France, where Rousseau's visions of unspoiled primitive societies and "noble savages" had dominated the imagination of intellectuals for more than fifty years, such Romantic writers as Chateaubriand turned their eyes toward America and created stories filled with emotional descriptions of the land and its people. Although the English painters had developed their love of landscape throughout the eighteenth century, gradually liberating the landscape backgrounds from the many portraits of country gentlemen, their families, and their animals, the French were somewhat slower to move. No official recognition of landscape painting came until 1819, with the establishment of a *Prix de Rome*, a prize to study at the French Academy there, for landscape. Indeed, many older painters still held the attitude that landscape painting was inferior to history painting and portraiture. What happened at the beginning of the nineteenth-century— and what continued throughout at least its first fifty years—was that an art based on careful study of the human figure and the selection of appropriate models was opposed by a more immediate or spontaneous art based on the direct perception of nature.

As the century wore on, the conflict between the conservative, "learned" art of the *École des Beaux-Arts* and the new, open type of painting came

9

to be expressed in the opposing styles and personalities of Jean Auguste Dominique Ingres (1780—1867) and Eugène Delacroix (1799—1863). These two great painters espoused radically different points of view on virtually every aspect of life and art; but the most significant difference of opinion was Delacroix's conviction that color, as a form-creating element, was superior to line. Delacroix's paintings are like color explosions, and his handling of color and light, as well as his feeling for contemporary issues, had a strong impact on a generation of younger painters, who idolized him as both an artistic and a political revolutionary.

The search for natural settings, which permitted more variety of light, combined with a belief that they could best realize their objectives in

Eugène Delacroix, "Abduction of Rebecca," p. 17

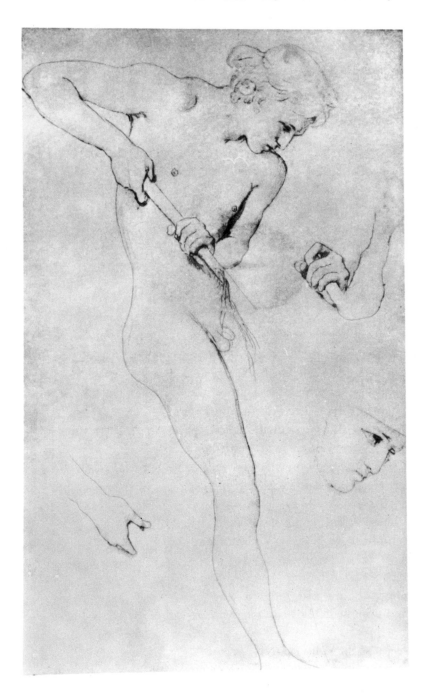

Jean Auguste Dominique Ingres, *Nude Study*, Pencil Drawing

communities removed from the bustle of urban life, led many painters to move from Paris to Fontainebleau, the Normandy coast, Brittany, or the south of France. It also led them to examine closely the properties of color, since color represented the primary means of expressing the dazzlingly brilliant light they experienced out of doors.

Of the many factors influencing the course of nineteenth-century French painting, some were intellectual: the aesthetic theories and criticism of the poet Charles Baudelaire, the novelist Émile Zola, and, later, the Symbolist poets Stéphane Mallarmé and Paul Verlaine. Some factors were scientific: the color theories of the French chemist M. E. Chevreul and the American physicist O. N. Rood. The development of photography by L. J. M. Daguerre in the 1830's had considerable impact on the way artists of the late 1850's and the 1860's and 1870's began to "see" and record things. The obliteration of shadows and tonal values in many early photographs influenced such painters as Gustave Courbet (1819–77), Édouard Manet (1832–83), and Edgar Degas (1834–1917) to dispense with traditional modeling and to heighten the tension between relatively three-dimensional individual forms and the flat background in which they were set. The democracy of photography, which is reflected in its wide range of subjects and its ability to re-create the particular aspects of everyday life, turned painters' eyes to the world around them. As a result, the new kind of painting they created conflicted with what was still considered "approved" style and content emanating from the classrooms of the *École des Beaux-Arts*—namely, the repetition of historical and mythological themes.

The argument of many rebels with the official style and with its domination of the *École* and the government-sponsored Salon (a large annual or bi-annual art exhibition) led them to seek other ways to show their work to the public. Thus, one-man shows or independent group shows, virtually unknown the century before, became more common after the 1850's.

As time wore on, arguments about painting focused less on the kind of subject matter chosen and more on the artist's manner of execution. Successive movements tended to isolate various painters or such groups of painters as the Impressionists, neo-Impressionists, the Nabis, and the Fauves, but an underlying preoccupation with color was a major unifying factor. From painting landscapes or subjects drawn from contemporary history, some artists moved to less familiar, exotic, or highly personal types of subject matter. They ultimately rejected David's notion that art must serve society, insisting that the sole justification for the existence of a painting or sculpture was its aesthetic value. This attitude, which had been restricted previously to a group of French writers in the 1840's, gained considerable support among artists of the next generation and was popularized by the slogan "art for art's sake." Realizing that their discipline presented special problems, painters concentrated on developing new techniques that would enable them to express more completely the uniqueness of a work of art. In so doing, artists acknowledged the artificial nature of a painting. Unlike the painters of previous generations,

they did not regard it as a mirror of reality but as something parallel to reality. In examining the process of painting and attempting to redefine its nature and aims, many painters began to develop new insights into the creative process. In his book *The Earthly Paradise* (New York, Braziller, 1961), the art historian Werner Hofmann has observed that "the artistic consciousness became its own subject in works of art."

By the end of the nineteenth century, even the most radical painters had discovered that line and color were not necessarily antagonists. The experiments of Georges Seurat (1859–91), the theories of Paul Gauguin (1848–1903) and, later, of Henri Matisse (1869–1954) did much to reconcile Ingres' emphasis on design and Delacroix's love of color. Before this reconciliation took place, however, many other experiments—some tentative, some more decisive—had to be undertaken. The recounting of these experiments and an attempt to clarify their significance for the reader will be our major concern in this book.

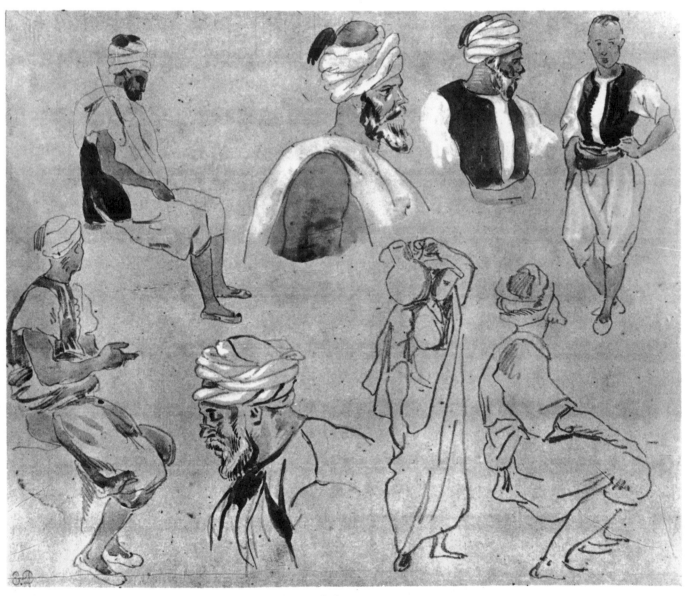

Eugène Delacroix, *Studies of North Africans*, Water Color

ROMANTICS AND REALISTS

During the first half of the nineteenth century, French painting was dominated by two extraordinary figures, Jean Auguste Dominique Ingres and Eugène Delacroix, men of very different character and social background. Ingres, the son of a sculptor, grew up in the provinces, studied for a time in the prestigious studio of David, and later received the *Prix de Rome*, the highest honor that could be accorded a young artist by the professors of the Academy. He remained in Rome for eighteen years; there, he perfected his doctrine of art; a doctrine based on the assumption that a painter could best achieve ideal beauty by studying the masterpieces of the Renaissance and Greco-Roman art, by creating form through the subordination of color to line or drawing, and by cultivating subjects of a primarily classical or historical nature. At the same time, Ingres was hardly indifferent to the study of nature. A true pupil of David, he possessed a keen eye for detail and a superb knowledge of human anatomy. Whether recording the lithe, sinewy form of an athlete (p. 10) or the ruffled particulars of his wife's bonnet (p. 9), his line is firm, informative, and, above all, elegant. It is not surprising to learn that the artist augmented his student's stipend by doing portraits of the numerous foreigners who traveled to Rome to see its magnificent art treasures.

Jean Auguste Dominique Ingres, "Nude Study," p. 10, "Madame Ingres," p. 9

Although he never formally set down his artistic views, Ingres' attitudes—expressed in conversations with his numerous pupils and followers—were recorded and published later in the nineteenth century. They influenced such painters as Degas, Maurice Denis (1870—1943), and Gauguin, and provided the technical guidelines for many lesser-known artists who hewed more closely to the artistic standards set by the conservative Academy.

As did Raphael (1483—1520) and the seventeenth-century classicizing master Nicolas Poussin (1594—1665), Ingres believed that to be truly beautiful, art had to combine forms found in nature with ideal, abstract forms. Critics have often observed that his paintings seem somewhat eclectic—that is, composed from various motifs or models that are familiar, rather than based on flashes or individual, unique inspiration. Certainly, the cool colors and relief-like, simple composition of the "Bather of Valpinçon" (p. 20) recall both the uncompromising clarity of his master David and the perfect balance of light and shade that marks the work of the High Renaissance genius he so admired. The clearly subordinated blues and grays of the painting express Ingres' often quoted remark that "a thing well drawn is a thing always adequately painted." As if to prove the truth of this declaration, the artist went so far as to paint a variation on the theme of the bather or *odalisque,* as the exotic female was often called, in which the only colors used are varying shades of black and white.

Jean Auguste Dominique Ingres, "Bather of Valpinçon," p. 20

Where the compositions of Ingres exude a sense of stately calm and cool detachment, those of Delacroix are full of color and motion, and com-

Eugène Delacroix, *Studies of North Africans*, Water Color

municate a sense of strong emotional involvement. Unlike the middle-class provincial background of Ingres, that of Delacroix was cultured, cosmopolitan, and distinctly upper class. His father was, in turn, a delegate to the National Convention, minister of foreign affairs, ambassador to the Netherlands, and prefect at Marseilles and Bordeaux. Although he studied briefly with a pupil of David, Delacroix's artistic education

14

was largely self-imposed. He copied the paintings of the great seventeenth-century Flemish colorist Peter Paul Rubens (1577–1640), and he further cultivated his taste for vivid, vigorous color during his friendship with the painter Theodore Géricault (1791–1824). The latter was only about seven years older than Delacroix, but he was already an artist of marked independence and maturity. It was Géricault who encouraged Delacroix to paint with vibrant, broken color and to turn to subjects of a heroic, dramatic type. His own "Wounded Cuirassier" (p. 22) is less a portrait of an individual soldier than it is the characterization of a heroic ideal, romantically silhouetted against an angry sky, with the smoke of the battle visible at the low horizon's edge of the picture, the officer sinking to the ground.

Théodore Géricault, "Wounded Cuirassier," p. 22

Delacroix followed Géricault's example and, in 1825, journeyed to England. He had seen fresh and exciting landscapes by John Constable (1776–1837) in the Salon of 1824. Although some conservative French critics reacted negatively to Constable's famous landscape "Hay Wain," stating that it looked as though it had been produced by soaking a sponge in paint and throwing it at the canvas, the young painters who viewed the work were impressed by the artist's directness and sincerity, by the freshness of his color, and by the vigor of his brushstroke. The artist himself was decidedly pleased and surprised at the warm reception accorded his work, and in a letter to a friend he spoke of this appreciation:

> They are struck with their vivacity and freshness, things unknown to their own pictures. The truth is, they study (and they are very laborious students) pictures only. They know as little of nature as a hackney-coach horse does of a pasture. In fact, it is worse, they make painful studies of individual articles, leaves, rocks, stones, etc., singly, so that they look cut out, without belonging to the whole, and they neglect the look of nature altogether, under its various changes. (C. R. Leslie, *Memoirs of John Constable*, ed. J. Mayne, London, Phaidon, 1951.)

It is difficult to imagine how exciting the young French painters must have found works like Constable's "Weymouth Bay" (p. 24), with its great sweep of changing, troubled sky, its sense of breadth and natural grandeur. If we consider that Ingres and the painters influenced by him concentrated almost exclusively on figure painting, since they felt it to be superior to landscape painting, we can begin to understand that Constable's work was indeed a breath of fresh air in the closed, musty atmosphere of the Salon. In a sense, the English artists' sensitivity to nature, their appreciation of its various moods and its changing aspects, their dedication to recording the particulars of a given place and a given time, their experiments with color, and such technical innovations as Constable's use of the palette knife as well as the brush seem to prefigure the Impressionists' preoccupation with what Claude Monet (1840–1926) called "instantaneity," or the capturing of the ephemeral.

John Constable, "Weymouth Bay," p. 24

Eugène Delacroix,
"The Massacre of
Chios," p. 23

Delacroix stayed in England with the water-colorist Richard Bonington (1801–28). Possibly because of the influence of this master of the quick sketch, Delacroix began to perfect a technique that was to serve him well for many years. Like many British painters before him, Bonington executed plein-air (open-air) or on-the-spot rapid compositions, sometimes with pen and ink heightened with washes or water color. These studies enabled British painters to note with acute perception the changing impressions of nature. When Delacroix visited Morocco, in 1832, he was able to utilize the water-color technique with remarkable success. His souvenirs of his exotic North African sojourn communicate, through their intense, bright colors, the light-saturated ambiance of that Islamic culture.

The earliest of Delacroix's great modern-history paintings, "The Massacre of Chios" (p. 23), established him as a painter of genius and the leader of the avant-garde. If the coolly rational works of Ingres deserve the stylistic designation "neoclassic," surely those of Delacroix merit the term "romantic." The painting, which was hailed by all but the most narrow adherents to the doctrines of Ingres, recalls one of the most poignant and compelling moments in contemporary European history, the Greek War of Independence from the Turks. The struggle of the Greeks attracted intellectuals, artists, and countless other foreign sympathizers in much the same way as did the Spanish Civil War in the 1930's. The burning of Chios and the devastation and subjugation of its miserable inhabitants by the Turks enlisted the support of such faraway champions of the Greek cause as the poet Lord Byron, whom Delacroix admired enormously. Like the verses of this English poet, the pathetic images of his suffering victims testify to Delacroix's concern for human rights. The rearing horse of the proud Turkish officer, itself an echo of Géricault's lively equestrian studies, forms a dramatic contrast to the sagging, passive forms of the captive Greeks. The swirling smoke, enlivened by patches of vivid color, and the sense of an almost theatrical event elicited the praise of one of France's greatest writers, Charles Baudelaire, who described the colorist Delacroix as an epic poet. Only a few years later, Delacroix was to address himself to another political struggle—the abortive French revolution of 1830–31—and to produce one of the most memorable and potent national symbols in his "Liberty Leading the People."

It was Baudelaire, the most sensitive and astute of the earlier nineteenth-century art critics, who recognized that Delacroix was indeed the leader of what he called "the modern school." Writing in the 1840's, when the Salon reflected the conservative taste of the Academy and when controversy still raged between the colorists, or devotees of Delacroix, and the devotees of Ingres who acknowledged the superiority of line and tradition, Baudelaire sensed the basis of Delacroix's appeal. Perhaps the artist's own

Eugène Delacroix, *Abduction of Rebecca* (Detail)

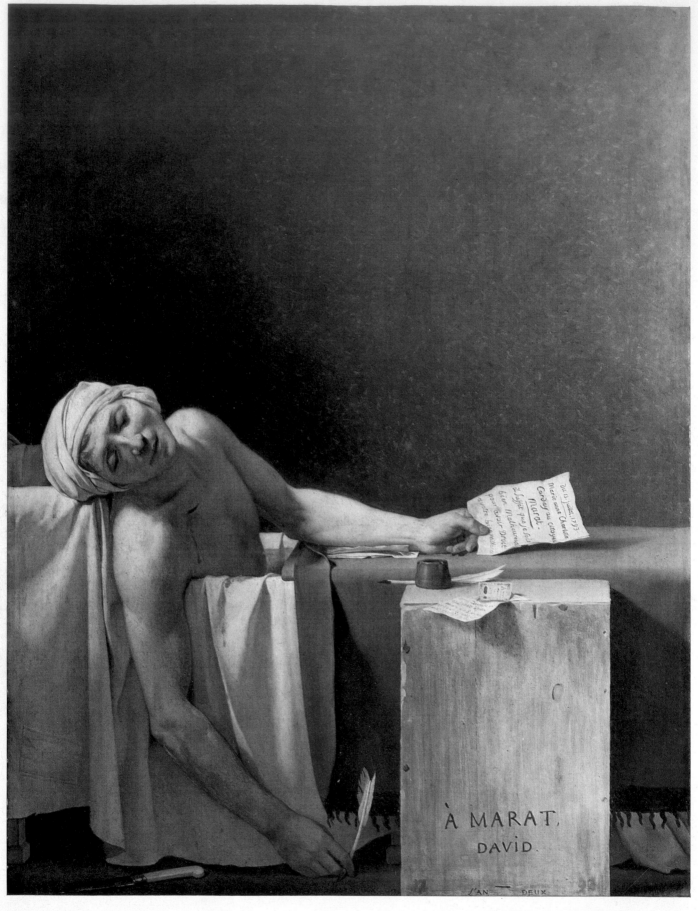

Jacques-Louis David, *Death of Marat*

Jacques-Louis David, *View of the Luxembourg Gardens*

On the following pages:
Jean Auguste Dominique Ingres, *Bather of Valpinçon*
Honoré Daumier, *The Walk*

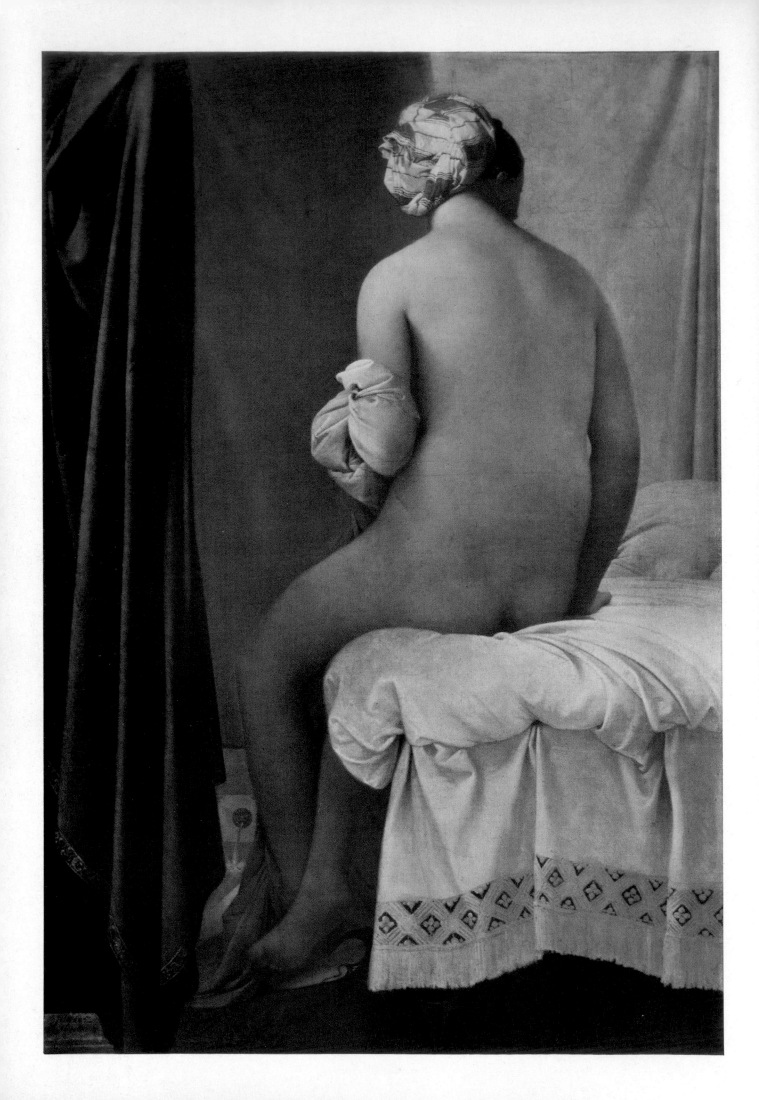

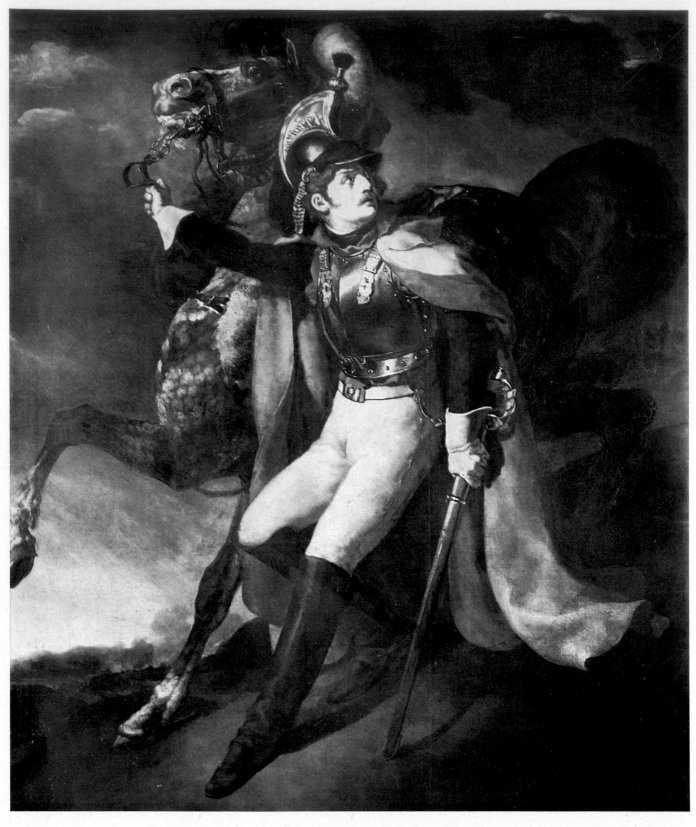

Théodore Géricault, *Wounded Cuirassier*

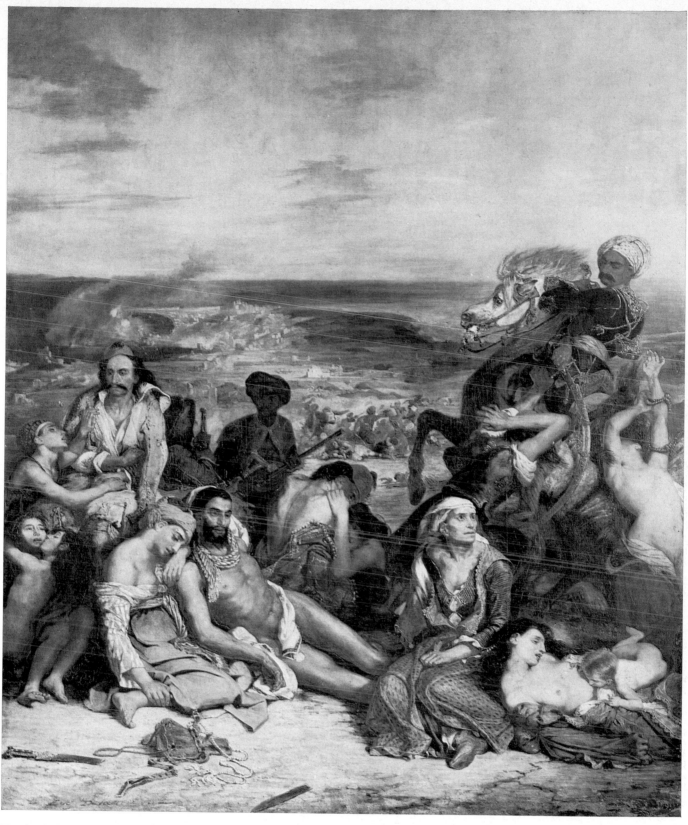

Eugène Delacroix, *The Massacre of Chios*

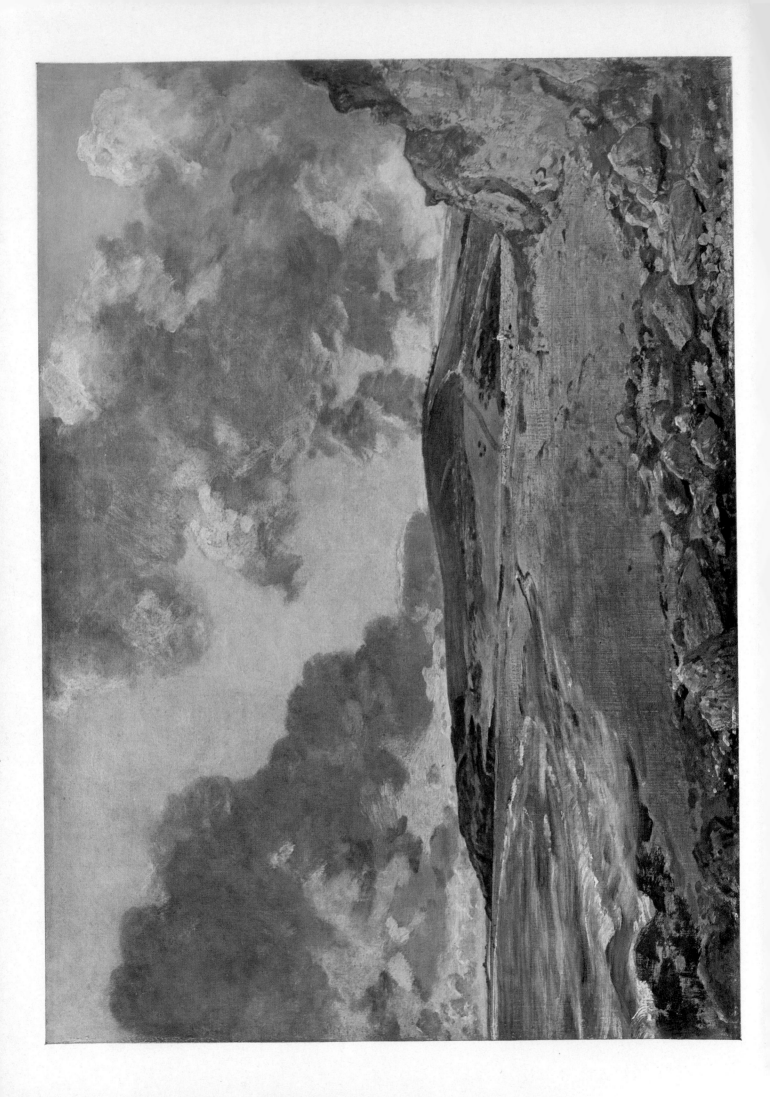

words summarize as well as any the essence of his artistic credo: For Delacroix, the primary task of an artist was "to draw from his imagination the means of rendering nature and its effect and to render them according to his own temperament."

The notion that temperament is important to the artist is also reflected in Baudelaire's attempt to define the task of the critic. For Baudelaire, it was essential that criticism be "partial, passionate, and political, that is to say, written from an exclusive point of view, but a point of view that opens up the widest horizons." This notion of personal conviction and this awareness of the possibility that great art may have many faces lead the critic to appreciate the work of numerous and strikingly different artists. One of Baudelaire's earliest enthusiasms was for the caricatures and political and social satires of Honoré Daumier (1808—79). Daumier left a legacy of paintings, drawings, and literally thousands of cartoons, executed for such popular journals as *Caricature* and *Le Charivari*. As Baudelaire remarked, his lithographs provided a daily diet of entertainment for the public, with their apt characterizations of the foibles of doctors, lawyers, bureaucrats, merchants, and the high and the lowly members of Parisian society. Daumier was an ardent believer in the French Republic. His political cartoons had cost him his job during the civil war of 1830—31, and he never ceased to be concerned with the various manifestations of injustice in contemporary French society. His drawings and paintings reflect the attitude of a man who knows very well how to present the touching and pitiful as well as the cruel or the absurd. Daumier has been called a realist in his preoccupation with the day-to-day side of life, his characterizations of ordinary individuals and their social framework. In this respect, one can compare him to an important school of contemporary French writers, who sought to present and explain some of the more disturbing aspects of the society in which they lived and worked. Looking at the poor, hopeless laundresses or charwomen or the crude tradesmen of Daumier's paintings and drawings (p. 27), one is reminded of characters in the novels of Honoré de Balzac and Émile Zola. The bleak, murky quality of many of his canvases suggests an atmosphere of hopelessness: the despair of people trapped in a system that has no regard for human dignity. In a painting like "The Emigrants" (p. 35), which underlines Daumier's continuing involvement in the social and political problems of his time (in this case, the brief, violent Revolution of 1848), the sagging, dehumanized bulks bear little relation to people. They are, quite literally, masses, and, looking at the picture, one is reminded that the revolution represented a moment of revolt in which the lower classes pitted themselves not only against the "bourgeois king," Louis Philippe, but against the middle-class businessmen who supported the ineffectual ruler. The revolution that occurred in Paris was only one

Honoré Daumier, "The Butcher," p. 27

Honoré Daumier, "The Emigrants," p. 35

John Constable, *Weymouth Bay*

of a number of similar disturbances that reverberated throughout Europe; the streets of Berlin and Vienna were also filled with student and working-class revolutionaries. It is interesting to note that, only a year before, Friedrich Engels and Karl Marx had written their *Communist Manifesto* and that Marx, a very interested student of the French Revolution, had published a political study dealing with the history of the revolt.

In his paintings, Daumier generally deals with boldly deployed masses of muddy browns, grays, and earth-greens. There are occasional exceptions, however. A water-color (p. 21) done for a good friend, the poet and critic Théophile Gautier, reveals him to be as fully aware of the contemporary interest in landscape as the young painters who began to frequent the French countryside in search of new subject matter. One of these, an acquaintance of Daumier, was Jean François Millet (1814–75), who also had a basic sympathy for the poor—the peasants who worked small farms. He celebrated the dignity of their life in paintings and drawings, sometimes sentimentalizing them, but at least asserting their validity as worthy subjects for a work of art. Millet expressed his aim to paint "men and women who must belong to their surroundings, and it must be impossible to imagine them otherwise than as they are. Both people and things should express a definite purpose. I wish to convey what is essential in a clear and convincing manner." The directness and simplicity of his artistic language—as in his drawing "The Farmyard" (p. 42)— and that of Daumier, were later much admired by Vincent van Gogh (1853–90), who produced his own great series of paintings and drawings of Belgian peasants.

Millet lived near the village of Barbizon, which was situated on the edge of the forest of Fontainebleau. He was friendly with the painters Camille Corot (1796–1875), Théodore Rousseau (1812–67), and Charles François Daubigny (1817–78). All of these artists worked at one time or another in the vicinity of Barbizon, so that by the 1840's, one could speak of a Barbizon School of landscape painting. Although the artists who worked at Barbizon may have differed in their individual personal interpretations, they had one common aim: to work close to nature and to paint in the fresh, open air.

Rousseau was the first to visit Barbizon. From 1836 on, he spent every summer working in the meadows and forest that surrounded the village. Rousseau, like the seventeenth-century Dutch landscapists whose work he had so admired in the Louvre, decided that nature was the best teacher. As did others of his generation, Rousseau felt an antipathy for the classicizing style of Ingres and was drawn to what he felt to be the more sincere and real world of ordinary human experience.

Among the other artists who worked at Barbizon, Daubigny was possibly the most thoroughgoing of the open-air painters. Not only did he produce spontaneous sketches that might later be worked into large, more finished compositions, as in "Hermitage near Pontoise" (p. 36), but he actually completed canvases on the spot where they had been conceived. This is apparently one of the reasons why he is so frequently cited as having been

Honoré Daumier, "The Walk," p. 21

Jean François Millet, "The Farmyard," p. 42

Charles François Daubigny, "Hermitage Near Pontoise," p. 36

26

a precursor of the Impressionists. One of Daubigny's most interesting innovations—a practice that inspired Claude Monet to emulate the older artist—was to paint along the Seine River, using a boat as a studio. From the river, it was possible for artists to capture the varying effects of light on its surface and to record the topography of the countryside along its banks. Daubigny's paintings met with mixed reactions. The novelty of his approach escaped even as sophisticated a critic as Théophile Gautier, who complained that the artist had contented himself with "impressions and [was] neglectful of detail... M. Daubigny's landscapes are nothing but specks of paint in juxtaposition."

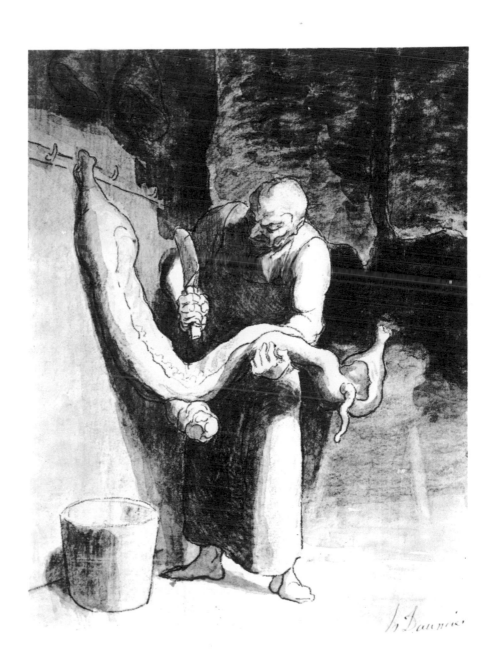

Honoré Daumier,
The Butcher,
Brush Drawing

Honoré Daumier,
Mother and Child,
Brush Drawing

Camille Corot,
"Moulin de la Galette,
Montmartre," p. 37

Camille Corot,
"Seated Girl," p. 40

28

The word "impression" is employed by Gautier in a manner that suggests a sketch or first idea. It is interesting that, at about the same time, Corot used the same word to express his belief that artists must "subject (themselves) to the first impression." Corot had cultivated landscape painting from his early years as a student traveling in Italy. There, he first developed his love and feeling for the natural forms of the Roman *campagna*, or countryside, perhaps stimulated by the model of his country-man, the seventeenth-century master of the poetic landscape, Claude Lorrain (1600–1682). Corot's work is lyrical, grander, and somewhat detached from the mainstream of Barbizon School painting. He created a very personal style, sometimes hazy, filled with softly diffused light, otherwise, as in "Moulin de la Galette" (p. 37), bold and clear as a cloudless summer's day. He painted subjects of a classical nature, but in a dreamy, indifferent manner quite opposed to the stiff rhetoric of Ingres' school. He always maintained his respect for the human figure and some of his most charming paintings are studies of young girls sitting, as in "Seated Girl" (p. 40), or reclining in pensive, gentle melancholy. Although never a committed open-air painter, his sensitivity to color, his balancing of tonal values, and his amazing atmospheric effects clearly mark him as France's greatest landscapist before the advent of the Impressionists.

If we have characterized the approach of Daumier as that of a realist, in contrast to the fantastic or frequently visionary temperaments of Romantic artists like Delacroix, the attitudes and work of Gustave Courbet are far more difficult to categorize or define. Courbet is one of the giants of nineteenth-century art, and his work is only now beginning to be understood and properly evaluated. At first glance, the compositions of Courbet may seem curiously objective, lacking in animation and devoid of any strong narrative or dramatic content. A painting such as "The Burial at Ornans" (p. 34) depicts a scene that was obviously familiar to the artist—Ornans was his native village and the mourners shown in the painting were all townspeople whom he had known since childhood. Yet there is no trace of sentimentality, much less feeling, in the painting. The

Gustave Courbet, "The Burial at Ornans," p. 34

Constantin Guys,
The Shawl,
Pen and Brush Drawing

few indications of emotion, men and women holding handkerchiefs to their faces, are definitely low-keyed, and the general atmosphere of the work is one of quiet or even curious detachment. The landscape of the painting is sparse, monochromatic, and uncompromisingly horizontal, emphasizing and underlining the strung-out, horizontal placement of the figures. The only exception—and it is a notable one—is the sharp, vertical accent of the processional crucifix, from which the small figure of Christ seems to look down pathetically. The well-to-do peasants, tradespeople, and widows of Ornans are real only insofar as they are physically tangible. Indeed, Courbet was so obsessed with communicating the three-dimensional concreteness of forms that his figures often seem to possess an almost clumsy sense of weightiness, achieved at the expense of vitality, intelligence, and charm.

Unlike Delacroix or Corot, Courbet was not primarily a colorist. In fact, his colors are often somber or muddy. The painter utilizes certain darker tones to project a sense of the tangible object, whether it be a group of mourners or a rather ordinary bunch of flowers. In "Bouquet of Flowers" (p. 33), a painting done in 1855, when the artist's work had already generated a considerable amount of critical excitement, and when Courbet was becoming a kind of hero to some of the more rebellious younger painters, we see none of the meticulous detailing of surface that marks the work of numerous seventeenth-century Dutch still-life painters, whose work Courbet had studied both in the Louvre and on a trip to Holland. Instead of the individual appearance of each flower, the artist has captured the bulk of the entire darkish bouquet and has silhouetted it against a clear, cloudless patch of blue sky. The entire impression is one of a study made in the artist's studio or home, and, indeed, Courbet—no matter how revolutionary were his ideas about subject matter or how bold his execution—did not share the enthusiasm for painting outdoors that characterized the work of a number of his contemporaries. Unlike the plein-air artists, he was not really interested in recording various effects of light and atmosphere. Even later, when he produced a rather substantial number of landscapes, the artist usually expressed preference for woodland or rocky scenes that afforded him the possibility of depicting massive forms.

What attracted Courbet above all was the "representation of real and existing things." At times, the artist expressed his strong opinions in language that seems strongly anti-intellectual, and, in fact, he cultivated a personal style and attitude that was often arrogant and self-consciously rustic. Indicating his distaste for visionary or fantastic subject matter, Courbet professed a vital concern for his own age. He proposed a kind of painting in which the poetic language of such romantics as Géricault or Delacroix would be entirely out of place. For him, "imagination in art" meant the knack of "knowing how to find the most complete expression of an existing object, but never in imagining or in creating the object itself."

The nonconformist, revolutionary aspect of Courbet's character and his

Gustave Courbet, "Bouquet of Flowers," p. 33

Camille Corot, *Landscape*, Lithograph

friendship with the socialist philosopher P. J. Proudhon, has been rather exaggerated by some historians. Yet, it is clear that, although his political concerns were limited, they were genuine. When a radical group took over the government and briefly established a Commune in Paris after France's defeat in the Franco-Prussian War in 1871, Courbet was elected president of an assembly of artists. When he became curator of fine arts, he abolished the official, conservative *École des Beaux-Arts*, the Academy in Rome where favored students studied, and all medals. It is interesting, however, that he did not abolish the Salon jury system. During his brief period in office, a mob tore down the column in the Place Vendôme, a memorial to Napoleon's victories. When the government was restored to power, Courbet was charged with the responsibility for the destruction and ordered to pay the costs of rebuilding the column. He was imprisoned for six months, then fled to Switzerland, where he remained until his death in 1877.

The fact that Courbet did not attempt to abolish the jury system of the Salon is particularly interesting in the light of the artist's clashes with officialdom. When two out of twelve of his canvases were refused for exhibition at the important *Exposition Universelle*, or world's fair, of 1855, the artist organized a one-man show in a building on the fairgrounds. Significantly, he called his exhibition the "Pavilion of Realism." Forty-three canvases, including an immense, twenty-nine-foot-long

painting of the artist's studio, overshadowed the official exhibition and spotlighted the gap that separated Courbet's fresh, bold paintings from the tired, hollow works that hung in the salons. Courbet's gesture was also important because it set a precedent that younger artists later followed. He showed them that a painter of force and conviction could demonstrate that fine art could also be found outside the Salon.

If we try to comprehend what it meant for a painter to buck an all-powerful institution like the Salon, we must examine its rather long history. Very few important nineteenth-century artists were exempt from its harsh judgments, and some, like Édouard Manet, suffered terribly from its apparent rejection, despite the enthusiasm of many enlightened critics and artists. The story of the Salon is one of the most crucial chapters in the history of French painting. In fact, the Salon came close to being the clearest expression of official, or government-approved, taste.

The idea of holding an official art exhibition every year or every other year dates back to the reign of Louis XIV. The king's desire to assert France's superiority in the fine arts and in literature led to the foundation of the Royal Academy in the mid-seventeenth century. From 1665 on, the professors and other members of the Academy were accorded the privilege of exhibiting. After 1737, these official shows were held every two years in the *salon carré* of the Louvre palace and came to be called the Salon.

It seems amazing that this institution, rooted in absolutism and exclusivism, not only was able to survive three revolutions but was little affected by any attempts at reform. Although Jacques-Louis David succeeded in liberalizing the Salon practices and, at least theoretically, in opening the exhibition to all artists, the monolithic character of the institution was stronger than the forces of reform. There were cries for the democratization of the salons in 1830 and 1848, years of turmoil and great social change, but no real reform was forthcoming, although protests were made by hundreds of artists and intellectuals. As more and more younger painters became disenchanted with the conservatism of the Academy and its rigid adherence to Ingres' brand of classical art, a climate of open rebellion developed. While many progressive painters—Delacroix, Corot, and even Courbet—continued to exhibit in the salons, there was an increasing number of defections. Naturally, if an unknown artist wished to make a name for himself, he had to submit to the rules and regulations that would guarantee advancement. The Academy of Fine Arts controlled the *École des Beaux-Arts*, where young painters were trained, administered the awards for study in Rome, and controlled the jury that chose the paintings to be exhibited in the official salons. In

Gustave Courbet, *Bouquet of Flowers*

Honoré Daumier, *The Emigrants*

36 Charles François Daubigny, *Hermitage Near Pontoise (Detail)*

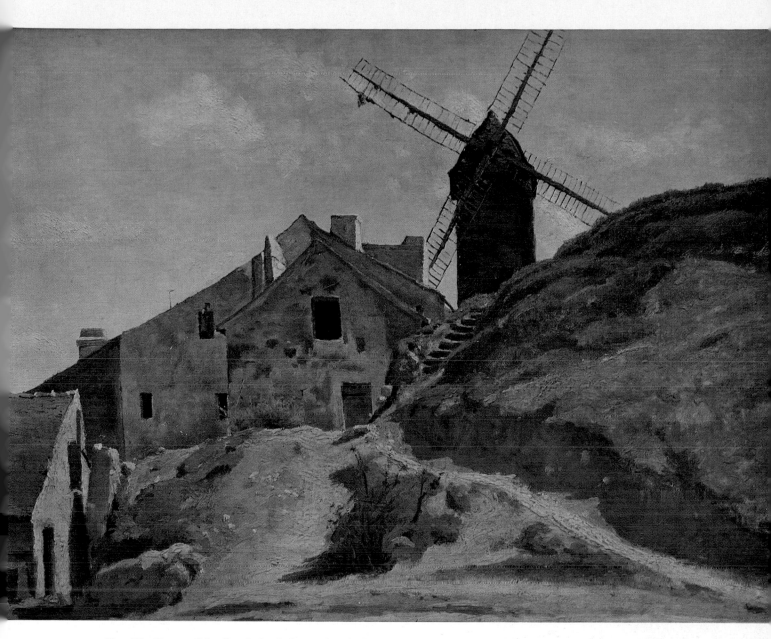

Camille Corot, *Moulin de la Galette, Montmartre*

On the following pages:
Camille Corot, *Rocks by the Seashore*
Camille Pissarro, *Wharf and Bridge at Pontoise*

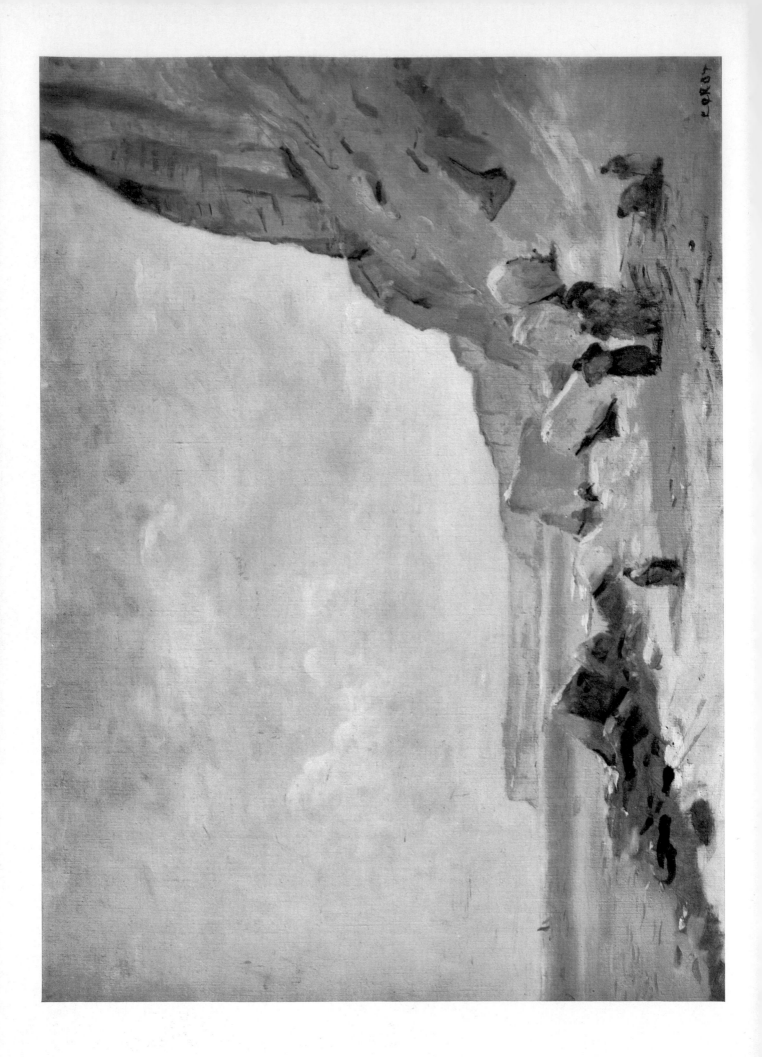

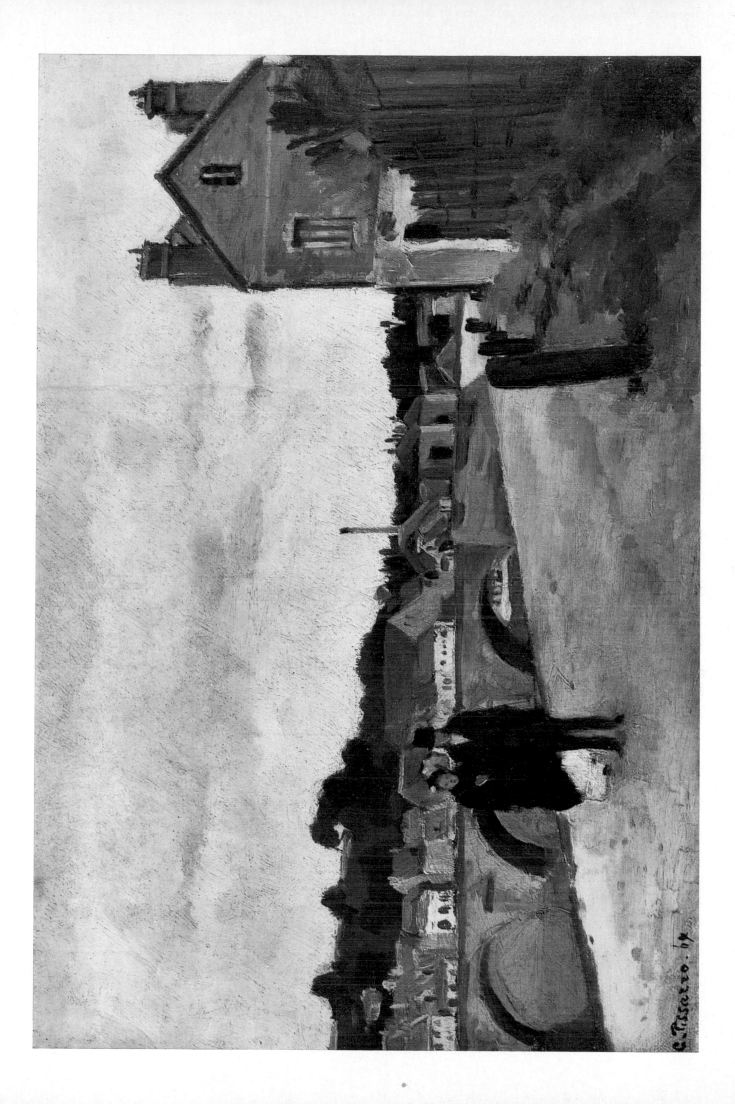

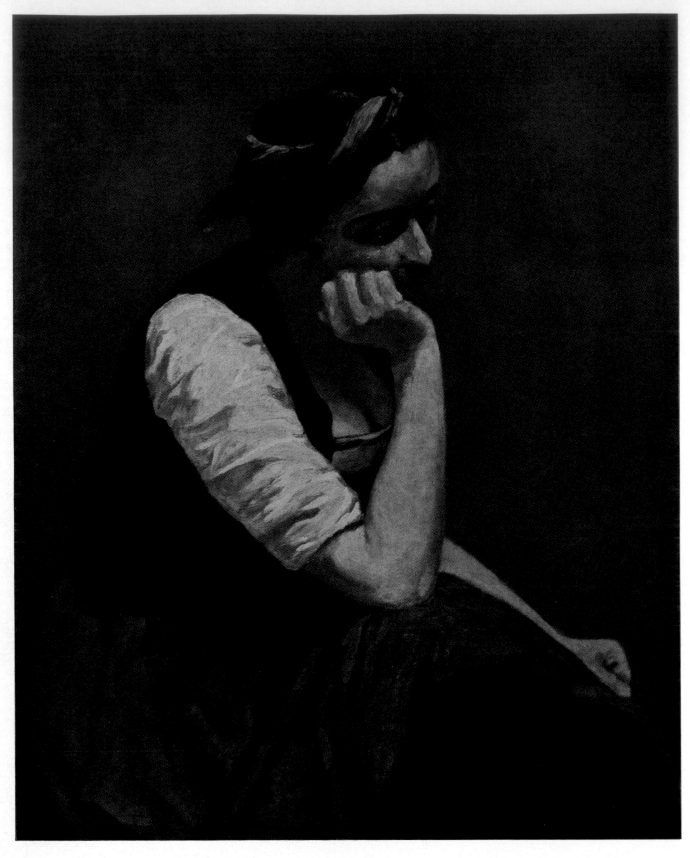

Camille Corot, *Seated Girl*

addition, the members of the Academy could influence the Director of Fine Arts to favor the purchase of certain pictures or to see to it that some painters received important official commissions.

Each year, the number of pictures submitted to the official Salon increased. By 1855, the year of the first great world's fair, the Salon was so large that it was held in the enormous *Palais de l'Industrie*. Twelve years later, when another world's fair was organized in Paris, the Salon was even bigger.

To understand the importance of the Salon, its role in the formation of public taste, and its important connection with the subsequent development of French painting, we can focus for a moment on the Salon held during the world's fair of 1855. Although Courbet, who was by this time the idol of the young, restless painters of Paris, had exhibited many times in the official salons, two of the twelve paintings he offered o the Salon were refused. The two works were "The Burial at Orrans" and an elaborate allegorical work entitled "The Artist's Studio," or "real allegory summarizing a phase in my life that lasted seven years." Courbet decided to hold an independent exhibition; he rented space in a building adjacent to the gate to the exposition, thus creating his Pavilion of Realism. In a letter to a friend, the critic and novelist Champfleury, Courbet clarified his intention of painting "the moral and physical history of my studio," of his personal experiences with the world "that comes to me to be painted." Previously, in a letter addressed to some restless young artists who had withdrawn from the *École des Beaux-Arts* as a form of protesting its teaching methods, Courbet had maintained the need of every age to have its own artists who would interpret it and present it to future generations. Speaking more specifically about painting, he declared the purpose of the Pavilion of Realism: to represent "real and existing objects." The comparatively candid, objective language of many of Courbet's paintings made him appear to be the most radical of the progressive or avant-garde painters. Thus, his Pavilion of Realism generated great enthusiasm among artists, critics, and amateurs, and the impact of Courbet's art was felt well into the next decade.

Among the many young painters who came to Courbet's Pavilion was Camille Pissarro (1830–1903). He had visited the large official Salon and had viewed, with a mixture of awe and disappointment, the numerous works on exhibition. Like so many of his contemporaries, Pissarro was impressed with the strong, dramatic colors of Delacroix and the uncompromising physicality of Courbet. He was also charmed by the dreamy landscapes of Corot and began to take a greater interest in this type of painting. Although he attended some classes at the *École des Beaux-Arts*, Pissarro was apparently dissatisfied with the rigid and outdated teaching and work methods employed there, and he sought out Corot, who seems to have spent many hours with the young man, clarifying his views on light and color.

Pissarro was a diligent pupil. By 1859, he could boast of having had a small landscape accepted for the Salon. It became clear to Pissarro that

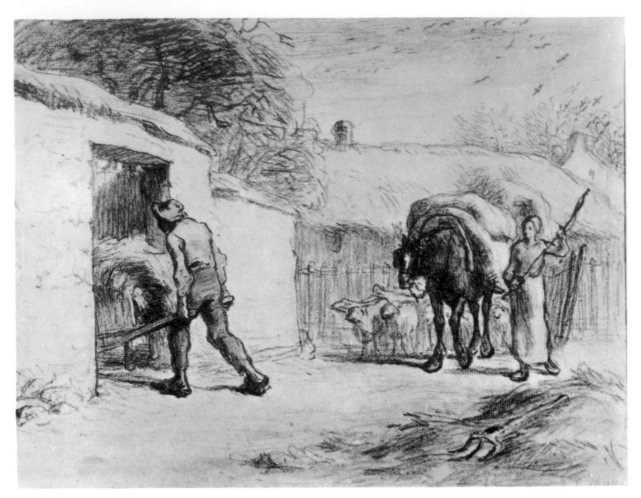

Jean François Millet, *The Farmyard*, Pencil and Water Color

Eugène Boudin,
"Beach at Trouville,"
p. 54
Johan Barthold
Jongkind,
"Demolition of a
House in the Rue des
Franc-Bourgeois,"
p. 51

the study of nature was more important than all the rules of the Academy. He began to frequent the *Académie Suisse*, an open studio run by a former model, where it was possible to sketch a live model for a very small fee. Many landscape painters worked there in order to develop a knowledge of anatomy, among them, periodically, Édouard Manet, Claude Monet, Alfred Sisley (1839—99), Frédéric Bazille (1841—70), and Paul Cézanne (1839—1906).

One can imagine the discussions and arguments that took place among these young painters. Monet and Bazille were especially committed to the new idea of working directly from nature and endeavored to convince some of their other comrades. Monet had begun working in plein-air when he first became influenced by Eugène Boudin (1824—98), a painter of small, charming seascapes, such as "Bridge at Trouville" (p. 54). Working with Boudin and the Dutch painter J. B. Jongkind near his hometown of Le Havre, Monet came to appreciate the extraordinary variety of atmospheric and lighting effects available along the coast of Normandy. The canvases of Boudin were full of bright light and color, and Monet soon began to entreat other artists to join him in his painting jaunts along the beaches and harbors that dotted the coasts of Brittany and Normandy.

Later, in the 1860's, Monet introduced his friends Auguste Renoir (1841–1919), Bazille, and Sisley to Édouard Manet, who was by that time the most controversial figure in French art. His conversations with Manet sharpened Monet's senses and exposed him to the sophisticated world of which Manet was very definitely a part. At the same time, Monet and the others constantly sought refuge from the disappointments of the Paris art world in the gay, carefree life of the cafés along the banks of the Seine just outside of Paris.

Camille Corot, *Landscape*, Lithograph

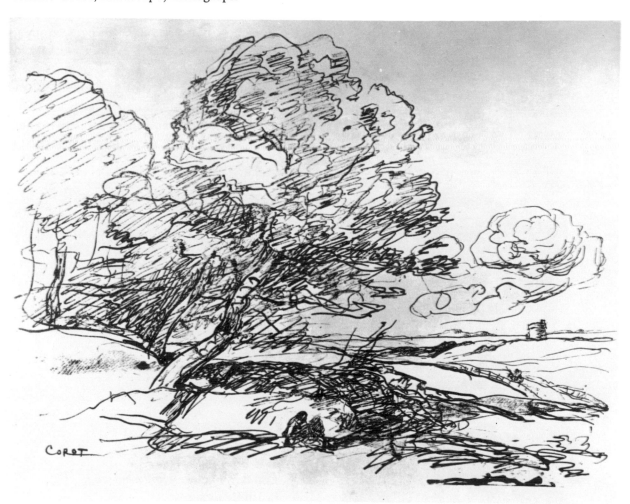

MANET AND THE SALON DES REFUSÉS

When they were not working in the countryside near Paris or along the Channel coast, the younger painters generally met for discussions in their studios or in cafés. In prolonged debates about how an unknown artist might present his work to the public, they returned again and again to the role of exhibitions. They recognized that the surest road to popular recognition lay in acceptance by the official Salon jury, which was composed of largely conservative painters drawn from the Institute of Fine Arts, the despotic body that also chose the professors for the *École des Beaux-Arts*. While their rebellious spirits induced them to strike out on independent paths of their own, most young painters reasoned that the financial security that followed on the heels of honorable mentions, medals, and official purchases of the Salon paintings was the inevitable consequence of working within the "system." As a result, most of them attempted to show in the Salon, where they generally met with indifference or rejection. They could take consolation from the fact that many talented artists had been excluded from the Salon. It was even possible to cite the low opinion of the official exhibitions held by some of the recognized greats of their day. Even Ingres, a member of the Academy of Fine Arts for more than forty years, had openly deplored the low level of the official shows when he stated, "The Salon stifles all sense of greatness and beauty. What moves artists to exhibit is above all the hope of gain, the desire to attract attention at any price. ... The Salon nowadays is really nothing more than a dealer's shop." Although he quite accurately diagnosed the

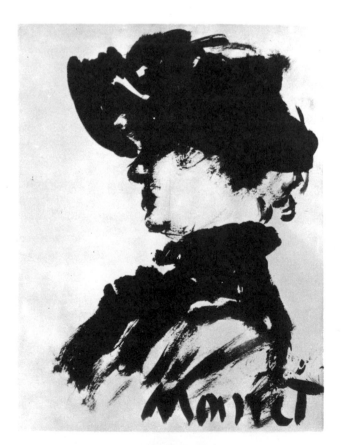

Édouard Manet, *Woman's Head*,
Brush Drawing

sickness of the official exhibitions, Ingres was not prepared to play the role of physician. He never once used his enormous prestige to effect changes; thus, year after year, the sickness persisted and worsened. Although Delacroix was finally made a member of the Academy in 1857 (six years before his death) and was even elected a member of the jury for the Salon of that year, his belated acceptance did not change the complexion of that essentially conservative body. Both Manet and Pissarro had pictures accepted in the salons of 1859 and 1861 — Manet's work "The Spanish Guitar Player" actually received an honorable mention — but they subsequently met with great difficulty. Even Degas, despite his veneration of Ingres and the Italian Renaissance masters, had considerable trouble with the Salon juries.

In 1863, the jury rejected more than 4,000 works of art. So great was the outcry against the exclusion that Emperor Napoleon III intervened and sanctioned the establishment of an exhibition of the works that had been refused. Although the quality of this enormous exhibition was terribly uneven — certainly a large number of those who were turned down by the jury of the Salon were artists of questionable talent — the *Salon des Refusés*, as it was called, represented a break-through. The Emperor was a highly sensitive political animal who recognized a popular cause, and he seized this opportunity to appear to be a champion of justice and freedom of expression. But the *Salon des Refusés* proved to be a brief interlude. In 1865 and 1867, the more progressive painters again met with rejection. Despite the appearance of such sympathetic painters as Corot and Daubigny on the Salon jury, success was very limited. Monet and Sisley managed to have pictures accepted, Bazille was represented by a still life, and Pissarro by a landscape of Pontoise. However, the main cause for excitement now was not the works exhibited but the new critical reaction that was developing in the late 1860's. Among the critics, the most radical voice was that of a relatively unknown author, Émile Zola, whose task it was to review the Salon of 1866 for the newspaper *L'Événement*.

In his four articles (twelve were planned, but Zola's contract was canceled because of the outspoken nature of his writings), he attacked the outmoded jury, its make-up, and its curious and absolute tyranny. He accused the Salon of not being representative of French art but rather of being "a *ragout* [stew] prepared and simmered by twenty-eight cooks." He discussed realism as an artistic movement and, as did Baudelaire, pleaded for the cause of artistic subjectivism and the importance of temperament. He praised some of the landscapists, singling out Pissarro as one of the freshest among them, but his greatest enthusiasm was reserved for the paradoxical and willful painter who had been shut out of the Salon, Édouard Manet. He correctly analyzed Manet's approach to painting and, while denying a strong resemblance between Manet's work and that of Courbet, identified the artists' similar intention of depicting "in all their vigor the different objects that stand out from one another." Zola appreciated Manet's bold, strong outlines, his sometimes brutal transitions from black to white, and his tendency to "see in terms of areas, of simple ener-

Édouard Manet,
"Dejeuner sur
l'herbe," p. 50

getic fragments." For Zola, Manet's "masterpiece" was the "Déjeuner sur l'herbe" ("Luncheon on the Grass") (p. 50), a large, revolutionary canvas that had dominated the *Salon des Refusés* and that, along with the "Olympia," which was rejected two years later, made Manet the hero of the avant-garde.

A more unlikely revolutionary one could not imagine. Manet was the son of a highly respectable and wealthy Parisian family. His appearance was extremely elegant, his manners cultivated, his conversation witty. Moreover, he had studied for six years with Thomas Couture (1815–79), one of the great exponents of historical painting, and he always maintained a respect for the art of the past, constantly improving his knowledge by studying the works of Dutch, French, and, especially, Spanish masters in the Louvre. Nevertheless, like many of the budding Impressionists, Manet drew at the *Académie Suisse* and was, at the same time, highly receptive to the important development of photography. Contemporary photographs, with their absence of tonal values and their strong, sharp silhouettes, were providing a source of inspiration for many artists working during the 1860's, as were the flat, strongly colored Japanese woodcuts that were first introduced to Western artists during the 1855 world's fair.

Édouard Manet, "The
Balcony," p. 52

If we look at Manet's "The Balcony" (p. 52), painted in 1868, two years after the artist had returned from a brief trip to Spain, we can get some idea of how he managed to combine motifs drawn from the past with a totally new conception of form and a radically different appreciation of subject matter. Manet had developed an appreciation of Spanish art when two great private collections including works by Diego Velázquez (1599–1660) and Francisco Goya (1746–1828) were made available for public exhibition. Subsequently, this artistic interest was fortified when a company of Spanish entertainers and bullfighters visited Paris in 1862. Manet's first, brief success in the Salon had been the "Spanish Guitar Player," and this predisposition to Spanish subjects was to remain throughout the decade. "The Balcony" differs from "The Guitar Player," "The Dead Toreador," "Lola de Valence," and other works of a more obvious Spanish derivation, in that the figures depicted are the elegant Parisians of Manet's circle. One of them is, in fact, the darkly beautiful seated figure of Berthe Morisot (1841–95), a painter of landscapes and later one of the Impressionists. The painting was inspired by a work by Goya, the great Romantic painter of the late eighteenth and early nineteenth centuries, who had produced a work entitled "Majas on a Balcony." Whereas Goya's painting appears spirited and mysterious, Manet's work seems curiously detached. Goya's brushstroke is vigorous, animated, his colors dark and atmospherically suggestive; Manet's colors are flat, his palette limited to strong contrasts of black and white, with the green of the railing and the fragment of shutter providing virtually the only relief. More curious still is the isolation of the figures—not merely physical isolation but a psychological one as well, akin to but more heightened than the isolation and detachment that we observed in Courbet's "The Burial at Ornans." Where Goya's painting bespeaks the Romantic artists' concern with projecting an ambiance or environment, Manet's approach is totally objective. It is

hard to speculate about the figures, since they seem to exist only as pigment and not as flesh-and-blood human beings acting out a real situation.

As did many of the seventeenth-century Dutch painters whose work he studied in the Louvre, Manet produced a considerable number of still-life paintings. Despite the persistent academic belief that history painting was superior to landscape and still life, numerous artists turned to these last types of paintings precisely because they rejected the old notion that subject matter had to be ennobling or instructive. While the still lifes of the Dutch painters were painted with rich, sparkling colors and an often deceptively convincing sense of texture, in order to convey a sense of their actuality to the viewer, Manet's still-life paintings (p. 53) seem motivated by other concerns. His early work shows a marked interest in the formal arrangement of objects, while later paintings reveal him to be more and more involved in the quality of the pigment and in the manipulation of his brush. At times, his strong colors seem a bit harsh, as though the painter had made an effort to avoid the kind of prettiness so often associated with paintings of flowers.

Édouard Manet, "Peonies in a Vase," p. 53

Manet's early masterpiece, "Déjeuner sur l'herbe," is a strange and fascinating painting that baffled many of the artist's critics and offended the vast majority of the public that viewed it in the *Salon des Refusés*. At first glance, its subject matter may seem a bit unorthodox, and to many prudish Parisians, including the Emperor, it was indeed shocking. Two young gentlemen, dressed in costumes of the day, and two young women are depicted in a clearing in the forest. One of the young women, clad in a filmy dress, is wading in a stream; the other, a nude, stares provocatively at the viewer. A picnic basket and the lady's clothes are scattered carelessly in the lower left-hand corner of the picture and seem to compete with the seated group for the viewer's attention. Although the figures are somewhat detached from one another, as in "The Balcony," the nudity of the female in contrast to the fully clothed males and the disturbing frankness of her gaze make us a bit uncomfortable about the painting. Unlike so many other painters of nudes, Manet has not projected an image that is overtly sensual. He has depicted the figure in terms of harsh outlines and strong yellowish flesh tones, which contrast sharply with the darkish color of the landscape. Many viewers were struck by the boldness of Manet's subject, although the artist could point to at least two distinguised models from which his conception drew inspiration. In the Louvre, there was a painting by the sixteenth-century Venetian colorist Giorgione (*ca.* 1478–1511) entitled "Concert Champêtre," in which two young gentlemen are seen in a similar situation with two partially clothed females. The other work that served as the model for the grouping of the three figures was even more unassailable, since it was an engraving after a lost painting by Raphael depicting the "Judgement of Paris." Superficially, Manet seemed to have done what the professors of the *École des Beaux-Arts* encouraged their students to practice: copy or adapt themes and motifs from High Renaissance sources. Yet certain differences cannot go overlooked. Although Manet borrowed poses from Raphael's work,

his own subject was contemporary rather than mythological, and, indeed, the very juxtaposition of the two clothed men with the scantily clad or unclad females suggested to Manet's contemporaries, who may not have been aware of his use of sources, that they were witnessing a real event. Nevertheless, Manet's lack of idealization of the female, the strong, often harsh colors, spatial ambiguity, and frozen quality of the composition suggest that, while his painting clearly refers to High Renaissance sources, the painter does not intend to imitate or emulate them. The warmth of Venetian color so integral to Giorgione's work or the harmonious proportions and balance between figure and landscape so essential to Raphael's are rejected in favor of a composition that will underline the fictional and artificial nature of the scene. For Manet, a painting was not primarily a mirror of reality, full of illusionistic space and the reflection of tantalizingly real surfaces, but was rather a record of a particular encounter with reality and an attempt to translate that encounter into the visual language of line and color. When Manet referred back to well-known paintings of the past and utilized various aspects of their composition, he was, above all, stressing the newness of his approach.

When paintings by Manet were rejected by the Salon juries of 1866 and 1867, he followed the example of Courbet and took the bold step of organizing a one-man show outside of the official exhibition space in the world's fair of 1867. In a note explaining his reasons for organizing the exhibition, he disclaimed any revolutionary intention and stated that he had "no pretensions either to overthrow an established mode of painting or to create a new one." It is also true that, although he encouraged many of the younger painters who were later associated with Impressionism, especially Monet, he never took part in the Impressionists' group exhibitions and, indeed, seemed to lack their common and abiding enthusiasm for plein-air painting. Although he produced some marvelous landscapes—or landscape fragments—Manet's forte was, ironically, figure painting, and in this respect, like Degas, he seemed to stand somewhere between the past and the future.

Manet's greatest attraction for the young artists who were to change the direction of French painting was as a hero—a man who, like Courbet, had managed to make his way without bowing down to the arbitrary dictates of the artistic establishment. In the late 1860's, Manet presided over the group that gathered at the Café Guerbois—a group including Degas, Monet, Renoir, the charming Berthe Morisot, and the photographer Nadar (1836–1910), as well as the writers Duranty and Zola, who became the painters' staunchest defenders. From time to time, Baudelaire would join this group, and it may have been admiration for the poet that prompted Manet to paint, in the 1870's, subjects conforming more to Baudelaire's cry for a painter of modern life.

Right: Auguste Renoir, *Alfred Sisley and His Wife*
On the following pages:
Édouard Manet, *Déjeuner sur l'herbe (Luncheon on the Grass)*
Johan Barthold Jongkind, *Demolition of a House in the Rue des Franc-Bourgeois*

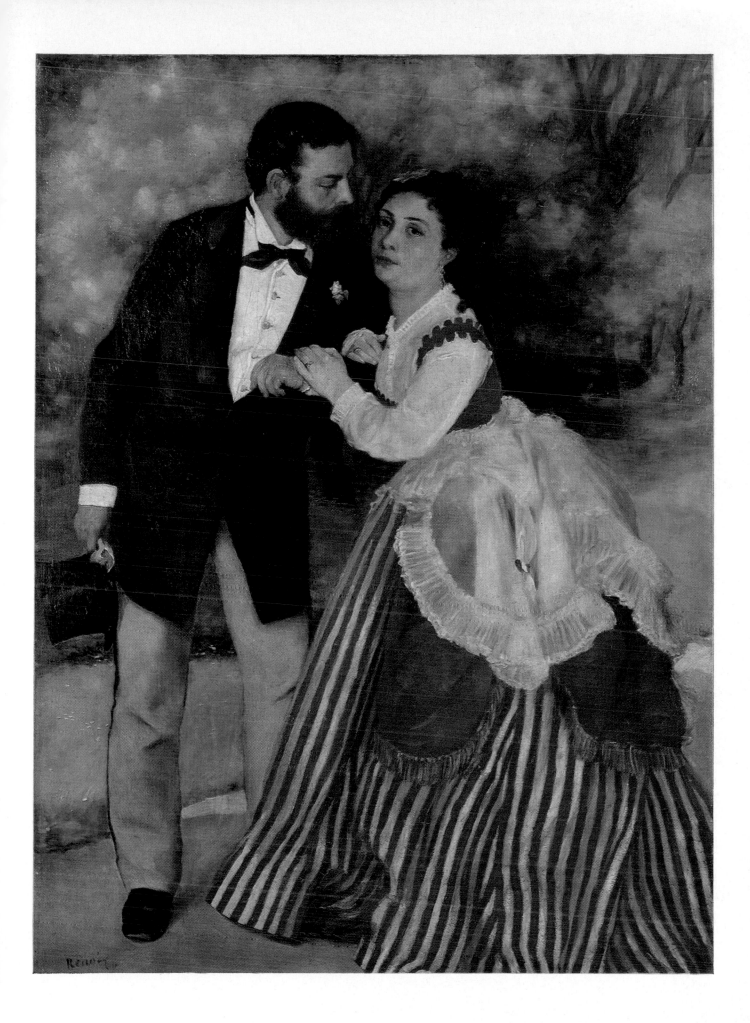

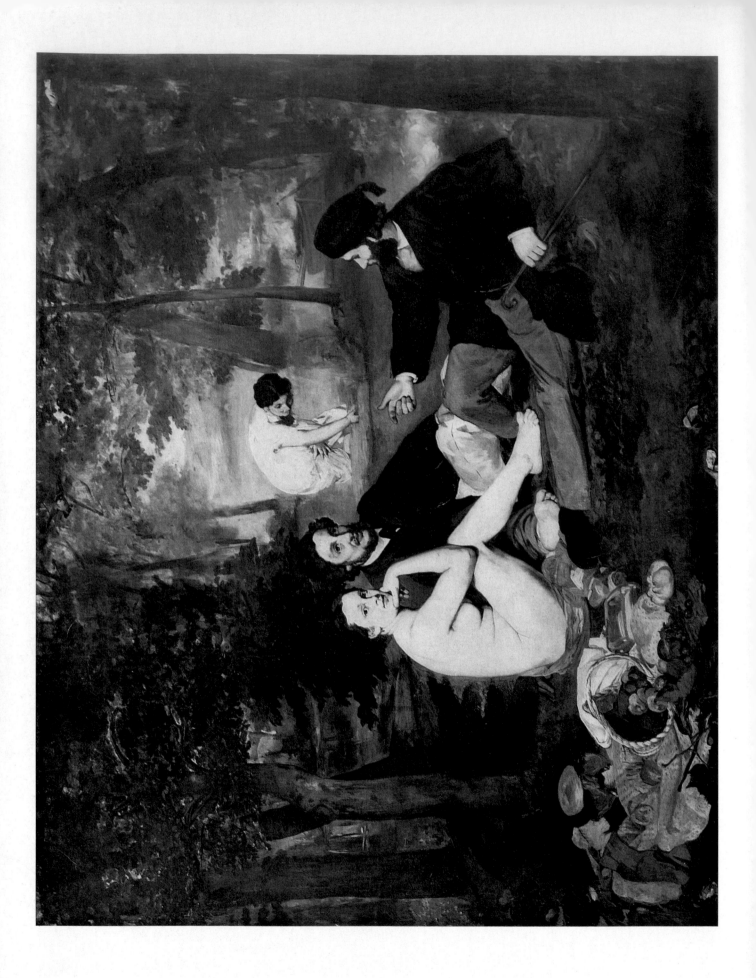

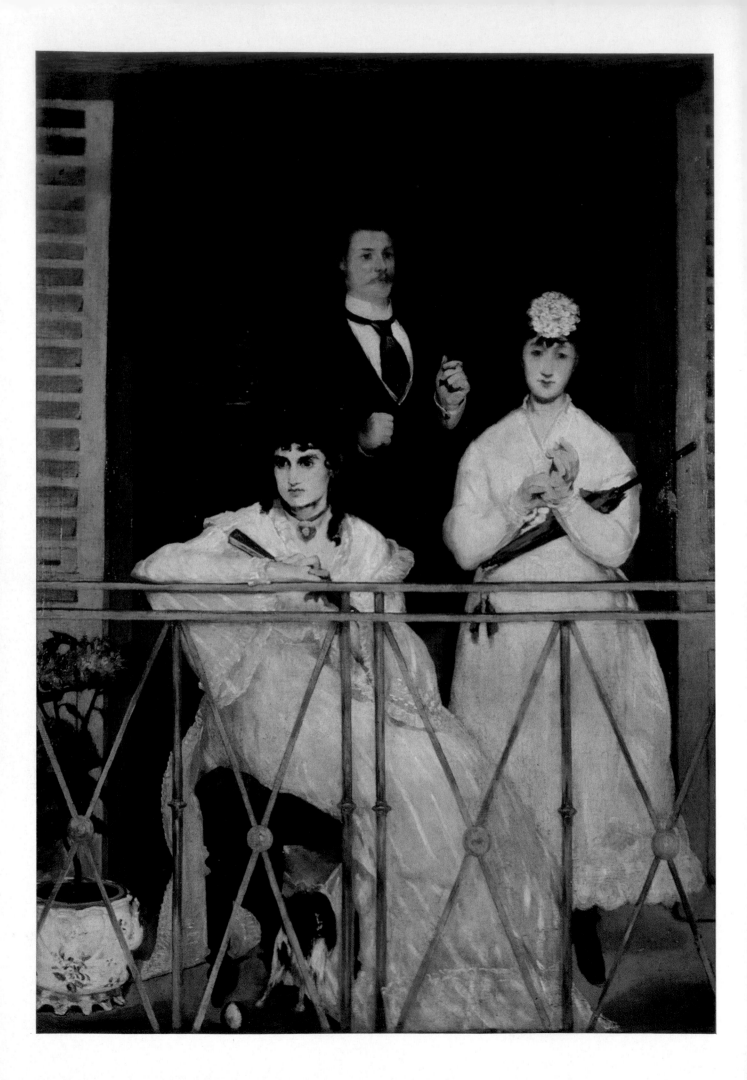

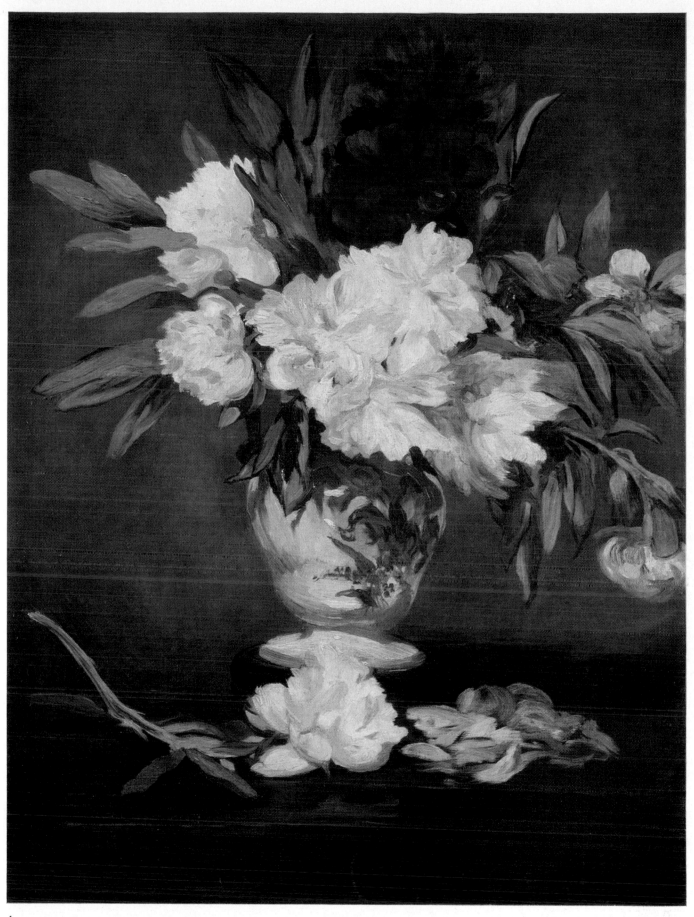

Édouard Manet, *Peonies in a Vase*

Left: Édouard Manet, *The Balcony*

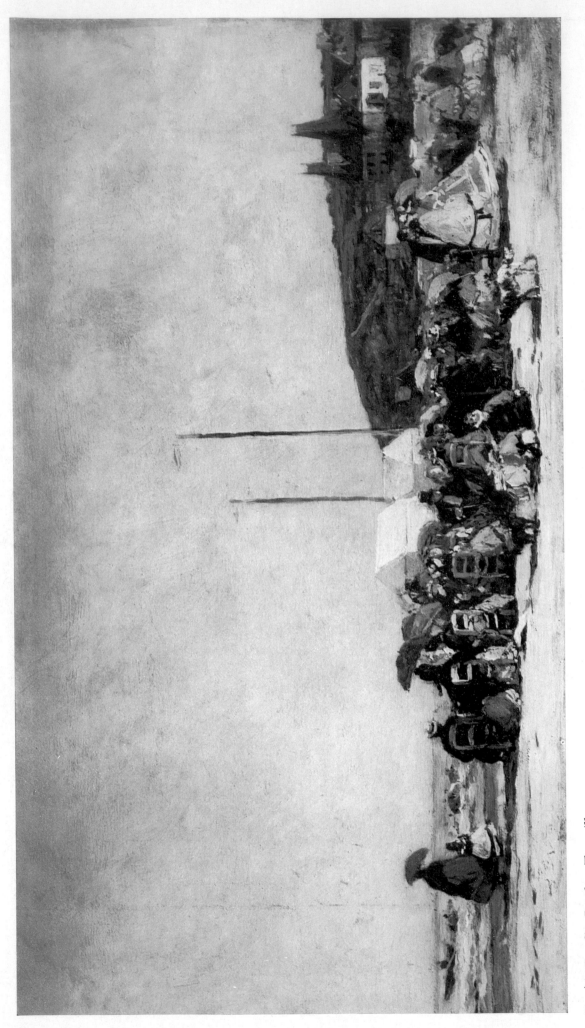

Eugène Boudin, *Beach at Trouville*

Below: Claude Monet, *Farmyard*

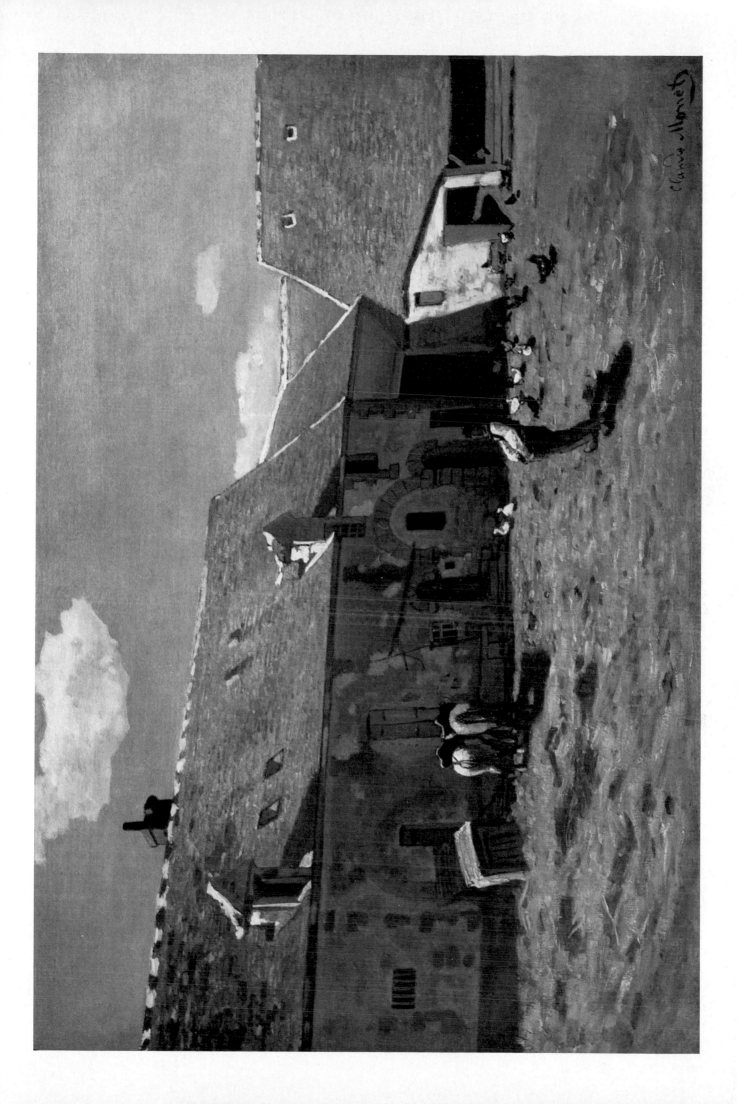

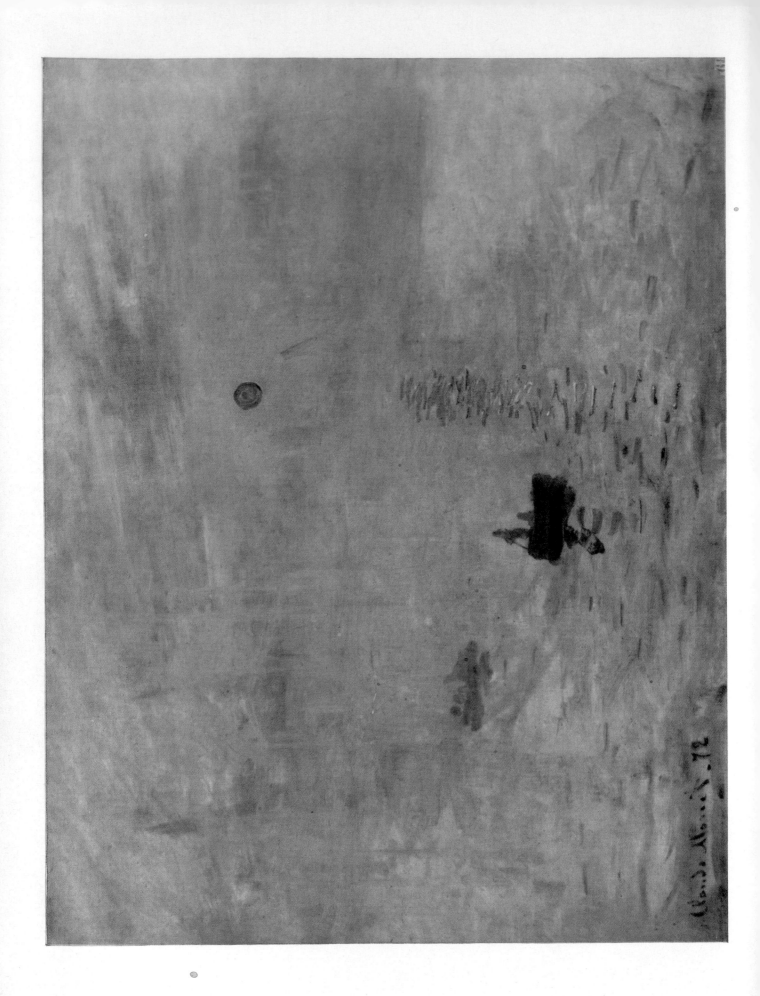

THE FIRST IMPRESSIONIST EXHIBITION

The character of the loosely knit group that gathered at the Café Guerbois was decidely heterogenous. While Monet, Sisley, Pissarro, Renoir, and the slightly remote Cézanne were distinctly landscape painters, Manet, Degas, and Henri Fantin-Latour (1836–1904), who painted several members of the group at Manet's studio, were more interested in interior scenes and, above all, the human figure. What united these strongly individualistic artists was a common sense of dissatisfaction with the *status quo* and a common desire to create an alternative to the existing exhibition system. In the pamphlet indicating his reasons for holding an independent exhibition, Manet summed up their views: " The matter of vital concern, the *sine qua non*, for the artist, is to exhibit; for it happens, after some looking at a thing, that one becomes familiar with what was surprising, or if you will, shocking. Little by little, it becomes understood and accepted."

With Manet's exhibition in mind, some of the younger artists had discussed the possibility of an independent group exhibition, but the Franco-Prussian War of 1870–71 interrupted their dialogue and prompted many to seek asylum in the provinces of France or even to journey abroad. They did not gather again until the end of the war, when conditions had returned to normal in Paris and when it was clear that nothing much had taken place to effect a change in the artistic "establishment."

When the painters did come together, their meetings were once again characterized by the divergence of opinion that had hindered them in the past. Bazille, one of the principal early spokesmen for the idea of an independent group show, had been killed in the war; Monet, who returned from a sojourn in England, tried to fill the vacuum of leadership and, with Pissarro's help, succeeded in convincing a majority to exhibit. Many organizational problems arose, and there were protracted discussions about methods of hanging the pictures (this point was surely a sore one, since so many painters had in the Salon suffered the indignity of having their works badly hung or skyed, so that it was virtually impossible to see them), which artists to invite, and where to hold the exhibition. The second question was a rather crucial one, as some of the group felt that, in order to stress the newer, revolutionary character of the exhibition, none of the painters of Corot's generation should be invited; others tended to agree with the advice of Degas that it would be wise to invite some artists who had established themselves in the Salon and who might lend more prestige to the exhibition. After considerable debate, Degas' suggestion was acted on, and the problem of where to hold the exhibition was solved when Nadar vacated his photography studio near the elegant Boulevard des Capucines. The group decided to call themselves a *Société anonyme coopérative des peintres, sculpteurs, graveurs, etc.* (Anonymous and Co-

Left: Claude Monet: *Impression, Sunrise*

operative Society of Painters, Sculptors and Engravers), and their exhibition opened to the public on April 15, 1874. The catalogue listed 165 pictures by a wide variety of artists, including the six whom we now consider the leading Impressionists. Although there was an admission charge, the public seems to have attended in large numbers (about 4,000 during the four weeks). However, it must be conceded that most of those who came did so out of a curiosity that was prompted by the sensational and devastating critical reviews of the exhibition.

Ten days after the opening of the exhibition, a critic for the satirical journal *Le Charivari* published a review that not only summarized the majority opinion of the works viewed, but became celebrated for coining the term "Impressionist"—a term that derived from one of Monet's paintings, "Impression, Sunrise" (p. 56), and that was quickly adopted to describe all of the artists exhibiting. In his biting, mocking critique, Louis Leroy reflected the great difficulty that viewers—who were accustomed to the fine brushwork and careful composition of most Salon painting—had with the broken color, the bold and seemingly undisciplined brushstroke, and the variegated surface that was characteristic of so many of the paintings shown. In speaking of the loose or nonexistent drawing and the "sloppiness of tone," Leroy mockingly lamented "Oh, Corot, Corot, what crimes are committed in your name! It was you who brought into fashion this messy composition, these thin washes, these mud-splashes in front of which the art lover has been rebelling for thirty years."

Since virtually all the critics were of one opinion about the independent group exhibition of 1874, it was quite natural that some of the painters were troubled and disillusioned at their lack of understanding. Some wondered whether Manet was not right after all when he maintained, despite his own example, that the Salon offered the best opportunity for public acclaim. Camille Pissarro probably spoke for the entire group when he wrote his friend the sympathetic journalist, critic, and collector Théodore Duret: "Our exhibition is going well, it is a success. The critics are tearing us to pieces and complain that we do not study. So I am going back to my work, which is better than reading their articles from which one learns nothing."

Just as Manet's "Déjeuner sur l'herbe" had dominated the *Salon des Refusés* in 1863, Monet's "Impression, Sunrise" attracted the greatest attention in the first Impressionist exhibition. Monet had inadvertently christened the movement with the title of his painting, and, in its exemplification of a new concept of painting, it also seemed to surpass the other works shown. Years later, Monet related that he had chosen to designate this work and others by the word "Impression" largely because he was having some difficulty describing the canvases. The editors of the exhibition catalogue had added the word "sunrise" in order to distinguish this painting from the others bearing the term "Impression." In attacking the celebrated painting, the critic Leroy pretended that he understood Monet's title to suggest that the viewer must be impressed by the work. He ridiculed the work by stating, "Impression—I was certain of it. I was just

Claude Monet, "Impression, Sunrise," p. 56

Alfred Sisley, *Huts on the Bank of the Loing River*, Pencil Drawing

telling myself that since I was impressed, there had to be some impression in it... and what freedom, what ease of workmanship! Wallpaper in its embryonic state is more finished than that seascape."

That Monet's designation "Impression" signified the first or spontaneous impression of an actual scene was clear to only the most sensitive observers, although it was not the first time the term had been employed. Corot had maintained that an artist "must subject himself to the first impression," and it was probably with this in mind that Leroy decided to place the blame for Impressionism on the older master. Nevertheless, the term was quickly adopted by friends and enemies alike to describe a group of paintings that constituted a definite style.

When the critic Théodore Duret, one of the few men who really grasped the significance of what Monet and the other Impressionist painters were trying to do, published his important study on the group in 1878, he accurately characterized Monet as the "Impressionist *par excellence*." He stated that the painter had succeeded in "setting down the fleeting impressions which his predecessors had neglected or considered impossible to render with the brush." Duret also recognized that Monet was a master of seascapes—a subject that allowed him to explore "the thousand nuances that the water . . . takes on." Monet himself had described painting as "experimenting with light and color effects" and this statement may be taken as a summary of the aim of most Impressionist painters. Clearly, their conception of light and color went far beyond the bold, dramatic,

Claude Monet, *Rocks by the Seashore*, Chalk Drawing

but comparatively conservative compositions of Delacroix or the controlled, nostalgic color harmonies of Corot. "When it is dark," Monet wrote, "I feel as if I were dying." And, indeed, the latter's concern with light almost amounted to an obsession.

Light enabled Monet and the others—Pissarro, Sisley, and Renoir, particularly—to see the external world under the varying effects of atmosphere. As Duret maintained, never before had painters seized upon "the play of light in the clouds, the vibrant coloring of flowers, and the checkered reflections of foliage in the rays of a burning sun." No longer primarily concerned with painting the immobile and immutable aspects of nature, as generations of artists had done since the Renaissance, they attempted to capture the impermanent, shifting aspects of a particular place and time. They strove to record what Monet called the "instantaneous." The reflections of light and color, the vibrations of intense sunlight, the haze or mist that obscured the contours of objects and rendered them vague and, to some, seemingly formless—all of these they attempted to reproduce with pure daubs of color and brushstrokes of varying intensity and size. Strong drawing, modeling, perspective, composition, and design, in the sense that Ingres had taught—the indispensable ingredients of traditional painting—all lost their meaning in the Impressionist search for a new kind of visual truth. While a hierarchy of subject matter had been accepted by the Salon painters almost as a matter of faith, the Impression-

ists selected their subjects primarily because of the opportunity they afforded to paint a particular visual effect. The subject matter had little didactic significance beyond the rather practical consideration of where one might find conditions that would allow the painter to experiment with varying kinds of light. Thus, the narrative content of a theme, which had been held so important by the artists of the past—classicists and romantics alike—was discarded in favor of a seemingly more objective, almost scientific approach. Figures, landscapes, still life, all offered what the artist sought, namely the possibility of studying objects whose surfaces were radically affected by light.

One end product of the Impressionists' experiments with light and color was the gradual disappearance of the central perspective that had been a major feature of painting since the Renaissance. Although compositions continued to be governed by a form of aerial perspective, depth, space, and the plasticity of forms were rendered largely in terms of the resonance of colors. The chiaroscuro, or strong contrast of light and dark, that Baroque painters had developed to communicate a sense of atmos-

Edgar Degas, *Drapery Study*, *Dancer*, Pencil and Chalk Drawings

phere was sacrificed for the absolute effectiveness of pure colors. Even in rendering scenes that were, for the most part, dark or gloomy, such as Sisley's "Flood at Port-Marly" (p. 67) or Pissarro's "Snow at Louveciennes" (p. 66), the Impressionist painter sought to activate the darker colored parts so that they interacted with the areas of warmer, stronger light.

Another aspect of the Impressionists' new attitude toward color was that painters relied so much on their vision that they did not paint local colors as their predecessors had done but attempted to depict the aspect of color an object seemed to project under specific atmospheric conditions. For example, in Renoir's painting "Dancing at the Moulin de la Galette" (book-jacket cover), we can see how light falling on a dark-blue garment might lend it a flowery, almost spotted effect, just as colors seen under a clear, cloudless sky might well seem different when viewed on a rainy day.

The Impressionists tried to be objective in their rendering of a momentary vision, but their experiments with color obliged them to come to terms with the laws and science of color and light. Thus, they gained through their practical experiments a knowledge of the colors of the spectrum. While Delacroix and Corot had spoken of these, it remained for Michel Eugène Chevreul, a professor of organic chemistry at the Museum of Natural History, to study and attempt to categorize the various properties of natural color. Some of the Impressionists may have read Chevreul's theories, which had been published in 1839 under the title *The Principles of Harmony and Contrast of Colors and Their Application to the Arts*, although it must be conceded that Chevreul's ideas did not really affect painting until the 1880's. Certainly, the colors of the spectrum were sensitively used by the Impressionists and regarded by them as the only way of recording natural light effects as they witnessed them. Moreover, by patient observation of nature, they also came to recognize the harmony and the simultaneous contrasts of which Chevreul had written. They saw, for example, that a red looks much more radiant next to a green than next to an orange, because red and green complement each other on the color wheel. In works like Renoir's portrait of Sisley and his wife (p. 49), such contrasts of complementary colors vibrate with a new intensity.

The exploration of color, the preoccupation with capturing spontaneous and accidental effects in nature, and the subjecting of the artist's vision to the "first impression" led him to discover a new freedom, not only in subject matter but also in technique. What the more traditional critics berated as sloppy draftsmanship or mere daubing of colors were, in fact, the new, unprecedented manifestations of a style that made possible the very freshness and vitality the Impressionists sought. If one examines the text illustrations, especially Monet's revolutionary seascape of the port of Le Havre, his hometown (p. 56), the steady development of the style in the 1870's will become evident. Indeed, the artistic development of Monet —the Impressionist *par excellence*—affords the clearest illustration of the more general nature and qualities of the style.

The name of Claude Monet comes to mind first when we try to determine which painter's work most accurately reflects the principles of Impressionism, although it is difficult to explain exactly why, since the compositions of many other painters display common characteristics and concerns. Possibly it is because Monet remained loyal to the principles of Impressionism longer than any of his fellow artists, well into the twentieth century, when he continued to pursue the exploration of light and to expand the possibilities of color expression. The fact that in his later years Monet refused to talk of Impressionism and even denied its existence merely illustrates his practical, intensely personal attitude toward art. He had always avoided the theoretical or systematic approach that characterized the art of the Renaissance and the great tradition on which French academic painting had been based. In place of formal doctrines of art, he would encourage his fellow painters to "try to forget what objects you have before you—a tree, a house, a field or whatever. Merely think, here is a little square of blue, here an oblong of pink, here a streak of yellow, and paint it just as it looks to you, the exact color and shape, until it gives

Claude Monet, *Haystack*, Chalk Drawing

your own naive impression of the scene before you." These words are revealed in the *Reminiscenses of an American Artist*, by Lilla Cabot Perry, who had met Monet in 1889, just before the painter began work on his famous series of fifteen paintings of haystacks.

Ever since Monet had met Eugène Boudin, with whom he made his first landscape studies in Le Havre, he had not ceased to explore the different aspects and nature of light. His predispostion to natural themes had been formed by the time he came to Paris in 1859, when, visiting the Salon, he expressed his admiration for the landscapists Constant Troyon (1810—65), Corot, and Daubigny. Until the last years of his life, Monet would remain for hours in a landscape, studying the light, even when failing eyesight no longer permitted him the kind of intense visual experience he had sought to capture in his paintings of the 1870's, 1880's, and 1890's.

Speaking in 1900, when the style had become respected, Monet reminisced about the early difficult years of Impressionism, when he was hard put to find sympathetic critics or patrons. Although a study he had done of his wife had been accepted in the Salon of 1866, this mild success was followed by a period of dark depression. During the 1870's, he lived with his wife and children in wretched conditions and was saved from starvation only by the help of Manet and Zola. Perhaps because of these miserable physical conditions, Monet plunged himself in his work, painting an extraordinary number of pictures in the 1870's, including the remarkable series of views of the enormous Gare Saint-Lazare in Paris (p. 65).

Claude Monet, "The Gare Saint-Lazare," p. 65

Besides examining the relationship of light and color, he penetrated ever more deeply into the mystery of the changing effects of atmosphere on objects. In attempting to capture instantaneous impressions, he abandoned himself to the various moods of nature. His friend the statesman Georges Clemenceau recounted "how I found him one day in front of a poppy field with four easels on which he painted furiously, one after the other, depending on the way the light of the sun changed." More and more, Monet turned to painting series of views that allowed him to explore more fully the nature of light. In these serial paintings, such as the haystacks or the views of Rouen Cathedral (p. 85), the subject, or object painted, loses its meaning by virtue of its repetition, and the true subject of the painting becomes light itself. Monet himself illustrated this when, in a letter to a friend, he referred to the fact that he was working on a series of different effects and then added, parenthetically, "haystacks." In a sense, the paintings, with their essentially nonrepresentational, non-narrative content, pointed the way to modern painting. Perhaps Monet did not consciously intend to paint "abstract" pictures; yet his dispassionate approach to subject matter did much to break ground for the movement toward a more abstract art.

Claude Monet, "Rouen Cathedral: Full Sunlight," p. 85

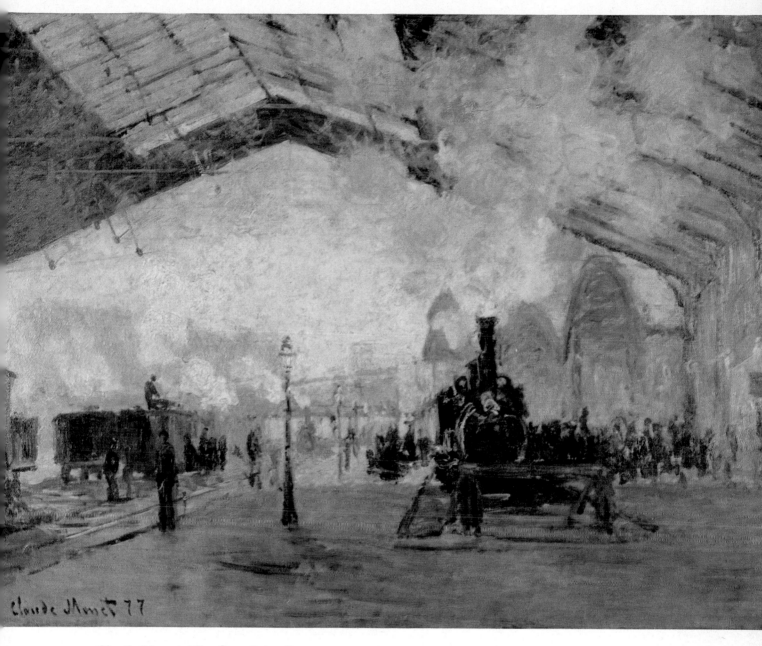

Claude Monet, *The Gare Saint Lazare*

On the following pages:
Camille Pissarro, *Snow at Louveciennes*
Alfred Sisley, *Flood at Port-Marly*

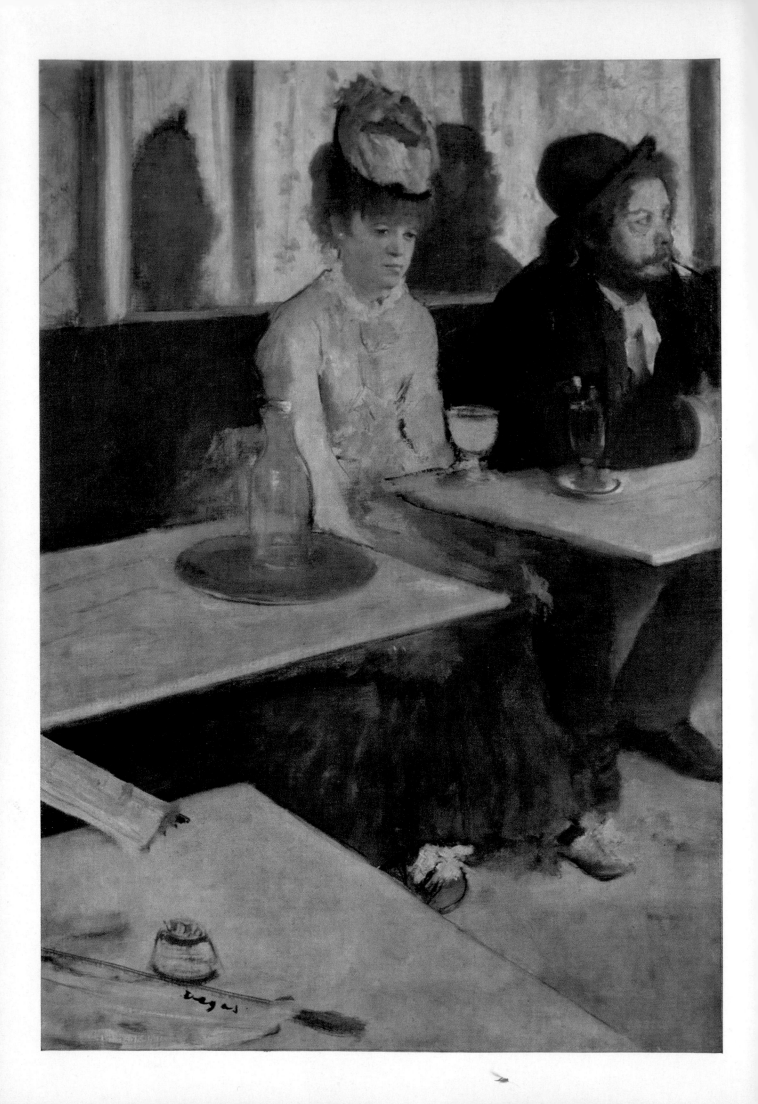

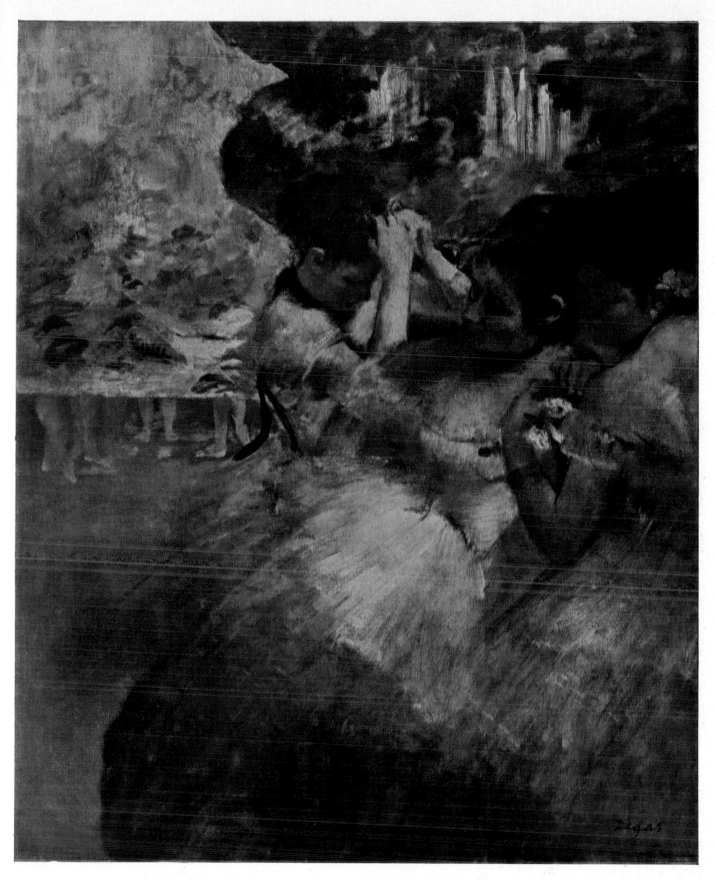

Edgar Degas, *Waiting for the Cue*

Left: Edgar Degas, *The Absinthe Drinker*

On the following pages:
Edgar Degas, *The Belleli Family*
Edgar Degas, *Cotton Exchange in New Orleans*

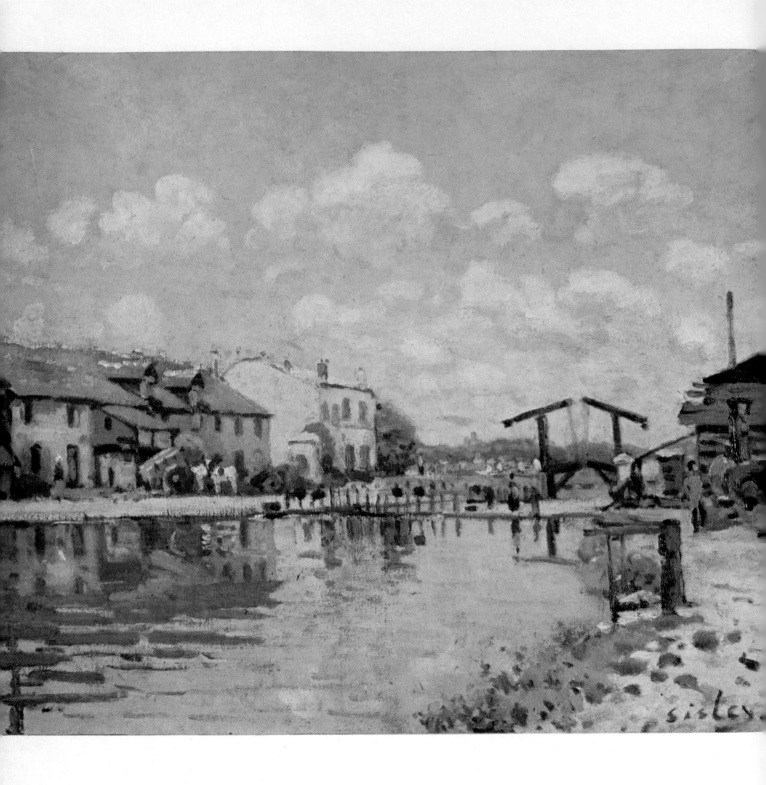

Alfred Sisley, *Canal St. Martin, Paris*

Although we have described the work of Monet as most typical of Impressionism, when we study the paintings of Edgar Degas, we may wonder whether it is correct to consider him an Impressionist. The fact that he was closely associated with the group does not mean a great deal. He was, in reality, an outsider who put great value on his independence. By temperament and artistic inclination, he was different from the vast majority of painters who exhibited in Nadar's ex-studio in 1874. He had great respect for Ingres and for what he conceived as the great tradition of French painting. He disdained sensational exhibitions and stated rather loftily, "A man who canvases for success by means of public exhibitions is like a huntsman who, instead of living in the open air, goes into a shooting gallery and blazes away at dummies."

Influenced at an early age by Ingres, Degas seems to have really taken to heart the master's advice to a young painter, "draw lines, young man, plenty of lines." Degas owned many drawings, including many by Ingres, and, at times, the firmness, precision, and grace of his line recall the older master. If we compare a life study of a woman (p. 6) with the little drawing of Mme. Ingres (p. 9), we can see how a great tradition was assimilated by the young painter.

As did the pupils of Ingres, Degas began his studies at the *École des Beaux-Arts* by working from plaster-of-Paris models. There is some reason to believe that Degas was not entirely happy or satisfied at the *École*, because in the same year of his entrance, he expressed admiration for Courbet's work exhibited in the Pavilion of Realism. The six years of careful, disciplined study at the *École* provided a firm technical basis for Degas' art and also later permitted him the luxury of experimentation. The young painter was constantly open to new experience and new ideas, and his contact with the Impressionist group in the 1860's certainly prompted him to reconsider or change some of his opinions about art. Nevertheless, his fundamental love of the past, of classical and Renaissance art, prompted him to interrupt his studies, in order to make a number of trips to Italy. There, according to his notes and observations, he came to appreciate the work of the masters of fourteenth- and early fifteenth-century Italian painting—artists who were still considered somewhat primitive because they had not as yet evolved a means of dealing effectively with three-dimensional space. Degas appreciated the strong linear values and good design of these paintings, and their two-dimensionality had a particular fascination for him. He stated that he spent hours copying the compositions of such artists as Giotto and Fra Angelico.

In the late 1850's, partially as a response to his training in the *École des Beaux-Arts* and also because of his admiration for the historical tradition and for the paintings he had seen in Italy, Degas began to execute large historical paintings, which combine a concern for draftsmanship and a

Edgar Degas, "The Belleli Family," p. 70

Edgar Degas, "Waiting for the Cue," p. 69

Edgar Degas, "Cotton Exchange in New Orleans," p. 71, "The Absinthe Drinker," p. 68

more lively grouping of figures than one might expect of an *École* student. Just about the same time, he painted a souvenir of his trip, namely, a portrait of some Italian relatives, "The Belleli Family" (p. 70). The geometric severity of the figures and sharpness of their silhouettes and of the furnishings contrast markedly with the soft blur of the patterns of the rug and of the wallpaper and give a slight glimpse of what was to become a hallmark of Degas' style in the 1870's: the characteristic combination of strong lines and soft color. Not long after this picture was painted, Degas began to expand his subject matter to include outdoor scenes, such as horse races, which, with their rapid movement, challenged his powers of drawing to the full and forced him to see an aspect of nature that he had previously excluded. More and more, in drawings and in finished pictures, Degas attempted to seize a moment and to convey both the spontaneity of a "first impression" and the sense of form that, by contrast, was lacking in much Impressionist painting. The wide range of his subject matter in the 1870's—cabarets, dance halls, theaters, racetracks—testify to his gradual emancipation from the tyranny of history painting. In all of his later work there is that amazing combination of masterful drawing and transparent, sometimes feathery, color that made him a sort of human bridge between Ingres and the Impressionists. Like Monet, who collected and carefully studied photographs, Degas was fascinated with the mechanics of vision. In such a work as "Waiting for the Cue" (p. 69), the unexpected vantage point, the arbitrary choice of limits for the picture, and the sense of abrupt cutting-off at the top make the viewer uncomfortably aware of the two-dimensionality of the work. There is in Degas' work a kind of artistic detachment, whether the subject is the "Cotton Exchange in New Orleans," a souvenir of a visit Degas made to relatives in America (p. 71), or two impoverished Parisians drinking absinthe in a café (p. 68). The latter work, especially, lacks the kind of social involvement that would have characterized the generation of realists like Daumier. It reflects the kind of thinking that prompted Degas to tell young artists that he knew nothing "of temperament." As did the great Japanese masters whose work he so admired, Degas sought a form of serene detachment that would permit him to render every experience in terms of line, color, and form. Where Delacroix had used line and color to conjure an emotional state, Degas consciously played down emotion and concentrated on a purely visual kind of painting. In his writings on art, Degas repeatedly stressed the artificial nature of painting. Like his distant master Ingres, he counseled young painters to stress drawing and the study of the old masters. For Degas, a painting was not a glimpse of nature but "an original combination of lines and tones that set each other off." Although he had given advice and encouragement to many of the Impressionists, he expressed his disdain of "paintings by which you can tell the time of day as by a sundial."

Degas, by temperament a loner, managed to achieve success without the anguish or suffering experienced by so many artists of the period. Like Manet, he was extremely well to do. Moreover, he quickly found friends

and collectors for his work. Although it was unusual for younger, lesser-known artists to find a ready market for their work, Degas, as early as 1873, had made a permanent contract with the perceptive art dealer Paul Durand-Ruel. During the last twenty years of his life, the artist virtually restricted his painting and drawing to studies of the human figure in motion. It was possibly a combined interest in anatomy and in what happens to the body in different types of motion that led Degas to turn to sculpture. His models of race horses and dancers possess both the energy and clarity that mark his drawing. It is curious, however, that, of the hundreds of models for sculptures he made during his lifetime, only one was ever exhibited by the artist—the exquisite "Fourteen-Year-Old Ballet Dancer," which was shown in the Impressionist exhibition of 1881.

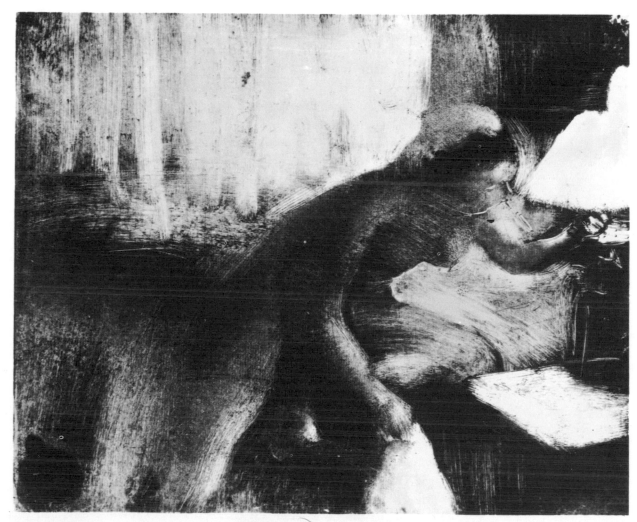

Edgar Degas, *Woman Putting Out a Lamp*, Monotype

FURTHER EXHIBITIONS

Even a cursory reading of the careers of Monet and Degas reveals the personal and artistic differences, the contrasting conceptions of the nature and aim of painting that existed among the Impressionists. These differences were so fundamental that they could not be resolved in the café discussions or in the group exhibition of 1874, which represented the artists' common purpose. Still, the slogan of Impressionism had been coined, and the young painters were at least partially united by their common reaction to the violent criticism of press and public. In 1875, some of them decided to try their luck again in an auction of works held at the Hotel Druot. Once again, they were disappointed, not only because of the familiar harsh reaction of the critics but because so many of them had counted on purchases at any price to enable them to continue painting. Still, there was one positive result. Victor Chocquet, a customs official and collector of Delacroix's paintings, and Gustave Caillebotte, a marine engineer and Sunday painter, developed an enthusiasm for Impressionist painting and, despite their relatively modest means, became active supporters of the artists who exhibited.

The fiasco of the auction also prompted the idea of a second group exhibition. The moment this idea was proposed, however, the old disagreements were revived. While Monet and Pissarro were of the opinion that only genuine Impressionists should be invited, Degas believed that a purely Impressionist exhibition might not generate sufficient critical enthusiasm or popular attraction. Often the seemingly trivial differences of opinion over invitation lists, hanging, and other technical aspects of the exhibition reflected deeper and more diametrically opposite views about the nature of art itself. The painter who exhibited with the Impressionists but maintained that he did not like pictures by which you could tell the time of day seemed to be speaking directly to his colleagues Monet, Pissarro, and Sisley when he complained:

> Your picture has not enough unity and that is inevitable because you do not paint it in your studio. And that was your mistake. You have tried to render the air of outdoors, the air we breathe, the *plein air*. Well, a picture is primarily a work of the imagination of the artist. It must never be a copy. . . . The air you see in pictures by the masters is not breathable. (*From the Classicists to the Impressionists [A Documentary History of Art*, Voll. III], ed. Elizabeth Gilmore Holt, Garden City, N. Y., Doubleday, 1966, p. 402.)

Certainly no serious critic of the movement was harsher than Degas in his assessment of the Impressionists' contribution.

In the end, some measure of agreement was reached, and the second group exhibition opened to the public in 1876 at the Durand-Ruel gallery in the rue Le Peletier. Of the 252 works shown, Degas had the lion's share, with 24 paintings. Although attendance was somewhat better

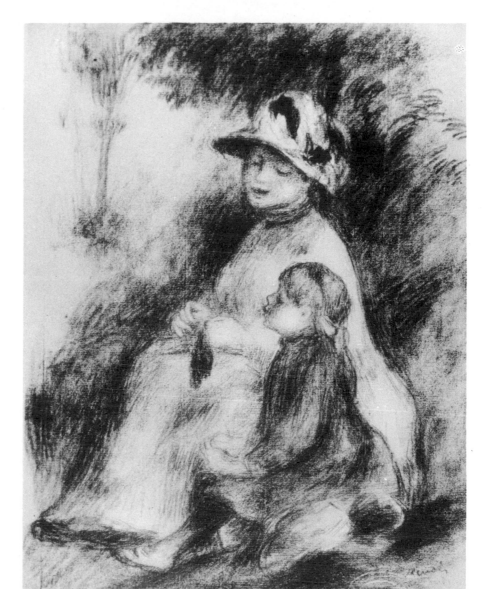

Auguste Renoir,
Mother and Child,
Chalk Drawing

than on the previous occasion, the tone of official criticism was little changed. Such supporters as Chocquet and Caillebotte did their best to encourage prospective purchasers to visit the exhibition, but very few pictures were sold. Public reaction to the predictably sarcastic criticism of the journalists was virtually identical with that toward the first group exhibition. Writing in *Le Figaro*, Albert Wolff smugly proclaimed:

The rue Le Peletier is a street of ill omen. Since the opera house burnt down, a new misfortune has descended upon it. An exhibition has opened at the Durand-Ruel gallery, where we are promised the sight of pictures. Unsuspecting people enter, attracted by the beflagged façade, and a fearsome spectacle meets their eyes; five or six maniacs [Degas, Monet, Pissarro, Renoir, Sisley, and Morisot], including even one woman, have met here, evidently blinded by ambition, to sell their works. Many people laugh themselves sick over these daubs, but personally I find them tragic. These so-called artists pose as revolutionaries, "Impressionists"; they get hold of some canvas, a brush and paints, slap on a few tones and put their signature at the bottom.

77

Undaunted, the artists arranged a third exhibition to be held the following year. Against Degas' advice it was called *Exposition des Impressionistes*, and, once again, the reaction of the public was largely negative. Although most critics remained hostile to the group, some—Duret for example— tried to persuade the public that all great artists have had to overcome obstacles, and that the Impressionists were only a natural outgrowth of a tendency toward naturalism expressed earlier in the art of Corot and Courbet. Duret, in an extremely perceptive observation, linked the seemingly arbitrary colors and cut-off views of Japanese woodcuts, wherein striking juxtapositions of color and shape are typical. He tried to explain why the Impressionist painters sat for long hours on the banks of a river, and he chided the public for thinking that what was different was necessarily bad.

Gradually, through the combined efforts of critics like Duret, collectors like Caillebotte, and committed painters like Pissarro, the public came to speak of the "revolutionaries" as artists and not merely as sensationalists. In 1879, Degas' will prevailed, and the word "Impressionists" was replaced by "Independents." For the first time, the exhibition was a financial success, although the list of exhibitors was somewhat altered: Renoir's departure was noticed, and among the new names of the young painters added to catalogue was one that would shortly become famous— Paul Gauguin.

The exhibitions of 1880 and 1881 gave rise to sharp dissension in the group. Many of the original members no longer felt a common sympathy, and, in fact, it would be inaccurate to describe these exhibitions as Impressionist. Too many other artists whose work was very different from that of the original Impressionists were taking the place of those who left the group. Ultimately, even Monet, the Impressionist *par excellence*, departed. Asked if he no longer felt himself to be an Impressionist, he replied, "Certainly I am an Impressionist and wish to remain one... but I do not see much of my male and female colleagues any longer. The little group... has turned into a commonplace school, opening its doors to the first dauber that comes along."

In 1882, the seventh group exhibition was held, and a marked show of unity seems to have been produced by a surprising organizational effort. For many, this was the best of all the Impressionists' group efforts, and, certainly, the large number of canvases by Monet, Sisley, and Pissarro accounted for the unusually high quality of the show. A slightly ironic note was added to this exhibition: Manet once again had chosen not to join the Impressionists but preferred to show his magnificent "Bar at the Folies Bergères" in the Salon, where it brought him his much desired nomination for the Legion of Honor.

The year 1882 was also the first year of the so-called international exhibitions organized by Durand-Ruel's rival, the dealer Georges Petit. The Impressionists took part in these exhibitions, and their work received much broader circulation as a result. Perhaps in response to Petit's innovation, Durand-Ruel arranged a series of one-man shows of the works of Monet, Renoir, Sisley, and Pissarro. Possibly because the Impressionists'

work was becoming more widely known and appreciated, the need for further group exhibitions was diminished. In any case, it was four years before Paris was to see another group effort: The eighth, and last, was held in 1886.

In the spring of 1886, Vincent van Gogh (1853—90), at his brother Theo's invitation, came to Paris to study painting. Theo van Gogh, who worked for an important dealer in Paris, was an enthusiastic supporter of the Impressionists and soon put his brother in touch with the painters of the younger generation. Perhaps because his own temperament was so deeply emotional, Vincent was sensitive to the differences that separated the young painters and often made them virtual enemies. He commented: "Each one flies at the other's throat with a passion worthy of a better cause." *(The Complete Letters of Vincent van Gogh*, eds. W. van Gogh and V. van Gogh-Bonger, Greenwich, Conn., New York, Graphic Society, 1958.)* If it was clear to an outsider that there were profound conflicts within the group, those who had once formed the nucleus of the Impressionists and championed the idea of a common cause felt the growing dissension even more. Pissarro wrote his son, "It's all over with the Impressionists. I don't believe Degas will succeed in bringing them together again."

Although van Gogh's observation and that of Pissarro reflected quite accurately the climate of disagreement that plagued Impressionism, it would be wrong to conclude that the style was doomed to failure or that nothing more was heard of the Impressionists. After the possibilities of a common struggle had been exhausted, it was natural for differences of personality to manifest themselves and for individuality to be more evident than unity.

Félix Fénéon, an avant-garde writer and art critic, was among the first to understand the basis for the split. A close friend and long-time defender of Pissarro, he published a series of articles on the movement that were based on conversations with the painters themselves. In the longest article, entitled "The Impressionists in 1886," he stated quite clearly that it was not merely a question of differing opinions or personalities but of profound theoretical differences. Fénéon distinguished between two opposing camps—such classic Impressionists as Monet, Sisley, and Renoir, and another group that he called neo-Impressionists. For Fénéon, the latter group—of which the most important members were Georges Seurat and Paul Signac (1883—1935) was composed essentially of reformers who wished to transform the more casual, spontaneous Impressionism of Monet into a style based on the rules of science. Fénéon's article, while sympathetic to the innovations of the Impressionists, clearly revealed a preference for the theories of the younger would-be reformers, who would shortly count Pissarro and his son Lucien among their ranks.

During the preparations for the last Impressionist exhibition, the irresolvable differences that Fénéon analyzed so acutely were once more isolated in the matter of who should be invited to exhibit. Tempers grew hot when Pissarro proposed the names of Seurat and Signac, the painters most strikingly different from the older Impressionists. In the end,

Georges Seurat,
"Sunday Afternoon
on the Island
of La Grande Jatte,"
p. 97

although Pissarro's will prevailed, these artists were restricted to a separate room, where their work was placed with that of their sponsor. After the details of the exhibition were settled, it opened in a small gallery in May, 1886. Ironically, the major source of controversy in this last Impressionist exhibition was not the work of Monet but of Georges Seurat, whose enormous canvas "Sunday Afternoon on the Island of La Grande Jatte" (p. 97) dominated the relatively small room in which it was placed. Spectators clustered mockingly around the painting, much as an older generation had done with Manet's "Déjeuner sur l'herbe" (p. 50) or Monet's "Impression, Sunrise" (p. 56). The major attraction of the imposing composition was its *pointillisme*, or an orderly, schematic arrangement of dots of color that made the canvas take on the aspects of a huge piece of tapestry.

Despite the appearance of this seemingly cooler and more calculated approach to painting, and despite the increasing defection of former adherents to the group, the Impressionists scored something of a public triumph in 1886. It could even be termed an international triumph, since Durand-Ruel chose to arrange an exhibition of "Works in Oil and Pastel by the Impressionists of Paris" in New York, where the reception accorded the paintings was generally warm. Although a number of American-born artists had traveled and worked abroad—notably James Abbott McNeil Whistler (1834–1903) and Mary Cassatt (1845–1926)— no great collections of modern painting were assembled in the United States until the last two decades of the nineteenth century. The impact of Impressionist painting in America can be grasped if one simply considers the large number of works in the museums of New York, Chicago, Philadelphia, Washington, and Boston.

The painting styles of the so-called classic Impressionists—Monet, Sisley, Renoir, and, to a lesser extent, Pissarro—seem to have been relatively unaffected by Seurat's color theories and painting technique, which Pissarro termed "scientific Impressionism." Monet, as has been noted, had a lifelong aversion to theories of any kind. "You approach nature with your theories, and she turns them upside down. Theories do not make a good picture—the most they do as a rule is conceal the inadequacy of one's means of expression." In fact, Monet continued to strive for a direct encounter with light and for the rendering of specific visual impression. More and more, in the late 1880's and 1890's, he sought to capture the nuances of light that seemed almost to torment him.

It would appear that the creative possibilities inherent in Impressionist painting were essentially limited to the painter's increasingly sensitive reaction to light vibrations, and thus to color. This opinion is borne out in the series of pictures in which the potential interest of the subject matter was entirely sacrificed to that of light. In the fifteen paintings of haystacks that Monet exhibited at Durand-Ruel's gallery in 1891, and in the Rouen Cathedral series done in 1894 (p. 85), the contours, details, and the essential identity of the object seem to disintegrate before the viewer's eyes. In the latter painting, the gray stone of the building façade

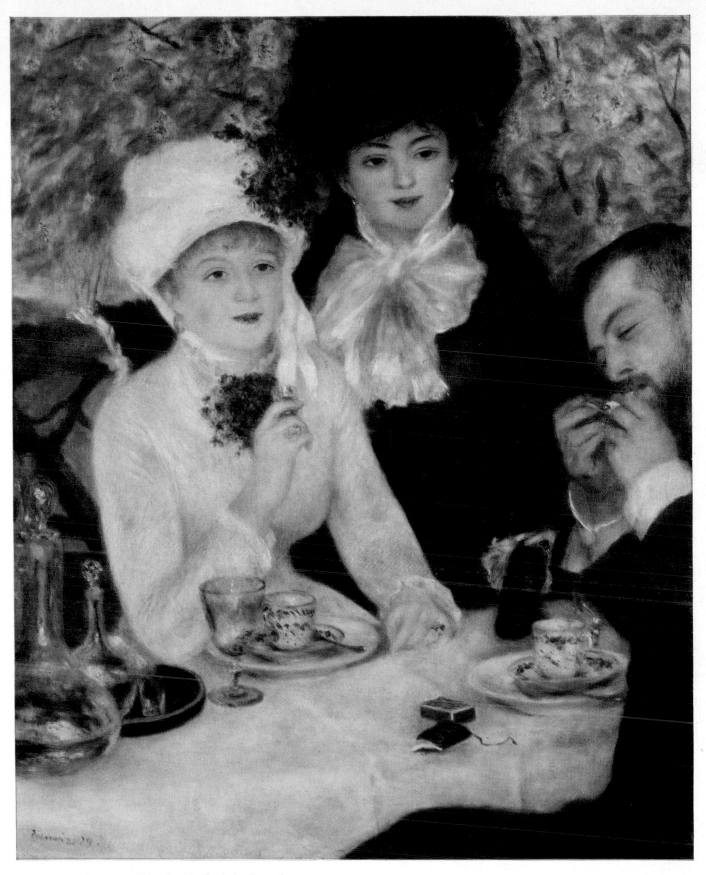

Auguste Renoir, *End of the Lunch*

On the following pages: Auguste Renoir, *Luncheon of the Boating Party*
Camille Pissarro, *The Great Bridge at Rouen*

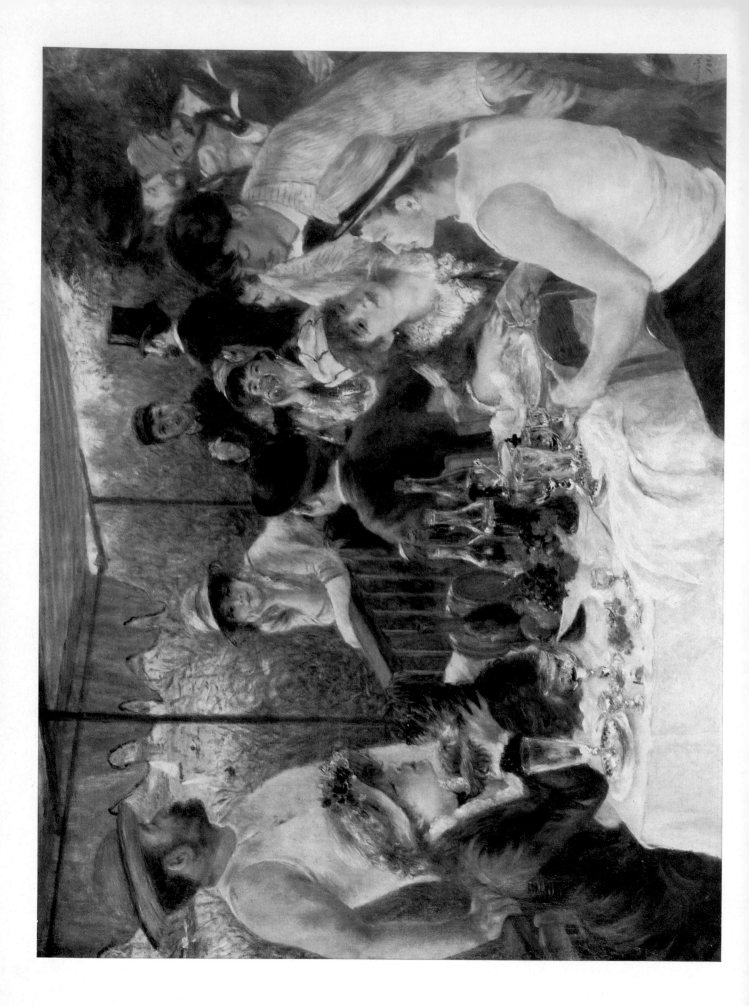

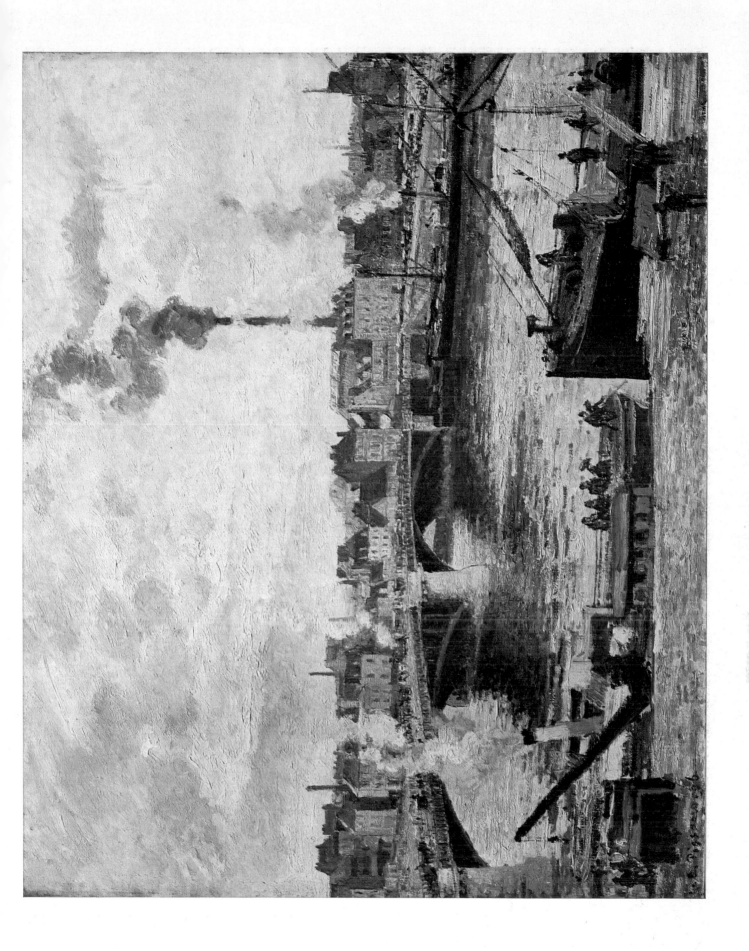

Camille Pissarro, *The Boulevard des Italiens in Morning Sun*

Right: Claude Monet, *Rouen Cathedral: Full Sunlight*

Auguste Renoir, *Sleeping Nude*

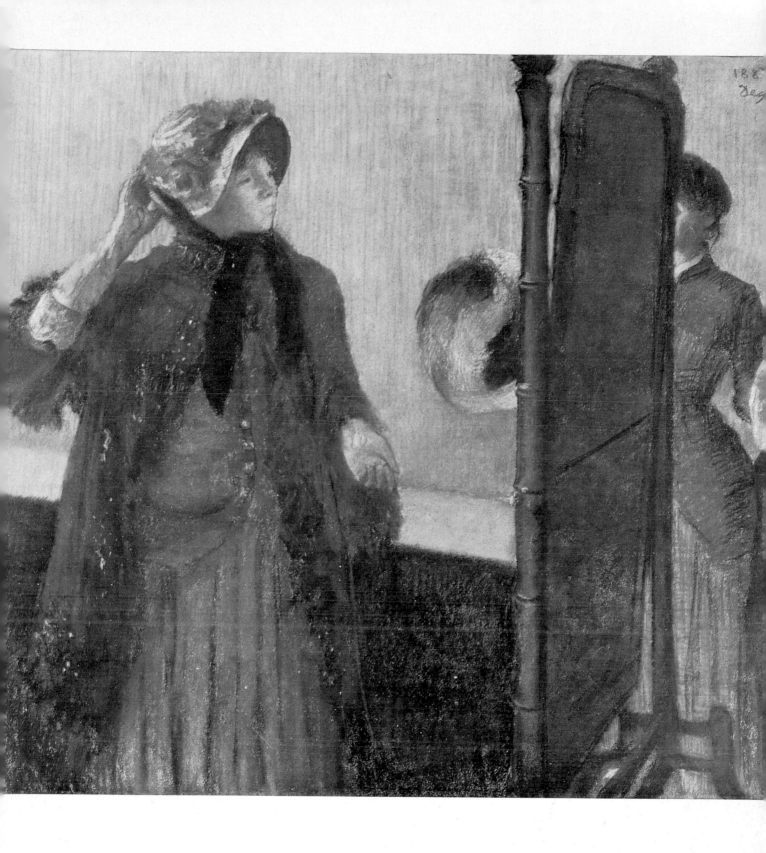

Edgar Degas, *At the Milliner's*

Camille Pissarro, *Children in a Farmyard*

is transformed into rose, lavender, and orange pigment. Only after the impact of the energetic brushwork and strong contrast of colors was exhausted could the viewer begin to consider the significance of the subject: the front of a cathedral, robbed of its stained-glass windows, sculpture, and heavy monumentality.

Monet was not alone in his professed dedication to capturing the essence of light. Sisley, his good friend, spoke repeatedly of the charm of light and of its every varying effect on nature. His painting of "The Canal St. Martin," with its bright blues and whites, its horizontal slashes of color suggesting the rippling and reflecting surface of the water, and its general simplicity, shows the artist's dedication to the fleeting impression and his determination to capture it. Sisley once remarked that the sky should be the painter's means of presenting his objects as if "bathed in light," and he added that "it is essential for an artist to breathe life into his work: everything—form, color and execution—must contribute to this. The artist's excitement creates life and arouses similar feelings in the spectator." Sisley's statement is rather interesting, not only because it confirms our ideas about the intention of the Impressionist painters but also because it reveals a slightly different concern with reaction of the viewer. While Monet, for example, was concerned that the viewer share his *visual* experience, he never spoke about the sharing of *feelings*. Indeed, everything he ever said or did would seem to indicate that he was not interested in emotional or intellectual reactions. Sisley, on the other hand, displays a concern with feeling, and perhaps this slight nostalgia for an older kind of romantic landscape painting makes his work, at times, seem very different from that of the more detached Monet. Sisley liked to call himself a pupil of Corot, and if we compare his landscapes with those of this "grandfather" of Impressionism, we may observe some temperamental affinities.

The seeming absence of subject matter or, at least, of its diminished importance, presented a problem for even the most enlightened critics. In

Alfred Sisley, "Canal St. Martin, Paris," p. 72

Camille Pissarro,
Kneeling Woman,
Chalk Drawing

his Salon criticism, even as understanding a writer as Duret could advise Pissarro to "paint pictures with a subject...something that looks like a composition, not just dashed off on the spur of the moment but with some degree of order about it." To achieve the maximum amount of spontaneity in a composition and to re-create the impression of a particular moment, many Impressionist painters chose to represent views that seem almost accidental. To accomplish this, they employed bold and unusual juxtapositions of color and form. The aim was to re-create the original, unique visual impression and to impart what Pissarro called the whole "idea of movement, life and atmosphere." Naturally, this rejection of traditional principles of painting, in which the choice of an ennobling or beautiful subject matter played so important a role, aroused criticism.

Camille Pissarro, "The Great Bridge at Rouen," p. 83

An English painter and critic of the Impressionists, Philip Gilbert Hamerton (1834–91), chided Pissarro for the manner in which he painted one of a series of views of the city of Rouen (p. 83): "He has so little aversion to ugly subjects that...the spire of the distant cathedral is almost hidden by a tall factory chimney and the smoke coming out of it, just as might happen in a photograph." The last remark is particularly illuminating, because it again confirms our knowledge of the importance of such technical achievements as photography to the broadening and development of the nineteenth-century painter's vision. Of course, it is true that Hamerton was reminded of a snapshot in the same way that Manet's, Monet's, and Degas' compositions, with their arbitrary angles and cut-offs, remind us of the way the camera "crops" a scene. From Degas' *Notebooks* (informal memos, written in the late 1870's and the 1880's), we know that he used mirrors in drawing and that he often drew objects from unnaturally high and low points, so as to capture a view of an object similar to that which the camera presented. The type of "beauty" the Impressionists sought after consisted, above all, in the degree of veracity or objectivity with which they reproduced what they saw. What their contemporaries considered to be ugly or unaesthetic was viewed by them as fresh, new, and exciting. Concerning one of his later pictures of the recently built Paris boulevards (p. 84), Pissarro proclaimed,

Camille Pissarro, "The Boulevard des Italiens in Morning Sun," p. 84

"It is a most beautiful motif. It may not be very aesthetic, but I am delighted to be able to paint those Paris streets that are generally considered ugly, though they are so silvery, sparkling and full of life."

Although most Impressionists probably agreed, Renoir never completely subscribed to the Impressionists' doctrine of equality of subject matter, for he always retained a primary commitment to the rendering of the human figure (p. 86) in preference to landscapes or still-life painting. His fundamental delight in rendering the female form—the traditional embodiment of ideal beauty—his return to clear, strong modeling of forms, and his appreciation of the sensual appeal of colors may remind us of the approach of such great Venetian masters as Titian (1477–1576). In any case, it is interesting that Renoir, with Degas, shared an interest both in the painting of the past and in the problems of sculpture, to which he dedicated himself in his later years.

Auguste Renoir, "Sleeping Nude," p. 86

THE ROLE OF CAMILLE PISSARRO

We have seen what an important role Pissarro played in the camp of the artistic revolutionaries, whether Impressionist or neo-Impressionist. He earned the thanks of many young painters, not only because of his selfless and untiring efforts to insure the success of their joint exhibitions, but also because of his kindness and his personal generosity in giving freely of advice and encouragement. Naturally, a man as open and vulnerable as Pissarro made enemies. His willingness to listen to new ideas, to espouse different points of view was interpreted by some as fickleness or superficiality. The Irish writer and painter George Moore (1853–1933) was studying in Paris in the 1870's and 1880's, and in his *Reminiscences of the Impressionist Painters,* he displayed an occasionally critical attitude toward Pissarro. He chided the painter for "always following in others' footsteps: he was an artistic Jack of all trades. . . . But he never quite lost his individuality." It is possible that Moore's remark reflects something of the disappointment, or even resentment, felt by some of the Impressionists when Pissarro's painting style assumed a few of the compositional characteristics of neo-Impressionism. The clear division of evenly sized "points" of color in his paintings of the late 1880's (p. 88), for example, reveals the influence of Seurat and "La Grande Jatte" (p. 97).

Camille Pissarro, "Children in a Farmyard," p. 88

At times, Pissarro's physical appearance and manners may have prompted more sophisticated personalities to ridicule him. The town-bred painters smiled at this provincial, who was likely to turn up in the Parisian cafés wearing some strange, informal costume. He was once described by a critic as "having the head of an apostle. He is always to be seen with a drawing under each arm, and . . . at the group's headquarters, they say: 'Hats off, here comes Moses with the tables of the Law.'"

This last quip was probably more than a good-humored poke at the painter's appearance, and we can only appreciate its true significance if we understand something of the political and social context in which it was made. Later in life, Pissarro was to complain to his son Lucien of Degas' anti-Semitism—an anti-Semitism that Pissarro perhaps felt all the more keenly because his background was Jewish. Born in St. Thomas in the Virgin Islands, Pissarro first came to France at the age of eleven to enter a boarding school. He returned to St. Thomas six years later and did not come back to France to stay until 1855, when he arrived in time to see Courbet's Pavilion of Realism outside the grounds of the world's fair. Possibly because he was both an outsider and a Jew, Pissarro developed a sincere commitment to the ideal of social justice. He was surely disillusioned by the hypocrisy of many of his intimates—themselves the products of rather narrow, middle-class upbringings—and he was easily attracted by the writings of men like P. J. Proudhon, whose Socialist views had earlier affected Courbet.

The letters Pissarro wrote to his son Lucien in the 1880's and 1890's are as interesting for their revelations about his political interests as they are

for what they tell about his views on art. His passion for new developments was matched by his vital interest in the social and political events of his age. In 1897, when Captain Alfred Dreyfus was accused of having betrayed France by giving military secrets to the Germans, public opinion was easily persuaded that Dreyfus's supposed treason was the result of a Jewish conspiracy against France. People who had previously taken pains to disguise their anti-Jewish feeling now openly attacked Dreyfus in particular and the Jews in general. Arguments about the officer's guilt or innocence raged in the smart drawing rooms of Paris, in the middle- and working-class cafés, and, of course, in artists' studios. Some, like Degas, sided with the prosecutors of Dreyfus and with what might be termed the "official government explanation" of the affair. Others, notably Monet, Pissarro, and especially Émile Zola, took exception to the hastily fabricated government report and called for justice and reason. *J'Accuse*, Zola's passionate attack against the French army, ac-

Camille Pissarro,
Haymaking at Eragny,
Monotype

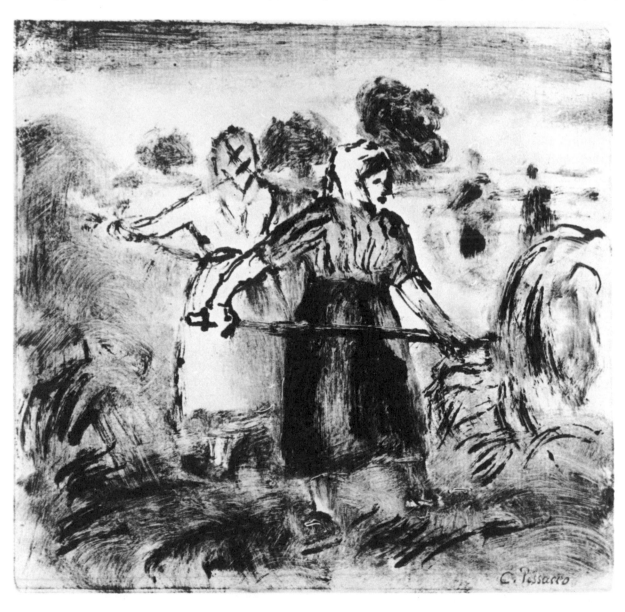

cusing it of falsifying evidence in order to discredit the Jewish officer, provoked strong feelings and resulted in the writer's conviction in a libel suit brought to the courts by the army. Taking sides for or against Dreyfus, friends and relatives became enemies. Degas refused to speak to Pissarro because of the latter's sympathy for Dreyfus, even after his conviction. Years later, after the reversal of Dreyfus's conviction, his vindication, and the exposure of another officer and several accomplices, the controversy still raged, and the intellectual consequences of the affair were felt. If one reads parts of Marcel Proust's *Remembrance of Things Past,* published some years after the pardoning of Dreyfus and his restoration to the rank of captain, one gets a real sense of how the controversy filled the very air of Paris.

While the Dreyfus case appealed to Pissarro's social consciousness, the fact that he suffered prolonged financial insecurity made him somewhat distrustful of bourgeois values and the success that inevitably followed the approval of the middle class. Although he had been kind and helpful to Paul Gauguin when that painter began to study painting seriously, Pissarro later turned against him, feeling that Gauguin was an opportunist who, with his religiously inspired paintings, was catering to the conservative or even reactionary tastes of the middle class.

Most people were prepared to overlook Pissarro's whims and passing dislikes because of his innate goodness and earnest desire to help those in need of advice and encouragement. The American painter Mary Cassatt maintained that "He was so much of a teacher that he could have taught the very stones to draw correctly." It is not surprising, then, that with his ebullience, his human sympathy, and his eagerness to share his experiences with others, Pissarro formed many close friendships and was regarded with affection by numerous younger painters.

Pissarro's influence on the younger painters might almost be considered as important as his own creative work. He can be regarded as the discoverer of Paul Cézanne, whose work he admired and repeatedly encouraged. He introduced Cézanne to Manet, Monet, and the others, and in the early 1870's, when Cézanne moved into Pissarro's neighborhood, the two men painted together for some time. Pissarro wrote of the younger man, "Our Cézanne shows the greatest promise and the picture that I have seen by him...is of extraordinary force and weight." Although it took some years for Cézanne's style to develop and for his paintings to be universally respected, Pissarro's assessment of his potential contribution to art was supported.

Of no less importance was his formative influence on Paul Gauguin. After spending several years in the merchant marine, Gauguin entered a brokerage firm, where he proceeded to accumulate the small sums of money that enabled him to collect pictures. At the same time, he began to paint and sculpt, and he even exhibited a small landscape in the Salon of 1876. Just about this time, he became seriously interested in Pissarro's painting, met him through a family friend, and subsequently was introduced by Pissarro to the other members of the Impressionist group. By

Georges Seurat,
Study for
La Grande Jatte,
Conté crayon

1880, Gauguin was exhibiting with the Impressionists, and three years later, he felt sufficiently confident about his development to abandon the brokerage firm in order to work full time at his painting. That year, he went with Pissarro to Rouen and painted by his side day after day. But a combination of financial problems and a basic difference in temperament led to quarrels and misunderstandings, and finally to Gauguin's departure. From that point on, Pissarro's relations with the willful Gauguin were strained, and the struggle between the two is reflected in their correspondence. Years later, Gauguin wrote, with only a slight edge to his words, "He was one of my masters, and I am not denying him."

In Pissarro's career, we can observe the struggle of an artist who sensed the tensions between contemporary attitudes toward painting and who was a disciple and major teacher of Impressionism, but who was still able to respond to the new ideas advanced by younger artists. Cézanne and Gauguin were not the only artists to realize his importance; Seurat and Signac also expressed gratitude for his interest and encouragement. Cézanne probably summed it up best when he declared to a friend, "Perhaps we all of us derive from Pissarro."

SEURAT AND THE REVOLT AGAINST IMPRESSIONISM

When we begin to consider the careers of Seurat, Gauguin, van Gogh, and Cézanne, we encounter what might be called an artistic counter-revolution. Arising out of Impressionism, and in many ways indebted to it, various conceptions of painting took shape in the 1880's and ultimately turned against the parent movement. Many painters keenly felt the loss of form, permanence, and stability that resulted from the Impressionists' preoccupation with the fleeting or transitory view. Some reacted strongly to the seeming casualness of Impressionist composition, others expressed

Georges Seurat,
*Portrait of
Paul Signac*,
Conté crayon

disillusionment at the absence of human values or feeling in most Impressionist painting. One of the first attempts to offer an alternative to the "chaos" of Impressionist compositions was Seurat's controversial "Sunday Afternoon on the Island of La Grande Jatte" (p. 97), which provoked so much argument in the final group exhibition.

The painting was at least as remarkable for its size (*ca.* 7 by 10 feet) as it was for its composition. It marked the culmination of several years of study and work, in which Seurat attempted to clarify his ideas about color and to prescribe entirely new conditions for the making of a painting. Although these ideas were in a sense an outgrowth of Impressionism and its belief in the interdependence of light and color, Seurat developed his theory independently. Not until his meeting with Paul Signac and Camille Pissarro, in 1884, did he get to know the work of the Impressionists well.

As a boy of sixteen, Seurat had enrolled in a public school where drawing was taught, to begin training for a career as a painter. As generations of young artists had done since the time of David, he copied plaster-cast models and spent a great deal of time copying the works of others, without having any intention of developing a style or manner of his own. His main purpose in this was to perfect his technical competence, to provide a solid foundation for whatever he chose to do in the future. Some idea of the general direction of his interests is shown by his choice of models at the time: Poussin, Raphael, and Ingres. When he entered the *École des Beaux-Arts* to study with a distinguished pupil of Ingres, Seurat seemed to be conforming to the pattern for success as a Salon painter; suddenly, however, a change in his thinking and working habits took place. He began to read Delacroix's writings on color, and from these he proceeded to such scientific studies as Chevreul's pioneering *Principles of Harmony and Contrast of Colors and Their Application to the Arts.* Of particular value to him was the more recent work of an American physicist, O. N. Rood, whose *Scientific Theory of Color and Its Relation to Art and Industry* provided him with the knowledge that colors mixed by the eye appear more intense than premixed colors. When Seurat realized that neither Delacroix nor the Impressionists had tried to formulate a system for controlled color, he decided the develop a theory that would enable painters to utilize science in the service of art. With extraordinary perseverance, he studied and worked to prove that a new style of painting could be attained by combining a precise study of line and tonal values in drawing with the adherence to fixed laws in the rendering of color/light.

For three years after the completion of his studies at the *École,* he produced only drawings (p. 95), and these remarkable works already demonstrate that he was not concerned only with line, as was his early model Ingres, but that he was, above all, interested in projecting, through the black and white of the drawing materials, the gradation of pure tonal values. His first attempts at oil painting, such as the "House Among the Trees" (p. 98), while still showing a dependence on Impressionism, already reveal a stronger sense of form, a more stable ordering vision, and,

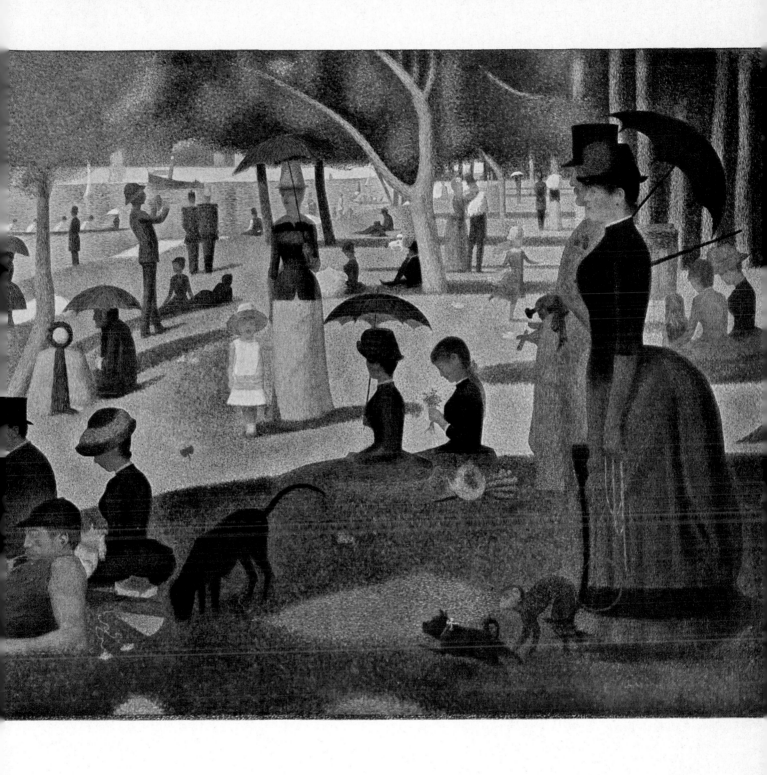

Georges Seurat, *Sunday Afternoon on the Island of La Grande Jatte*

Georges Seurat, *House Among the Trees*

Below: Vincent van Gogh, *Montmartre*

Georges Seurat, *Bridge at Courbevoie*

Vincent van Gogh, *The Sower*

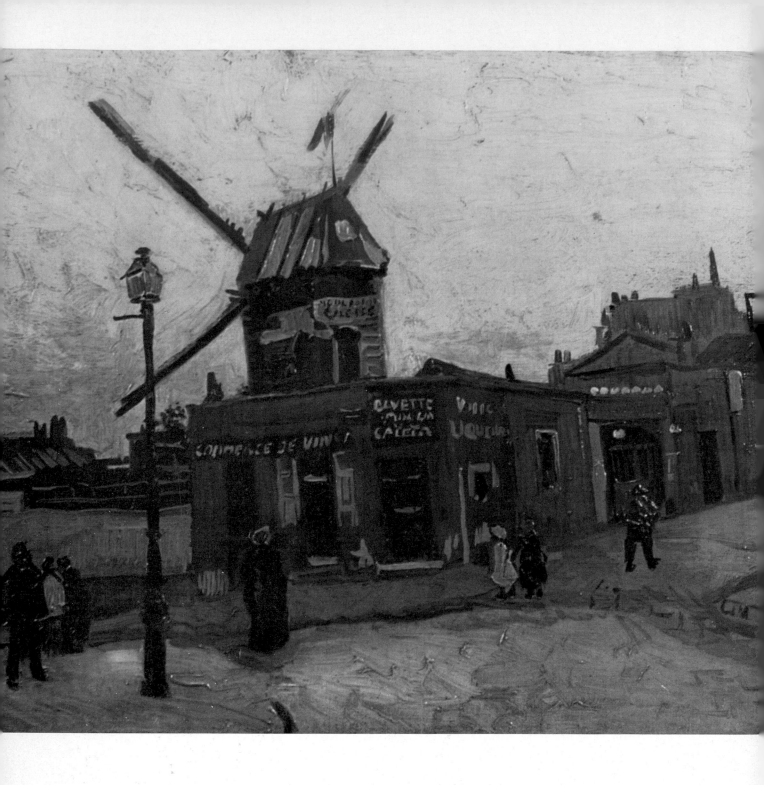

Vincent van Gogh, *The Mill of Le Radet, Montmartre*

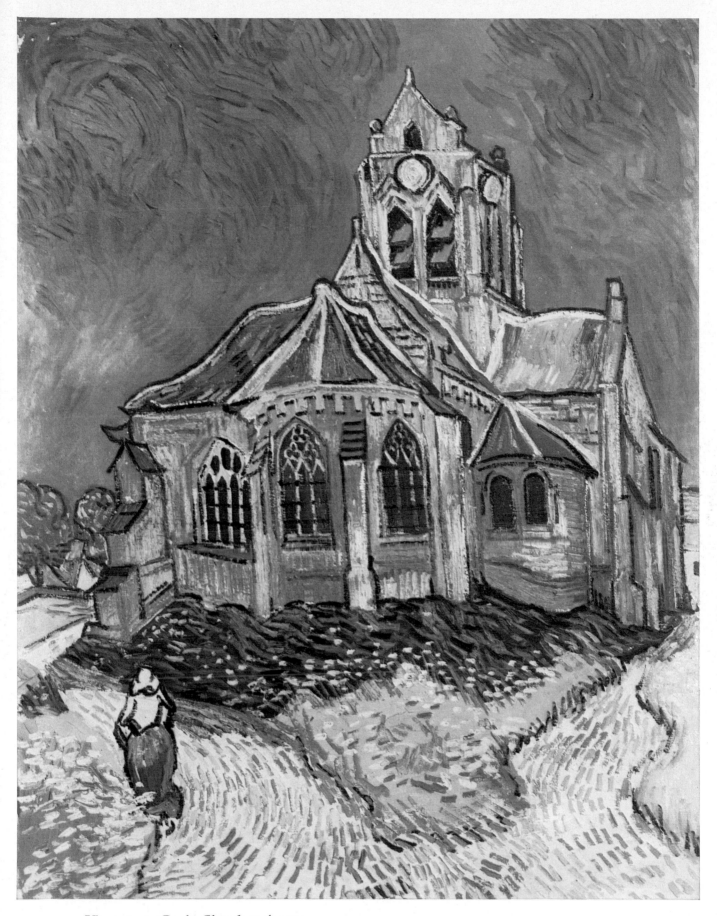

Vincent van Gogh, *Church at Auvers*

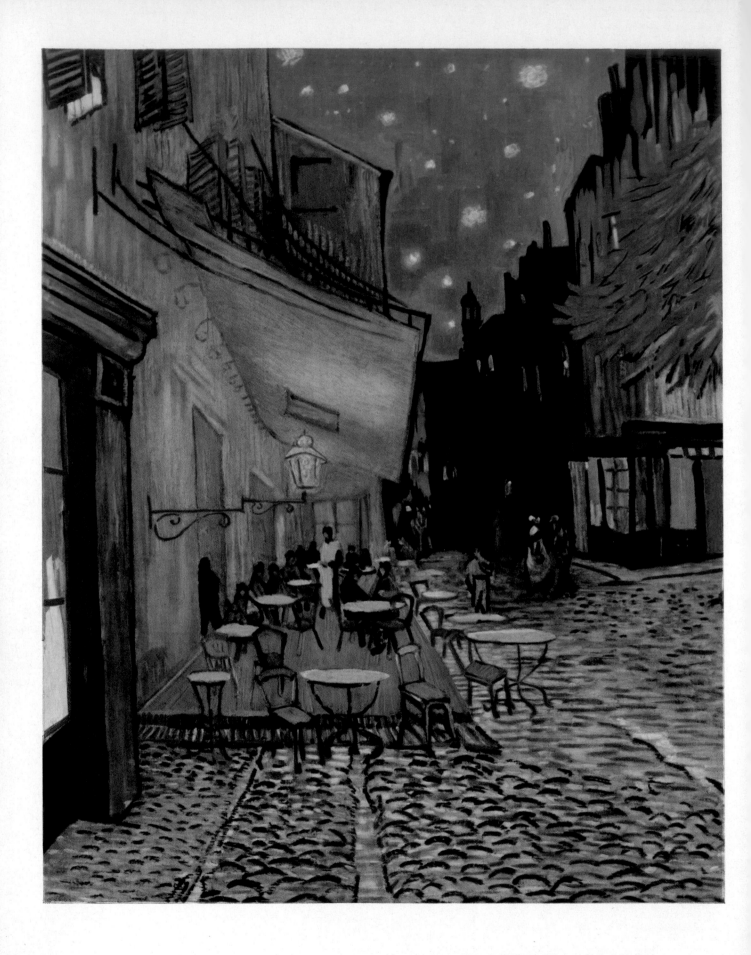

104 Vincent van Gogh, *Night View of Cafe, Arles*

above all, an understanding of the relationship between design and drawing and color. These small pictures were all painted in the open air and represent studies that look toward the more exact interpretation of light and color that Seurat developed by juxtaposing dots of pure color.

Despite his objections to the casual or accidental nature of Impressionism, Seurat considered himself an adherent to the style, and he frequently stated that his scientific investigations of color were actually undertaken with the object of defining more clearly the basic ideals of Impressionist painting. Seurat believed that when the Impressionists attempted to capture and reproduce the essence of light in its many aspects, and when they sought to communicate it by daubing the canvas with patches of pure color, they were intuitively led to seek the colors of the spectrum. From his study of Chevreul, Seurat knew that there was no color that was not a part of the spectrum, familiar to all of us as in the aspect of a rainbow. Seurat's innovation was the idea of applying systematically the colors of the spectrum to painting, in order to record the artist's impression in a purer and truer form. Seurat began, as he put it, to "divide" colors by the juxtaposition of dots, each of a pure spectral hue as it appeared on the color disc. Instead of being mixed on the artist's palette, these dots of color were mixed in the viewer's eye, thus retaining all the brilliance they possessed in nature. In 1886, Pissarro, excited by the new possibilities he had discovered through his contact with Seurat and Signac, wrote to Durand-Ruel:

> The modern synthesis of scientific methods is based on the theory of colors discovered by Chevreul. . . . and the measurements by O. N. Rood. The mixture of pigments is superseded by optical mixture, or, in other words, tones are split up into their constituent elements, the reason being that optical mixture produces much stronger luminosity than the mixture of pigments. (L. Venturi, *Les Archives de l'Impressionisme*, 2 vols., Paris, 1939.)

Despite Pissarro's enthusiasm and proselytizing, many Impressionists continued to view Seurat's painting as a threat or a challenge. Possibly these painters were merely venting their mistrust of all theorizing, but the fact remains that Pissarro had many arguments with Renoir and others about the importance of Seurat's views and, in an unusually agitated letter, complained of their resistance to new ideas or new trends in painting. If we compare Seurat's "Bridge at Courbevoie" (p. 100) with a similar type of scene, Sisley's "Canal St. Martin" (p. 72), we might begin to grasp the significance of his revolutionary theories and understand why the Impressionists felt so threatened by them. In contrast to the fresh, tentative scene presented in Sisley's work, Seurat's painting seems downright premeditated. The strong vertical accents of the boat masts, tree, and figures impart a sense of order, and the painting seems the very antithesis of spontaneous. Although both paintings make use of a strong palette, it is clear that the aim of Seurat's work is the reorganization of Impressionism on a firmer basis, namely, a more analytical approach to the dynamics of color.

Georges Seurat, "Bridge at Courbevoie," p. 100

105

Oddly enough, Seurat was not particularly interested in circulating his theory of painting or in having others adopt his views. He jealously guarded his secret lest anyone try to deprive him of the sole credit for the perfection of a new theory of color analysis. He probably worried a good deal more than was necessary, as it is apparent from his own paintings that the assimilation of his views was by no means easy. His friend and champion Fénéon saw this and assured Seurat that "The neo-Impressionistic method requires an especially delicate eye: its dangerous precision will deter those whose dexterity conceals their inability to see accurately. This type of painting is only possible for a true painter."

Seurat's suspicious nature caused him to break with some of his close friends. He became more and more of a loner, developing and perfecting his painting technique in relative isolation, much as he had done when he was a young boy teaching himself how to draw. He began to delve into the writings of others who, like himself, were preoccupied with establishing more exact correspondences between art and science.

Henri Matisse, "Luxe, calme et volupté," p. 147

Despite Fénéon's prediction that only the most gifted painters would adopt Seurat's style, a large number of artists were drawn to neo-Impressionism. For a time, Pissarro and even Vincent van Gogh were deeply affected by Seurat's ideas, and the painter's systematic approach to color was still useful for the young Henri Matisse when he painted his "Luxe, calme et volupté" (p. 147) in 1904. Rather quickly, the name of Seurat became celebrated not only in Paris but also in Belgium, where he was invited by a group of young painters to exhibit with them in 1887, and where he subsequently had great influence. When he was thirty-two, his promising career was cut short. Just before the opening of the exhibition of *Artistes Indépendants* in 1891, Seurat died.

While his immediate importance for the development of neo-Impressionism was considerable, Seurat's impact on such twentieth-century art movements as Fauvism (the strong-colored early style of Matisse), Cubism (the analytical, abstract style of Picasso and Georges Braque [1882–1963]), and Futurism (an Italian offshoot of Cubism concerned more with speed and a celebration of the machine age) was even more important. His friend and collaborator Paul Signac summed up Seurat's contributions quite admirably: "He had passed everything in review and established almost with finality: the black and white, the harmonies of line, composition, the contrast and harmony of color . . . and even the frames. What more can one ask of a painter?"

VINCENT VAN GOGH

Vincent van Gogh's visit to Paris in 1886 was not his first. In 1875, he had come to the city to see his brother Theo. Their father was a Protestant minister, and the two brothers had inherited an interest in art from their uncles, who were successful dealers. Both Vincent and Theo worked for a time for a large French art firm with branches in Holland, Belgium, and England. After six years of working in the various offices, Vincent quarreled with his employers and left the firm. Shortly thereafter, he expressed the desire to enter the ministry, but after failing the examination for entrance into the faculty of theology, he accepted a post as a lay preacher working

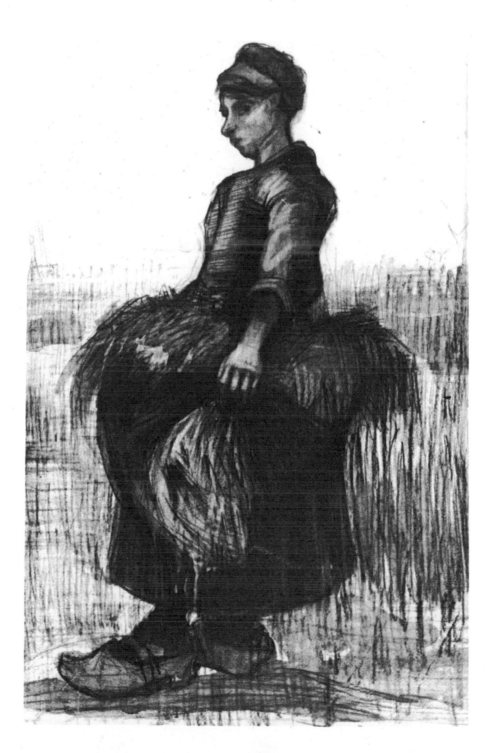

Vincent van Gogh,
*Peasant Woman
Returning Home,*
Calk and Water Color

with the poor in a mining district of Belgium. Here, amidst the destitute and hopeless circumstances of the miners, van Gogh first began to draw—and the intense feeling that seized him during this period became one of his personal stylistic traits. The same deep interest in humanity that prompted him to work with the poor is mirrored in his early artistic efforts. A drawing of a peasant woman (p. 107), vigorous, direct, and somber, is not merely a technical exercise but a sincere, personal statement of what the artist felt as well as saw.

Vincent van Gogh, "Peasant Woman Returning Home," p. 107

By 1886, when van Gogh accepted his brother's invitation to continue his art studies in Paris, the painter was already thirty-three years old. His training as an artist had been limited to a few months of study at art schools in Brussels and Antwerp, which he had left because of dissatisfaction with the traditional teaching methods. What van Gogh was looking for was a new approach, and this he knew he would find only in Paris, the artistic capital of the world. His first weeks and months in the city were packed with excitement. He missed no opportunity to meet with young painters, to hear their views, and to express his own passionate convictions. Years before, he had been attracted to the paintings of Millet, whose landscapes and understanding views of peasant life he defended against the ridicule of more sophisticated avant-garde painters, who found Millet's sentimentality old-fashioned. Awkward and rough in appearance, van Gogh expressed himself clumsily but with absolute sincerity of conviction. While some regarded him as an eccentric or even as a madman, others took the time to encourage the strange man and helped him to gain confidence in his artistic ability. Henri de Toulouse-Lautrec (1864–1901), with whom he drew in one of the studios, and Paul Signac became friends with whom he could talk and work.

Vincent van Gogh, "Montmartre," p. 99, "The Mill of Le Radet, Montmartre," p. 102

The pictures van Gogh painted during his first year in Paris bear witness to his breathtaking development. The influence of Millet and the Dutch masters of the seventeenth century, whose works he studied in the Louvre, gave way to the effect of his almost daily contact with the Impressionists. He began to purchase Japanese woodblock prints, attracted, no doubt, by their combination of expressive line and strong, decorative colors. He began to employ the pure color of the neo-Impressionists but transformed their brilliant color dots into elongated slashes. By the time he decided to leave Paris to work in the south of France, van Gogh had painted more than 200 pictures, including interpretations of Japanese subjects, flower paintings, interior scenes, and numerous views of Paris. Even a superficial comparison of two views of Montmartre (pp. 99, 102), painted within a year of each other, reveals the variety of influences and the different approaches that contributed to the formation of van Gogh's style. Where the tones of the earlier view (p. 102) are somewhat darker, the brushstroke flat or matte, and the general feeling of the work heavy, the later painting vibrates with energy. The short, choppy brushstrokes and brighter colors adapted from neo-Impressionism impart a sense of feeling and emotion that doubtless surprised Signac and Seurat as much as it did the Impressionists. Although van Gogh painted in the open

air, he was clearly no objective "eye" like Monet, nor a "scientist" like Seurat. What he sought was a type of intense emotional experience that could only be realized through painting. In order to dedicate himself completely to this, he decided to leave Paris, to put aside its sophisticated and distracting social life, and to concentrate on developing his own unique style.

While van Gogh's artistic development during his two years in Paris was greatly influenced by Impressionism, his move, in 1888, to Arles, in the south of France, marks the beginning of a period in which he was to reject this style of painting. He recognized this when he wrote, "Instead of trying to imitate exactly what is before my eyes, I am using color in a much more arbitrary way in order to express myself more strongly." (Van Gogh, *Complete Letters.*) Somewhat later he observed, "Pissarro is quite right: we should not hesitate to exaggerate the color effects produced by harmony and opposition." (Van Gogh, *Complete Letters.*) When he wrote these lines, van Gogh was not merely theorizing but was expressing his own sensitive reactions to the vivid impressions and brilliant light he encountered in the landscape of the south. The light and color of the area around Arles struck the painter's eye with an intensity it had never experienced, and he responded to it by resorting to more violent colors and more simplified and stylized forms. Van Gogh's painting was always dependent on a direct impression of nature. From Arles, he wrote his friend the poet and painter Émile Bernard (1868–1941):

> I cannot work without a model. Certainly I turn my back on nature when I am working up a sketch into a picture, deciding on colors, enlarging or simplifying; but as far as forms are concerned I am afraid of departing from reality and not being accurate enough.... Meanwhile, I devour nature with my eyes. I exaggerate and sometimes alter the subject, but I do not invent the whole picture—I find it already present, although it has to be disengaged from nature. (Van Gogh, *Complete Letters.*)

The attitude expressed in van Gogh's letters to Bernard and to his brother is borne out in the paintings he produced at this time. In "The Sower" (p. 101), the intense yellow of the sun pervades the sky and provides a striking contrast to the violets and greens of the landscape. The essential form and movement of the sower is silhouetted darkly against the lighter colors of the earth, and the graceful movement of the figure is echoed in the bending form of the solitary tree. The entire work imparts a feeling of melancholy and somber reflection.

Van Gogh, along with some of the earlier Romantic artists, had become persuaded that only in a community of artists thinking alike could the individual realize his potential. He was convinced that in Arles he had found the ideal spot to set up such a community, and he wrote such friends as Bernard and Paul Gauguin, urging them to join him there. Interestingly enough, Gauguin's own development was prompted by the

Vincent van Gogh, "The Sower," p. 101

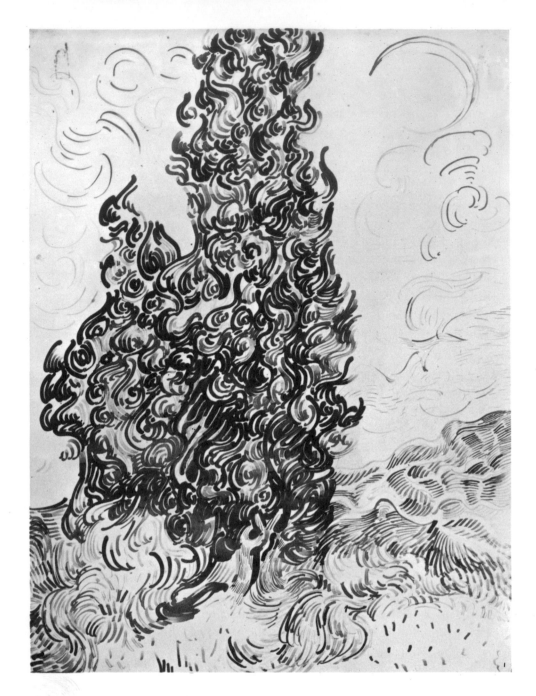

Vincent van Gogh,
Cypresses,
Pen Drawing

desire to find a simple rural spot, untouched by the effects of industrialization and urban life, where his art could find direct stimulation. It was natural, then, that he yielded to van Gogh's repeated pleas that he come to Arles and work there. Finally, in October, 1888, Gauguin arrived, but he expressed his disappointment with the landscape and some misgivings about the idea of living with van Gogh. He immediately felt the tension that was to doom any attempt at collaboration and that ultimately drove van Gogh to an act of violence. He wrote to their joint friend Bernard, "I am not a bit happy at Arles. I find it all mean and petty, the country and the people alike. Vincent and I are seldom of one mind, especially as regards paintings." His disappointment was shared by van Gogh, who confided to Bernard, "I think Gauguin was rather displeased with this little town of Arles, with the little yellow house we work in, and above all with me."

110

Despite his sincere admiration of Gauguin, van Gogh's personal character and strong artistic convictions led him to differ sharply with the slightly older man. Each had a clear concept of the painter's task and of the artistic method necessary to its fulfillment. Although they agreed about many things, such as their increasing aloofness from Impressionism, they were almost diametrically opposed in their approaches to painting. While van Gogh's creative ability was deeply dependent on his personal experience and appreciation of a visual reality, Gauguin's sensibility was more attracted to literature, music, and religion. He was constantly striving to distill his visual experiences and to produce paintings that would have a primarily aesthetic rather than emotional appeal. Although their intense personal relationship at Arles seems to have affected both men, it is difficult to assess the artistic effect of one upon the other. For both, the months spent together in Arles were a time of extraordinary artistic development. Van Gogh began to employ stronger contours and simplified tones similar to those Gauguin had utilized in his work, while Gauguin wrote enthusiastically, "I have sent [Theo] van Gogh two pictures that you simply must look at. A complete change for once: thickly painted in coarse canvas, with hardly perceptible transitions of color. I was only concerned to express the essential concept." A glance at one of Gauguin's Arles paintings (p. 114) reveals his partial response to van Gogh's work. Both the swirling brushstroke in the trees of a farmyard scene and the short chops of paint in the grass of the foreground attest to the artistic give-and-take between the two men.

Paul Gauguin, "Landscape at Arles," p. 114

The intense, nightmarish colors of van Gogh's "Night View of Café, Arles" (p. 104), a place where "one might go mad or commit a crime," attest to his worsening psychological state. Gauguin provoked him to violent arguments by trying time and time again to influence van Gogh to change his style. Finally, after a particularly vicious scene, van Gogh threatened his friend with a knife, went wild with anger and remorse, and cut off his own ear. Gauguin left Arles immediately, and van Gogh, in a state of complete mental and physical collapse, committed himself to a hospital. His months of isolation were especially painful to van Gogh. The painter was deprived of contact with his friends, of the conversation and exchange that was so necessary to his creative life. Despite the temporary help of the doctors, van Gogh's mental condition continued to deteriorate. He suffered continuously from anxieties and hallucinations. Yet, despite the most incredible suffering, he managed to work with an all-consuming energy that once more drove him to seek the care of a doctor in Auvers. Here, he continued to work and develop, although the state of his health did not improve. His colors became even more vivid, his brushstroke more fiery and agitated in its attempt to express fully the powerful and mystical forces he felt in nature. His last landscapes, such as the "Church at Auvers" (p. 103) or the views of wheatfields he painted while under doctor's care convey the sense of anguish and even desperation that marked the painter's last, feverish period of creativity. By Juli, 1890, he was dead. He had shot himself while painting in a wheatfield.

Vincent van Gogh, "Night View of Café, Arles," p. 104

Vincent van Gogh, "Church at Auvers," p. 103

PAUL GAUGUIN

We have already discussed some aspects of the early development of Paul Gauguin—his enthusiasm for Impressionism, his admiration for Pissarro, and his limited success, first as an exhibitor in the Salon and then with the Impressionists. Gauguin's struggle to forge a new style, which was manifested in his arguments with van Gogh at Arles, had dominated his artistic development even before 1888.

In 1886, thanks to Pissarro's support and in spite of strong opposition from the rest of the group, he was allowed to show some of his pictures in the last joint exhibition. However, little tangible success was forthcoming, and Gauguin, an extremely impatient and willful man, decided to put the intrigues of the Paris art world behind him and seek a kind of primitive quiet in the village of Pont Aven, in Brittany, where he worked with the painter Émile Bernard. There, in direct opposition to the Impressionists' concept of recreating a specific visual experience, he began to develop the decorative and symbolic power of line and color that was to mark his mature style. What he sought to capture and communicate was not the uniqueness of a fleeting impression but a transposition or transformation of a visual experience into an artistic equivalent for the experience. He called this method of painting a "synthesis," and in discussions with Bernard and others he clarified his theories, which called for a drastic simplification of composition and a suppression of details in order to achieve a certain decorative intensity.

Gauguin's restless quest for an unspoiled world as a model and inspiration for his work did not stop in Brittany. In the spring of 1887, he sailed for Martinique, which he had visited years earlier as a sailor. The purpose of his trip was to earn money by working on the construction of the Panama Canal, but he was doubtless also attracted by the idea of encountering new themes for his painting. The exoticism of the tropics exerted a strong influence on his painting and brought him closer to the achievement of his stated purpose, which he described as the "orchestration of color."

Forced by illness to leave Martinique, Gauguin returned to Paris and the poverty that was to dog his entire creative life. After he recovered, Gauguin began to do ceramics and to make woodcarvings. Theo van Gogh arranged a one-man show of his Martinique paintings, but few critics reacted sympathetically to the works. Only van Gogh expressed his admiration of the "sublime poetry" of Gauguin's scenes of native life. Undiscouraged, the painter decided to return to Brittany, where his friends were still working and where his style was to mature. A letter to his friend and benefactor, the painter Émile Schuffenecker (1851—1934), expressed the crystallization of his views about art: "Do not copy nature

Paul Gauguin, *Vision After the Sermon: Jacob Wrestling with the Angel*
On the following pages: Paul Gauguin, *Landscape at Arles*. Odilon Redon, *Vase of Flowe*

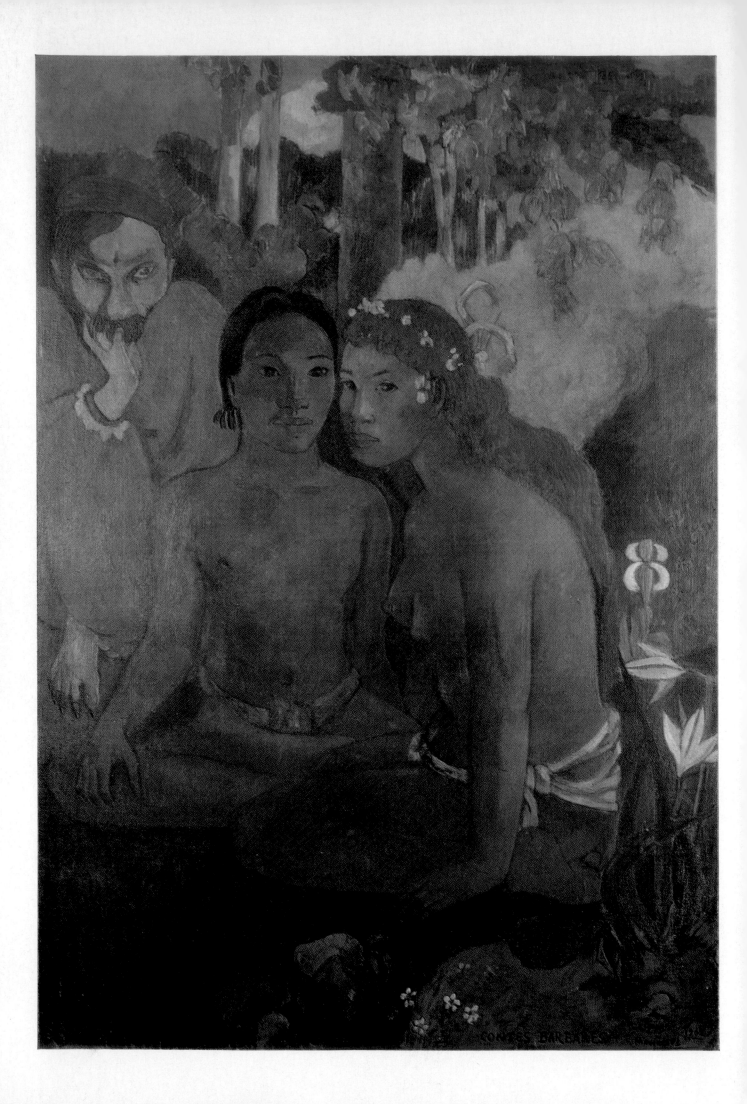

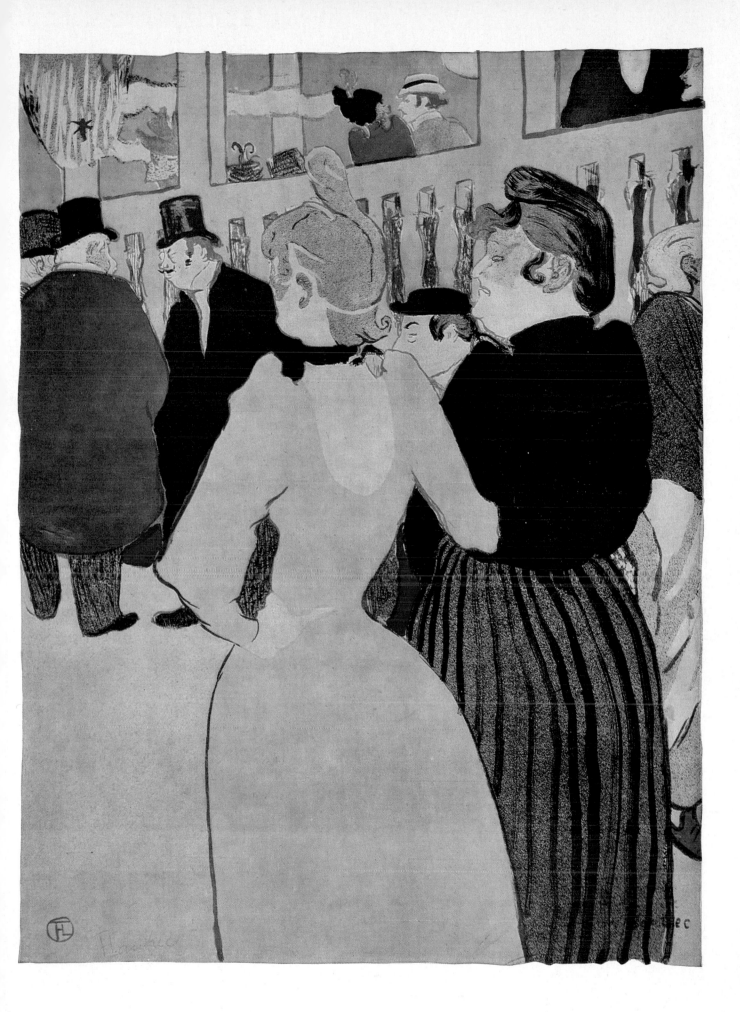

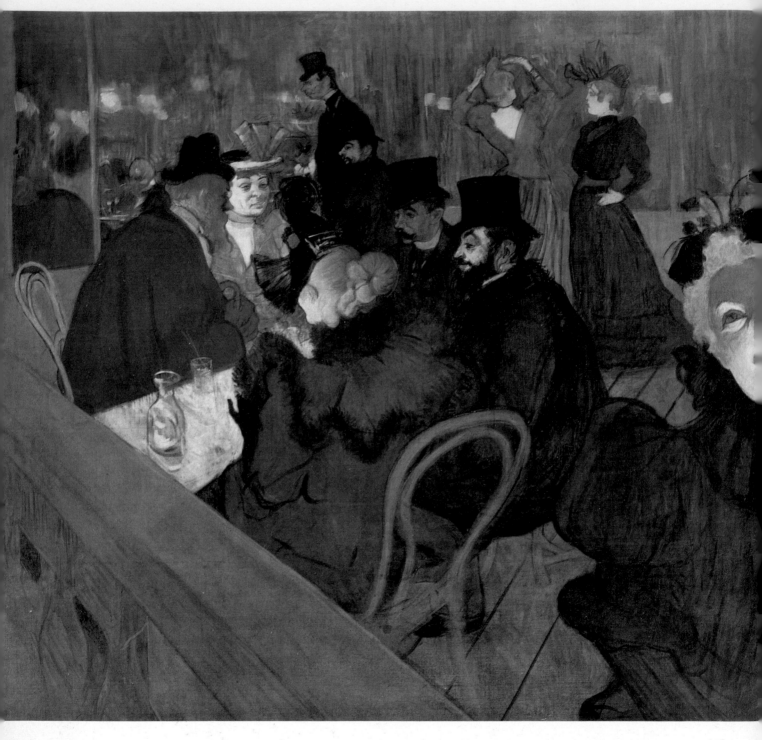

Henri de Toulouse-Lautrec, *At the Moulin Rouge*

On the previous pages:
Paul Gauguin, *Contes barbares (Savage Tales)*
Henri de Toulouse-Lautrec, *La Goulue*

Right: Maurice Denis, *The Muses*

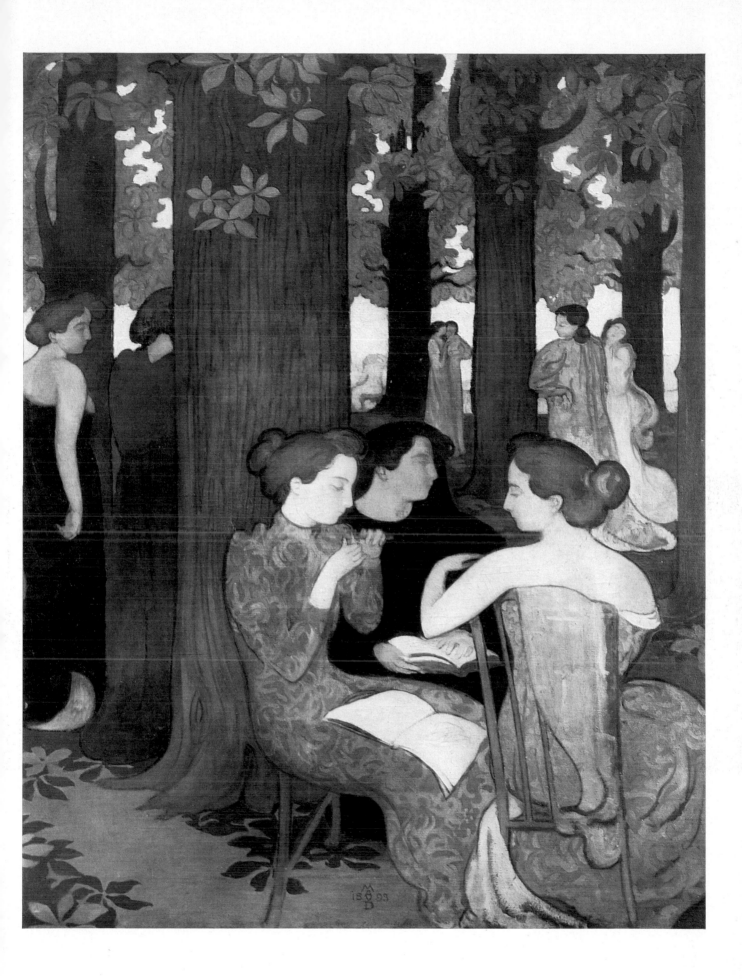

Paul Sérusier, *View of the Bois d'Amour (The Talisman)*

too much. Art is an abstraction: you should derive it from nature which you contemplate as if in a dream." In "Vision after the Sermon" (p. 113), as in other pictures inspired by the religious piety of the Breton peasants, we see him putting his theories into practice. The painting of women coming from church, where the subject of the sermon, Jacob wrestling with the angel, has been vividly fixed in their minds, reveals the many sources that contributed to Gauguin's development. The curious vantage point of the viewer, the cut-off at the top, and the use of strong, flat areas of color suggest that Gauguin, like the Impressionists, was attracted to Far Eastern art. The scene is fixed by the vivid red field against which the two small figures are silhouetted. It cannot be characterized as heaven or earth, and it certainly in no way resembles any part of Brittany. Writing to van Gogh about the painting, Gauguin provided his own explanation:

> I believe I have attained in these figures a great rustic and superstitious simplicity. It is all very severe. ...To me...the landscape and the struggle exist only in the imagination of these praying people, as a result of the sermon. That is why there is a contrast between these real people and the struggle in this landscape which is not real and is out of proportion. (John Rewald, *Post-Impressionism, From van Gogh to Gauguin*, New York, Museum of Modern Art, 1956.)

By using vivid, pure colors, and by emphasizing flat shapes by fluid outlines and avoidance of modeling, Gauguin has forced the viewer to accept a new kind of visual language, in which the simplified forms approach abstraction.

Despite his ever widening circle of artistic admirers, Gauguin's work was still relatively unsuccessful with critics. The ambitious painter began to appear at a café where some of the most important writers and artists gathered to discuss such ideas as the possibility of correspondences between music, literature, and art. Gauguin met the distinguished sculptor Auguste Rodin (1840—1917), and the poets Stéphane Mallarmé and Paul Verlaine. These writers were kindred spirits for Gauguin, who wished to flee the ugliness and banality of contemporary urban life by immersing himself in the remote, the exotic, and the symbolic.

One fateful day, the painter saw a brochure of Tahiti and decided to leave Paris for the South Seas. He had always been attracted by the tropics, and he hoped to find in Tahiti the "wild landscape" of his dreams. In February, 1891, he auctioned about thirty of his paintings in order to pay for his trip, and with the proceeds he was able to leave a few months later. Apart from a brief period when he returned to Paris in order to exhibit his work, Gauguin remained in the South Pacific for the rest of his life. The direct impact of this strange and novel world and its glorious range of color is seen in the paintings he produced in the 1890's and later. The "orchestration of colors" is richer, more subtle. The lines are more graceful and insinuating. He wrote: "By the combination of lines and colors, under

Paul Gauguin, "Vision After the Sermon: Jacob Wrestling with the Angel," p. 113

121

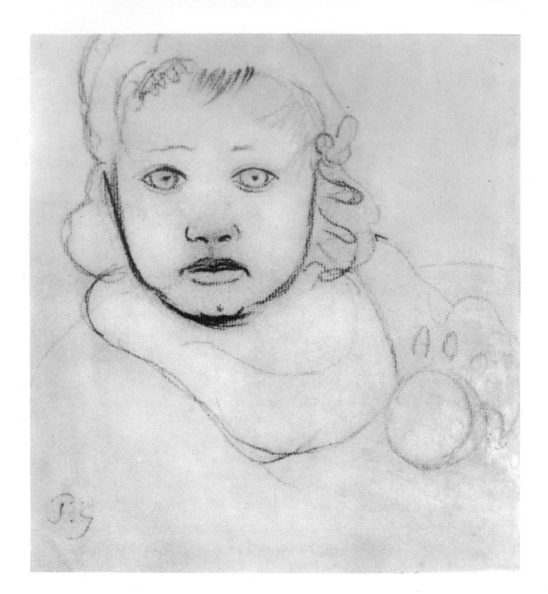

Paul Gauguin,
Child's Head,
Chalk Drawing

Paul Gauguin, "Contes
barbares," p. 116

the pretext of some motif taken from life or nature, I create symphonies and harmonies which represent nothing absolutely real in the ordinary sense of the word but are intended to give rise to thoughts as music does." These words seem to summarize perfectly the atmosphere of a painting like "Contes barbares" ("Savage Tales") (p. 116), in which the pensive figure of the dwarfed storyteller hovering menacingly behind the brown-skinned native girls is Gauguin's friend and sometime benefactor, Jacob Meyer de Haan. Gauguin had known de Haan since his Pont Aven days and had executed several portraits of the well-to-do Dutchman. This likeness, done from memory, stylizes the compellingly ugly features of de Haan and projects not so much the physical presence of the man as a sense of mystery and evil.

More than once, Gauguin had expressed his admiration for the great classicists and Ingres, and certainly his interest in the expressive possibilities of color was matched by his appreciation of the value of line. His concern with the potentialities of line was fed by his experiments with woodcuts. He maintained that he had become interested in that particular type of graphic technique because it was the most primitive and derived from a time when an essential line had to convey the entire message of a

122

work. Gauguin produced a large number of woodcuts, including a group that appeared in a satirical review he published from Tahiti called *Le Sourire* (The Smile) (below).

Paul Gauguin, "Frontispiece for *Le Sourire*," p. 123

Although Gauguin remained a poor man all of his life, his paintings with their haunting subject matter and their remarkable color harmonies impressed the generation of artists that was coming of age in the last decade of the nineteenth century. His strange personal symbolism influenced such young artists as Maurice Denis, who were trying to create a new kind of religious expression in their art. In his woodcarvings and paintings, Gauguin utilized non-Western sources and was thus instrumental in turning the eyes of other artists away from familiar European art works to a new source of powerful expressivism. But his greatest gift to subsequent painters was probably his insistence that a work of art was primarily the result of an intellectual process, of a series of decisions or choices rather than of a desire to imitate or reproduce. In this attitude, we can see the seeds of modern painting, with its stress on technique and its vindication of Gauguin's belief that "Art is abstraction."

Paul Gauguin, *Frontispiece for Le Sourire,* Woodcut

PAUL CÉZANNE

The participation of Paul Cézanne in the third Impressionist exhibition in 1877 marked the end of his close contact with the Paris painters. He had first become acquainted with the Impressionists through Camille Pissarro, and subsequently he became a frequenter of the Café Guerbois, where Manet held forth in the 1860's. On one occasion, Cézanne brought his school friend Émile Zola along with him, thus introducing Zola to the painter whom he would later celebrate in his art criticism. With the writer, Cézanne visited the official Salon and the renegade *Salon des Refusés*, where Zola first viewed Manet's work. Although Cézanne admired Manet's work in the early 1860's and was thrilled when Manet promised to pay a visit to his studio, his own work in no way resembled the sophisticated paintings of the older man. Like many other young painters, Cézanne had copied the work of certain masters, notably Delacroix, but his interest in vigorous drawing, strong, unromantic colors, and his lack of concern for historical subjects soon led him to evolve a powerful new style and content.

During the 1860's and 1870's, Cézanne virtually commuted between Paris and his native Aix-en-Provence. Perhaps it was his provincial background that made him somewhat uncomfortable in the sophisticated world of the Paris cafés, or perhaps it was a native shyness that prompted him to keep more and more to himself. In any case, the Impressionists were not generally enthusiastic about Cézanne's work, and Pissarro had to argue most persuasively to have his paintings included in the first group exhibition of 1874. Working alone in Provence and then again in Paris, Cézanne began to produce pictures that were greatly different from those that first attracted Pissarro's interest. It became increasingly clear that the painter was pursuing a quite different artistic course from that of the Impressionists. Later, he described his new style as a "theory developed and applied in contact with nature." For Cézanne, in contrast to the Impressionists, there was an important reflective stage between the receiving of the original impression and its pictorial representation. Light and color were studied and interpreted, and the painter's sensitive apprehension of the visual impression gave way to a conscious study of tonal values. Cézanne's aim was to express the whole physical and spatial experience of an object or group of objects by means of color rhythms. He wrote enthusiastically to Pissarro of his discoveries: " The sun is so terrific here that it seems to me as if the objects were silhouetted not only in black and white, but in blue, red, brown, and violet. I may be mistaken, but this seems to me to be the opposite of modeling."

Both Cézanne's desire to replace "traditional modeling and perspective by the study of color tones" and his fundamental concern with clarity and tectonic form can be compared with the aims of Seurat. For both, painting and the theory of painting were dependent on contact with nature. Till

Paul Cézanne, *House in Provence*, Water Color

the end of his life, Cézanne did his landscapes in the open air, directly from a model (above). As early as 1866, he had written Zola: "You know all pictures painted inside, in the studio, will never be as good as the things done outside." Despite the increasing abstraction of his later work, Cézanne remained true to this early belief.

Highly sensitive to the criticism of friends and enemies alike, Cézanne grew more and more reclusive. Scarcely any of his work could be seen in Paris, except by those who ventured into the little paint shop of Père Tanguy. This simple man, to whom painting meant everything, admired Cézanne's work and always accepted the artist's pictures as payment for the colors he purchased. Years later, Émile Bernard wrote of Tanguy's collection, "People used to go there as if to a museum. Members of the *Institut* [*Institut de France*], influential and progressive critics made their way to the little shop, which became the talk of Paris and of the studios."

However, a general recognition of Cézanne's importance was deferred until the late 1890's and, in fact, his real significance was only realized when the Cubist painters began to assimilate his message, "treat nature by the cylinder, the sphere, the cone."

Paul Cézanne,
"House in Provence,"
p. 125

125

TOWARD A MODERN STYLE

We have seen how Seurat, van Gogh, Gauguin, and Cézanne each reacted to some aspect of Impressionism and how these individual reactions constituted not only the turning away from a style of painting but the creation of vitally new and different approaches to art. Whether we speak of Seurat's theory of color analysis, van Gogh's expressive brushwork and personal involvement, Gauguin's telling lines and subtle color harmonies, or Cézanne's study of tonal values, we are dealing with various aspects of a new, modern vision. The wholly new concepts of the nature and function of art that were forming, so to speak, in the 1880's, suddenly burst forth in the next decade. During the 1890's, Gauguin and Cézanne, the surviving members of this quartet of revolutionaries, became increasingly involved in artistic experimentation. They realized that their own art was not really the culmination of something but represented instead the starting point for new ideas. Perhaps because of his fiery temperament, Gauguin saw himself as the prototype of the painter of the future. He felt that artists had to adjust to the ever changing functions of painting, and he urged his comrades to make war on the past and present, not by ridicule but by the example of new discovery. He urged his contemporaries "not to be afraid of the most extreme abstractions" and "to keep on learning things, and when we have learnt them, learn some more."

The bold, impatient words express a whole gamut of intellectual attitudes, which assumed both the rejection of Impressionism and the confidence that a new style was being formed. Although Gauguin formulated his ideas first and foremost as a result of his own practical experience, his opinions might as easily be ascribed to the others. Seurat and Cézanne certainly shared with Gauguin a tendency toward increasing simplification and stylization of forms, and a preoccupation with what has been previously described as the technical process of painting. The works of each acquired a new independence from the original impression or subject and became, as Cézanne put it, creations "parallel to nature." In the realization of harmonious lines and color combinations, the artist no longer sought to reproduce nature but rather a symbolic equivalent of what he had experienced. The generation that viewed Gauguin's work at Durand-Ruel's gallery in 1893 or Cézanne's series of mountains, his "Card Players," or "Bathers" at the dealer Ambroise Vollard's in 1895 was no longer afraid of the "most extreme abstraction."

Both van Gogh and Gauguin had been especially aware of the expressive value of line. The former consciously exaggerated the contours of forms in order to increase the emotional content of his work, while Gauguin characteristically analyzed lines in terms of their associative or symbolic value: "Some lines are noble, others are treacherous and so on. A straight line denotes the infinite, a curve delimits what is created." Although Seurat and Cézanne subordinated design to color, the element of design was quite strong in the work of each, and this is surely not accidental, since

Cézanne, like Seurat, had expressed his admiration of the seventeenth-century master of design, Poussin.

Taking a general view of the developments in the 1880's and 1890's, color still seems to constitute the major interest in the various trends that led to a modern style. Van Gogh was fond of speaking of "suggestive color," while Gauguin's idea of the "orchestration of colors" and his comparison of the painter's use of tones to produce certain effects like those of the musician were destined to have an impact on such artists as Wassily Kandinsky (1866–1944), who was one of the founders of nonrepresentational painting. The abstract resonance of color appealed to these artists in different ways but enabled each to find a personal style and a model for future artists. Van Gogh's painting inspired all of the subsequent tendencies that can be called "expressionistic," in the sense that they deal with human emotion; Cézanne's manifest interest in the inherent structure of natural forms and his use of color to reinforce the plastic properties of forms had considerable effect on the Cubists, while Seurat's and Gauguin's theories and practical experiments pointed the way to the importance of color in later nonrepresentational or abstract painting.

Édouard Vuillard,
Russian Student,
Chalk

PROPHETS AND POETS

Late in the summer of 1888, a young painter named Paul Sérusier (1863–1927) visited Gauguin at Pont Aven in Brittany. The meeting proved to be decisive for both, as Sérusier subsequently became one of Gauguin's most convinced disciples and an eloquent exponent of his views. Sérusier had studied painting for only two years or so, but he belonged to a circle of young artists who held lively discussions about new developments in painting and in literature. Some of the members of this group were Maurice Denis, Ker Xavier Roussel (1867–1944), Pierre Bonnard (1867–1947), and Édouard Vuillard (1868–1940)—all strongly influenced by the work of Gauguin.

Paul Sérusier, "View of the Bois d'Amour" ("The Talisman"), p. 120

Sérusier had traveled to Brittany in the hope of obtaining some criticism and direction from Gauguin. While working outdoors with the older master, Sérusier began to paint a small landscape in which the factual, visual impression of the scene was transformed into a decorative arrangement of simplified color shapes. Trees were painted yellow, the earth became red, and the surface of the water in a nearby stream was depicted in nearly abstract patches of blue, green, brown, yellow, and white. This little painting of the Bois d'Amour (p. 120), which was corrected by Gauguin's own hand, was brought back to Paris, where it was immediately dubbed "The Talisman," to stress its magical and initiative character. It certainly demonstrates Gauguin's practice of using color harmonies to create a lively two-dimensional surface design. The unusual painting was much admired by Sérusier's friends, who were virtually all products of the conservative training that still dominated the official art-establishment schools. For his part, Sérusier may have furnished his friends with a lively account of his experiences and conversations with Gauguin, thus providing further ammunition for their seemingly endless debates about such artistic concepts as "synthesis," "symbolism," and "art for art's sake"—concepts that were discussed in the studios and cafés of Paris.

It was Sérusier who invented the name "Nabis" (*nabi* is the Hebrew word for prophet) for the group of painters who met regularly in a café near the school where they all studied. In addition to his interest in painting, Sérusier was a student of Oriental languages and of philosophy. His intellectual curiosity was matched by that of other group members. Most of these had a pronounced aversion to contemporary middle-class civilization, which they rejected as both ugly and false. Despite different social backgrounds and education, they seemed to hold the common belief that nature should not be approached literally, and they vowed to create works of art that would transcend the commonplace. It is difficult to sort out the many exciting and sometimes confusing views of these articulate painters, but some general trends can be cited. One of these is certainly the belief that art should not present ideas directly but by allusion or implication. Stéphane Mallarmé, friend to Manet and Degas and the most important spokesman for the Symbolist poets, declared in

Édouard Vuillard, *Portrait of Toulouse-Lautrec*

Pierre Bonnard,
Narrow Street,
Paris

Édouard Vuillard, *In Bed*

On the following pages:
Édouard Vuillard, *Mallarmé's House at Valvins*
Pierre Bonnard, *Breakfast Room*

131

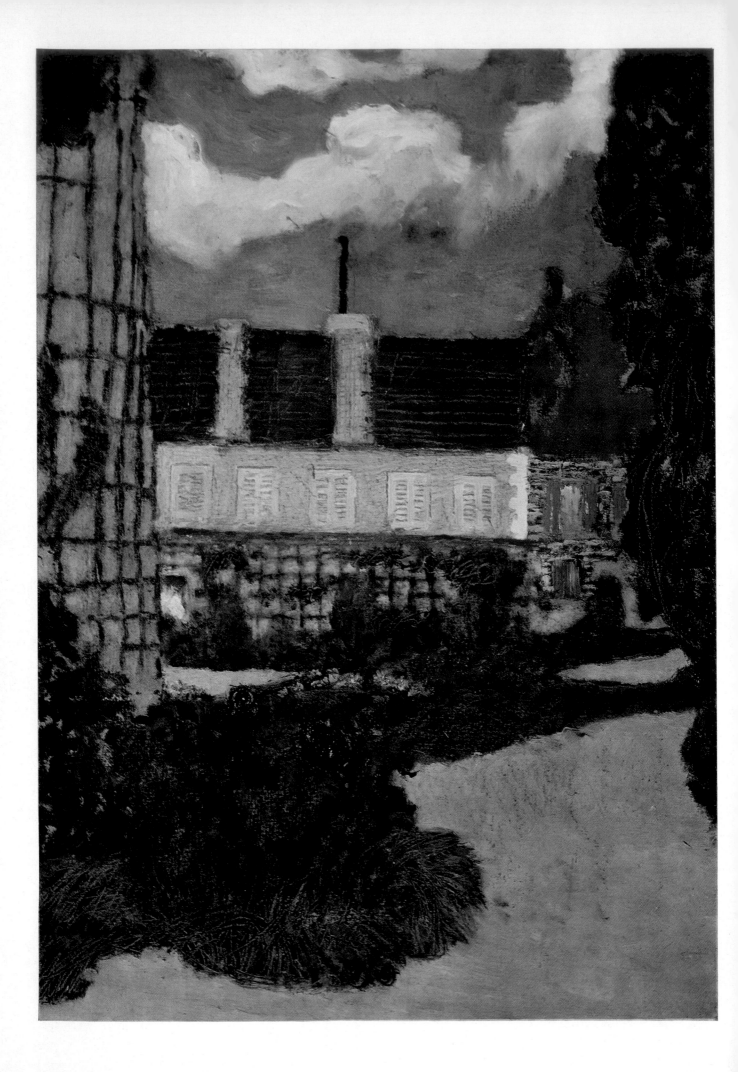

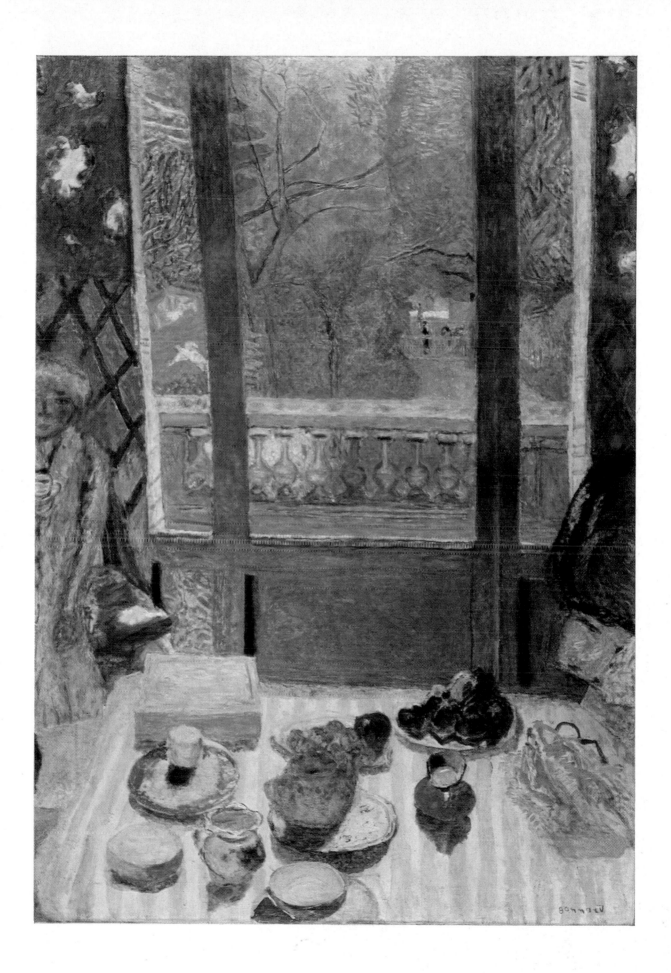

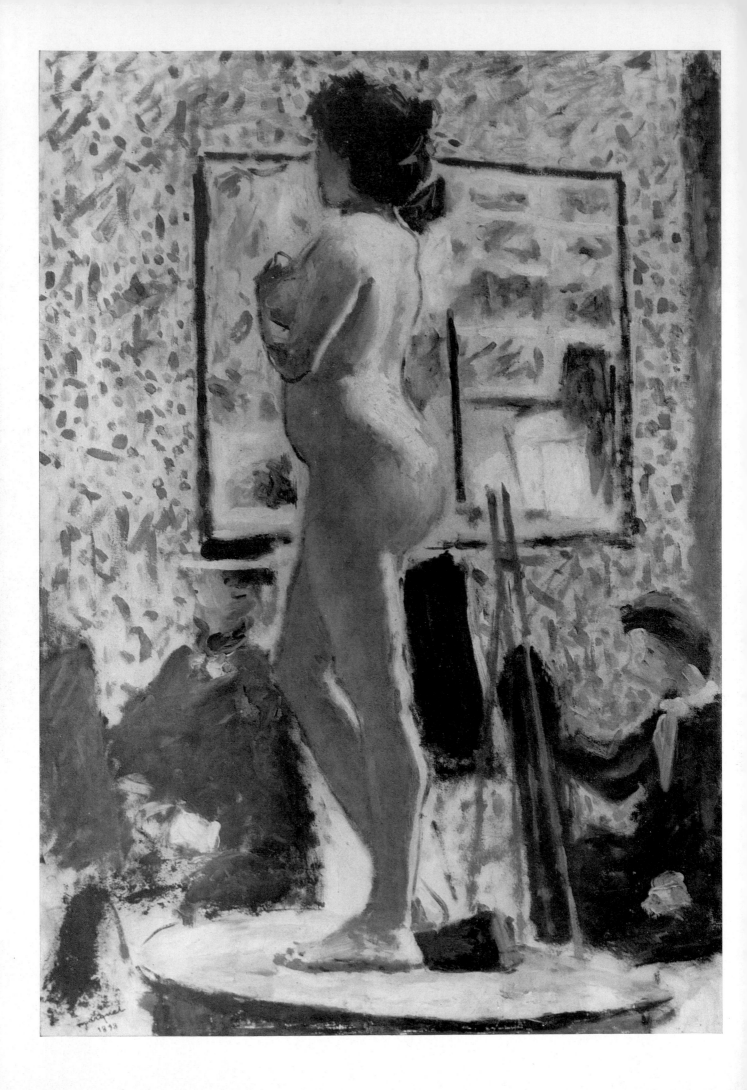

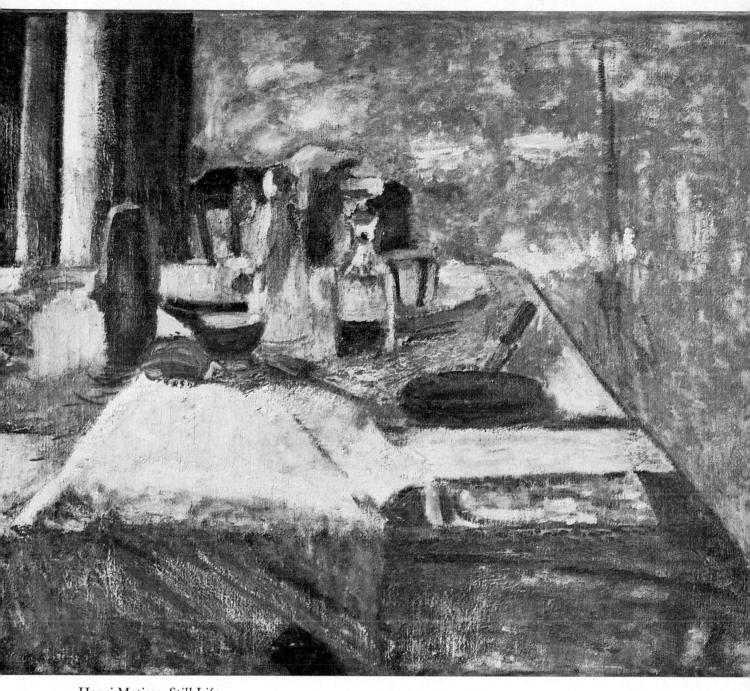

Henri Matisse, *Still Life*

Left: Albert Marquet, *Nude Called Fauve*

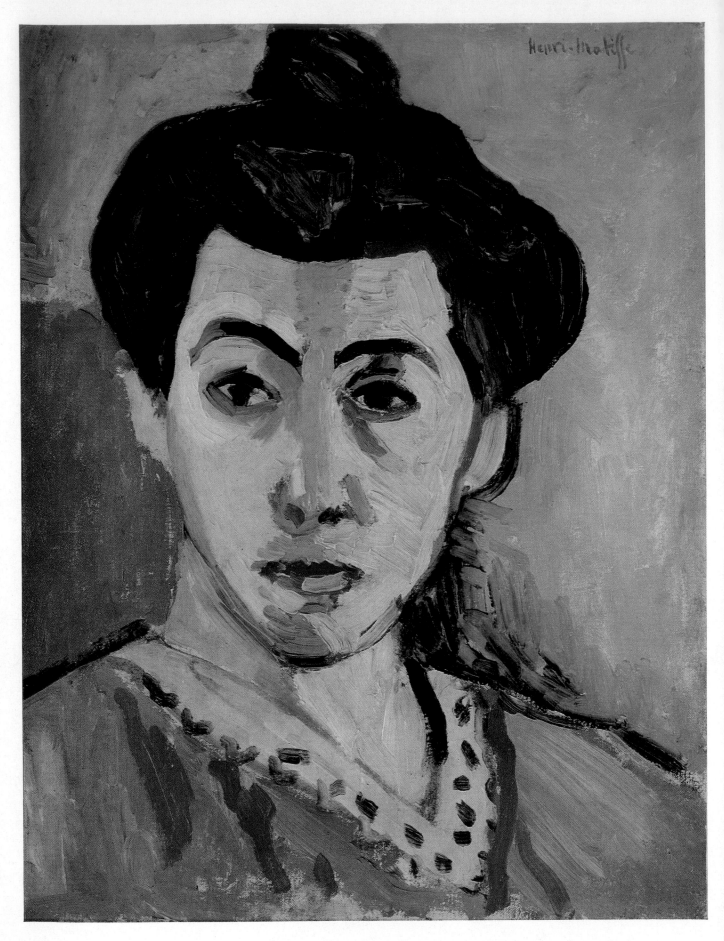

Henri Matisse, *Woman with the Green Stripe* (Madame Matisse)

Crisis in Poetry, "We renounce that erroneous aesthetic...which would have the poet fill the delicate pages of his book with the actual and palpable wood of trees rather than with the forest's shuddering or the silent scattering of thunder through the foliage." Another common belief shared with Gauguin and Mallarmé was that the boundaries between the various art forms could be more and more blurred and a "universal art work" would result. Many were increasingly convinced that painting was but one aspect of art, and that a kind of collaboration between painters, sculptors, and architects was necessary if a truly universal decorative art was to be produced. Some of the Nabis moved from easel painting to mural decoration or to stage design, which allowed them to work as collaborators with architects, writers, and actors. In fact, many of the Nabis foreshadowed the important artistic collaborations of twentieth-century artists when they created stage sets for the avant-garde theater of Lugné-Poe, one of their actor members.

The aesthetic revolution generated by the Nabis carried on, and in many ways intensified, the repudiation of Impressionism that had started with Seurat, van Gogh, Gauguin, and Cézanne. Gauguin was certainly the chief model for the new group: His appreciation of the lyrical value of color and line, his love of exoticism, and his sensitivity to the mysterious and the remote were eagerly embraced by them. The Nabis did not lack spokesmen. Sérusier continued to champion the ideas of Gauguin, even after the latter had journeyed to the South Pacific, while Maurice Denis, the group's major theoretician, attempted to define more precisely a modern conception of painting in an article, published in 1890, that proclaimed: "Remember that a painting—before it is a battlehorse, a nude woman, or some anecdote, is essentially a flat surface covered with colors arranged in a certain order."

Denis's own painting, despite its representational content, testifies to his belief in these words. The artificiality of his work is apparent. Human and natural forms are delicately stylized, and the rich pastel colors recall Gauguin's Tahitian palette. The titles of compositions like "The Muses" (p. 119) also reveal Denis's belief that art was a precious, almost sacred thing, and that a painter had to dedicate himself to it much as a priest might dedicate his life to the Church.

Maurice Denis, "The Muses," p. 119

Inevitable stylistic differences separated the work of some members of the group from others. One cannot speak of an absolute unity of approach or direction, as can be seen by a quick comparison of the paintings of Sérusier and Denis. In fact, a split occurred at one point between the theorists in the group and the artists who could not accept the rigid intellectualizing of Denis and Sérusier. Vuillard, Bonnard, and Roussel turned instead to the life around them, painting the streets of Paris and the interiors of studios and houses.

Pierre Bonnard, "Narrow Street, Paris," p. 130

The founding, in 1891, of the avant-garde literary magazine *La Revue blanche* provided the young painters with a vehicle for expressing their new ideas in words and pictures. The offices of the review became a meeting place for the airing of radical opinions. Its editors were particu-

137

Pierre Bonnard,
*Girl Putting on
Her Stockings*,
Brush Drawing

larly pleased by the graphic work of the young painters, which they found eminently well suited to the literary content of the review: poetry by Mallarmé, Verlaine, articles on Symbolism, and excerpts of plays by the contemporary Scandinavian dramatists Henrik Ibsen and August Strindberg. Lithographs by Bonnard, Vuillard, Denis, and Roussel were published along with those of Sérusier and Toulouse-Lautrec. The last named, along with Bonnard and Vuillard, became an official draftsman for the review, designing colored posters and covers that today are collector's items.

The Nabis must be given credit for promoting an integrated decorative style, which would shortly develop into an international phenomenon known as *art nouveau*. The idea of integrating the arts was experimented with right at the headquarters of *La Revue blanche*, when Henry van de Velde (1863—1957), a Belgian painter and later an architect, designed its office furniture.

TOULOUSE-LAUTREC, BONNARD AND VUILLARD

In describing the importance and influence of the Nabis, we mentioned the independence of painters who were less concerned with artistic theory, although they were nominally members of the group. Henri de Toulouse-Lautrec, an aristocrat who was born into one of the oldest families in France, was not a Nabi. Although he knew Sérusier, he only really became acquainted with the group as a contributor to *La Revue blanche*.

Lautrec was probably uninspired by the "prophetic" pronouncements of Sérusier and Denis, and possibly because of this, he was drawn to Bonnard and Vuillard, who shared his enthusiasm for Parisian life. Before working for *La Revue blanche*, Lautrec had kept pretty much to himself. He had studied painting at the *École*, but it was later, while drawing more or less

Henri de Toulouse-Lautrec,
Mademoiselle Lender,
Lithograph

independently at the studio of Cormon, that his style began to develop. It was there that Lautrec had given friendship and encouragement to Vincent van Gogh. Perhaps it was his own physical deformity that had caused him to be sympathetic to the painfully shy van Gogh. A childhood accident had crippled him in such a way that his aspect was that of a dwarf (p. 129).

In spite of the artistic seclusion that he imposed on himself—working in his studio long hours, then turning in the evening to the night life of Montmartre with its noisy cafés and cheap music halls (p. 118)—Lautrec's style developed in such a way that it seemed to parallel that of certain of the Nabis. Indeed, no one, not even Gauguin, discovered such manifold possibilities in line, expressive contours, and bright colors that emphasized continuously the surface of the picture. The fascinating milieu of Montmartre provided Lautrec not only with distraction but also with themes for his paintings and graphics. It was, above all, in his drawings and lithographs that Lautrec succeeded in capturing a variety of sensations and impressions and in endowing them with an almost symbolic significance. In 1891, he designed his first poster for La Goulue, a famous dancer who worked at the Moulin Rouge (p. 117). The work was so successful that more commissions followed, and Lautrec posters of the singer Yvette Guilbert (p. 141), Jane Avril, and other well-known Montmartre celebrities were soon as highly regarded as the artist's paintings. As his style developed, Lautrec's line became drastically simplified, and he consciously reduced the multiple forms of objects to a few clear patches of flat color. At the same time, although employing only red, black, and yellow, he was able to create through line and color the vital essence of a scene.

The style of Vuillard's painting in the 1890' is in some ways comparable to that of his friend Lautrec, as we can see from his portrait of the latter (p. 129). He had entered the *École des Beaux-Arts* in 1886, the year of the last Impressionist exhibition, but he left after only two years to live and work with Roussel and Bonnard. Although Vuillard was attracted to Sérusier's new ideas, it is difficult to think of him as a Nabi or even as a Symbolist. He attended the celebrated Tuesday evening meetings at Mallarmé's house (p. 132), but he was much more involved in working out problems in his painting than in matters of philosophy or aesthetics. An attempt to put into practice the Nabi theory that "a painting is essentially a flat surface covered with colors arranged in a certain order" can be seen in an early work of Vuillard, *In Bed* (p. 131). This strange, almost monochromatic picture approaches the abstraction that Gauguin, Denis, and others spoke of. Only a few colors are employed—white, brown, gray, and a kind of creamy yellow—modeling is avoided, and, as if to stress the artificiality of the scene, the painter arbitrarily terminates the gray-walled background in such a way that it cuts off the top of a cross suspended over the sleeping figure. This, plus the painter's signature and date at the edge of the broad gray stripe point up Vuillard's insistence that the viewer recognize that he is not looking at a naturalistic scene.

Vuillard's later development, which led him to render the intimacy and charm of the external world in extremely decorative terms and subsequently, in old age, to return to a more traditional type of painting, moved far afield of the narrow parochialism of the Nabis.

The same independent spirit and many of the same models can be seen in Bonnard's development. Like Vuillard, he admired Gauguin, and through this admiration he came to love Japanese woodcuts. Of their expressive color and its impact on his own work, he wrote: "I realized thanks to these simple, popular pictures that color can express everything without need of relief or modeling. It seemed to me possible to render light, forms and characters by the use of color alone." His pictures, with their bright, luminous tones, fairly radiate the warmth of the sun as it fills an interior (p. 133). A quiet, shy man, he, like Vuillard, expressed skepticism of the theorizing of the Nabis. While still a young man, he maintained, "I belong to no school: all I aim to do is create something personal."

Pierre Bonnard, "Breakfast Room," p. 133

Henri de Toulouse-Lautrec, *Yvette Gilbert*, Chalk and Water Color

HENRI MATISSE

In 1892, an art student named Henri Matisse left his studies at a painting academy to enroll in the evening courses that were offered at the *École des Arts Decoratifs* (School of Decorative Arts). There he made friends with another young painter, Albert Marquet (1875—1947), and the two formed the nucleus of a group with common interests and a new sense of purpose. Both Matisse and Marquet were anxious to be accepted as pupils in the *École des Beaux-Arts*. They were anxious to achieve the kind of official recognition that other young artists had tried to attain in the past, and, as had so many before them, they encountered obstacles. Matisse was the first to realize his ambition of being accepted by the *École*. Gustave Moreau (1826—98), the most popular teacher in the school by virtue of his liberal attitudes and genuine interest in his students' work, saw some of Matisse's drawings and accepted him as a pupil without the required examination. Ironically, the influential role that the *Académie Suisse* had played as a training ground for radical painters in the 1850's and 1860's was now assumed by an official class in the august *École*. There, Matisse met Georges Rouault (1871—1958), Moreau's favorite pupil, and when Marquet finally entered the class in 1897, Matisse introduced him to his new friend.

Moreau conducted his classes informally. He left his pupils free to discuss all of the contemporary trends in painting, guided them with a light hand, and allowed them considerable free time to pursue their own studies in the Louvre and in the streets of Paris. His sudden death in 1898 caused great distress to his best pupils, who were thrown out on their own and were forced to develop without the master's guidance. Some, like Matisse and Marquet, missed the experience of making studies from the nude model, and for this reason they decided to enter a private art school. There they attracted considerable attention with their strong opinions and began to find sympathetic ears among the students. One of these, André Derain (1880—1954), became an intimate of Matisse and later introduced him to a strange itinerant musician and painter, Maurice de Vlaminck (1876—1958).

Vlaminck was a habitual loner who alternately argued and painted with Derain, but who was unimpressed by the theories of the Paris painters that the latter recounted to him. Although there was no formal group comparable to the Nabis, the painters met informally, and one could say they shared common enthusiasms and met for joint study in the studio of another young artist, Henri-Charles Manguin (1874—1943). The first event that really united the young painters was the memorial exhibition for Vincent van Gogh in 1901. Even Vlaminck appeared at the gallery, although he had proclaimed his intention of developing a completely independent style and used to boast that he had never once set foot in a museum. The almost savage vitality and uncompromising sincerity of

van Gogh's pictures impressed Vlaminck deeply. He praised van Gogh for the expressive power of his line and, in typically dramatic fashion, maintained that he "loved van Gogh more than [his] own father."

Between 1901, the year of the van Gogh memorial, and 1905, the year of the *Salon d'Automne* (Autumn Salon), a number of things happened to make art-lovers aware of the new trends. The loosely knit group of painters gathered around Matisse came to recognize him officially as their leader and later began to call him "Doctor" or "Professor," not only because of his intelligence and maturity but also because of his elegant, scholarly appearance. During this same period, two other students came to Paris to continue their art studies. While initially independent of the group around Matisse, both Raoul Dufy (1877–1953) and Georges Braque followed in the footsteps of the latter when they combined training in decorative art with the study of the nude model. Later, both painters were decisively influenced by Matisse's bold use of color.

Henri Matisse, *The Harbor of Collioure*, Watercolor

THE SALON OF THE "WILD BEASTS"

On several occasions, we have spoken of the importance of the Salon and of the dreams of unknown artists to have their paintings accepted for official exhibitions, in the hope of achieving public recognition. We have seen how the constitution of the juries, their narrow prejudices and determination to maintain an artistic *status quo* led individual artists such as Courbet and Manet, and later groups of painters, such as the Impressionists, to find their own means of establishing contact with the public. The painters who were finishing their training at the turn of the century encountered the same difficulties when they tried to show their work to critics and collectors. The discontent of a large number of painters had led to the formation of an independent Salon in 1884, in which anyone who regarded himself as a painter might participate. Many important painters took part in this *Salon des Indépendants*—Seurat had his first public showing in the initial exhibition, and Matisse and his friends also owed their first opportunity to display their works to its continuing existence. But the *Salon des Indépendants* was plagued by problems, the most serious of which was the level of quality of the pictures, which, because of the easy admissions policy, became lower and lower.

The founding of a new, independent salon called the *Salon d'Automne* (since it was held later in the year than the official Salon) was intended to correct this unfortunate situation. Its purpose was to present to the public an intelligent selection of works that would provide a true reflection of the various tendencies in contemporary painting. Its fairness in representing all shades of artistic viewpoints was borne out in the group of artists who were its founding members: Impressionists, Nabis, independents, and the Matisse group found spokesmen in Renoir, Denis, Vuillard, Rouault, and Marquet.

Odilon Redon, "Vase of Flowers," p. 115

The *Salon d'Automne* was important in presenting to the public a large selection of the paintings of the Symbolist painter Odilon Redon (1840—1916) (p. 115) and the great recluse of Provence, Paul Cézanne. The latter had an entire roomful of paintings in the exhibition of 1904, and these proved to have a decisive influence on such younger painters as Braque and the Spaniard Pablo Picasso (1881—).73

The exhibition of 1905 was noted for the sensational comment that centered around Matisse's group. Their pictures were hung with literally hundreds of others, and it is hard to imagine how they attracted so much attention. Painters of the older generation, such as Renoir, exhibited along with the newcomers, and the exhibition, as a whole, was far from avant-garde, although one of its innovations was the appearance of two Russian artists working in Germany, Wassily Kandinsky and Alexis Jawlensky (1864—1941). These two would shortly change the face of contemporary Germany painting with their brilliant color abstractions, and it is safe to say that they received considerable impetus for their own development from their contact with Matisse's circle.

Henri Matisse, *Landscape at Collioure*

Henri Matisse, *Luxe, calme et volupté*

Left: Maurice de Vlaminck, *Père Bouju*

On the following pages:
Albert Marquet, *Pont Neuf*
Albert Marquet, *View of Naples*

Henri Charles Manguin, *St. Tropez: July 14, 1905*

Left: Kees van Dongen, *Anita with a Green Pendant*

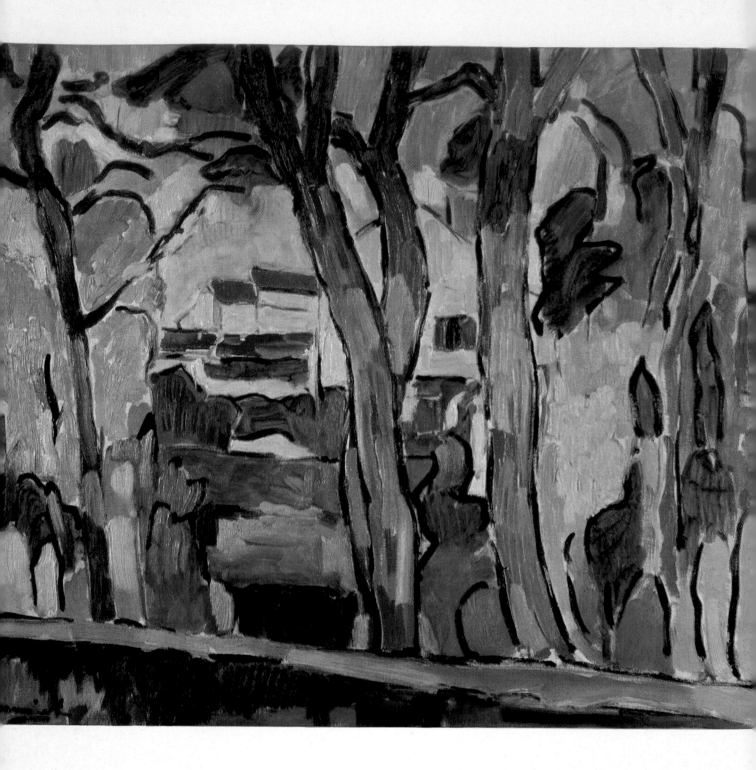

152 Maurice de Vlaminck, *Landscape with Red Trees*

Despite the size of the exhibition and the overpowering assortment of personal and group styles, the public's eye was caught by the intense colors of Matisse and his friends. A critic, Louis Vauxcelles, was inspired by the paintings to describe the artists as Fauves, or wild beasts, and this term was quickly adopted to describe the group style. Although all the pictures were not hung in the same room, the phrase *cage aux fauves* (cage of wild beasts) could justifiably be applied to the room that contained the works of Matisse, Marquet, Manguin, Derain, and Vlaminck. Despite all of the changes that had taken place in French painting, some critics were shocked by the savage force of the colors. The reaction of one of the newspaper critics—"They have flung a pot of paint in the public's face"—summarizes the general attitude of those who came to view such works as Matisse's "Luxe, calme et volupté" (p. 147), his portrait of his wife called "Woman with the Green Stripe" (p. 136), or Vlaminck's "Père Bouju" (p. 146). Matisse's portrait was easily one of the most sensational works in the exhibition. Its vertical slash of sickly yellowish green, proceeding from a mass of heavy blue-and-black impasto, seemed to divide the sitter's face into two distinctly different parts—one in full light, the other in partial light. The strident, flat colors of the face, dress, and "background" create a unique design, in which the color dissonances clash with one another and seem to strike out previous notions of color harmony. Although the critic and art historian Elie Faure had written a preface to the exhibition catalogue, in which he tried to place the various trends represented in the Salon within a historical perspective, most reviewers ignored his helpful and sage observations. Referring to the two great retrospective shows organized that year for Ingres and Manet, Faure urged his reader to realize that:

> These two painters, with all their reserve, assure us that the revolutionaries of today are the classics of tomorrow. . . . In order to meet the young generation of artists here [in the Salon], we must have the freedom to hear and understand a new language. Let us remember that the hero is always covered with ridicule by those to whom he extends his hand, and let us reflect before we laugh.

There were, of course, some connoisseurs who were prepared to reflect and even to comprehend the significance of the new painting style. Vauxcelles himself devoted a lengthy article to the Salon and to the contributions of Matisse's group. The critic had, in fact, followed the young painters' progress for some years, and he had noted their individual characteristics when they had exhibited in the *Salon des Indépendants*. While his review of the 1905 exhibition for the newspaper *Gil Blas* covered all the paintings, it discussed the work of the revolutionaries in detail. The works in Room VII, the *cage aux fauves*, inspired Vauxcelles' greatest enthusiasm:

> A room of excessive clarity; daredevils and hotheads whose artistic purposes one must try to discover while allowing clever but silly

Henri Matisse, "Luxe, calme et volupté," p. 147, "Woman with the Green Stripe," p. 136
Maurice Vlaminck, "Père Bouju," p. 146

153

people the right to laugh and indulge in all too obvious criticism. The painters under discussion are Marquet and several others from the *Salon des Indépendants* who form as close and brotherly a group as Vuillard and his friends did in the previous generation. Let us first speak of Matisse. He has courage, for, as he knows, his fate is destined to resemble that of a Christian maiden thrown to the lions. Matisse is one of the most talented painters of the day, and he could have scored an easy success; but he was preferred to aim for greater depth.

Vauxcelles went on to describe the especially brilliant coloring of Derain's paintings and the almost poster-like effects he achieved with his use of strong, complementary hues. He praised the work of Vlaminck, with its almost vicious brushstrokes, and the pure, expressive color of Matisse and Manguin (p. 151). Finally, at the conclusion of his discussion of the Fauvist painters, he dropped a remark that was soon repeated in every café and studio in Paris: "In the middle of the room we find the bust of a child [below] ... a small marble bust modeled with unobstrusive skill ... The ingenuousness of [this bust] comes as a surprise amid the orgy of pure tones, like a Donatello among the wild beasts."

Henri Charles Manguin, "St. Tropez: July 14, 1905," p. 151
Albert Marque, "Bust of Jean Baignères," p. 154

Albert Marque,
Bust of Jean Baignères
(Donatello Among the Fauves)

154

Albert Marquet, *Lamplighter*, Brush Drawing

The *Salon d'Automne* of 1905 marked a decisive moment in the assertion and clarification of the aims of the new Fauvist style, but it scarcely marked the beginning of a coherent, tightly formulated style. The "orgy of color" that Vauxcelles had commented on was the result of many influences that had grown and crystallized over a number of years. We can point to many sources, starting with Seurat and van Gogh. The latter had an especially decisive influence on one of the later members of the group, Kees van Dongen (1877—1968) (p. 150). Of Belgian origin, this painter, like van Gogh, was largely self-taught, and although he had contacts with Matisse's group, he remained a rather solitary figure. His style combined the strong colors of the Fauves with the vigorous, exaggerated brushwork of van Gogh.

Critics and collectors alike regarded Matisse as the primary inspiration for the new style. In 1904, he was first hailed as an innovator, although his work at this time still reveals the influence of Seurat's color theories. His painting, "Luxe, calme et volupté" (p. 147), which took its title from a celebrated poem by Baudelaire, provoked a strong reaction among the critics and painters who viewed it in the *Salon des Indépendants*. Many traditionalists raised the objection that color was being used as an end in itself; others pointed to Matisse's personal variation of Seurat's divisionist technique. The picture won a further convert to the doctrine of pure color

Kees van Dongen, "Anita with a Green Pendant," p. 150

155

André Derain, *Street Scene*, Water Color

in Raoul Dufy, who had previously had only sporadic contacts with Matisse's circle. Twenty years after viewing the work, he wrote: "Looking at this picture, I understood all the new motives of painting: impressionistic realism lost its charm for me in comparison with that marvel of imagination conjured up by design and color." A similar effect was noted a year later by Braque at the *Salon d'Automne*, when he saw for the first time the group of Fauvist paintings. Both artists quickly assimilated what they had seen, and the pictures that Braque painted during the summer of 1906, and those that Dufy produced under the influence of Marquet, attest to the importance of Fauvism in their development.

What were the individual characteristics that marked the color revolution known as Fauvism? Was there really a Fauvist style with common roots and sources? Certainly, the members of the group shared a common background of artistic education at the *École des Beaux-Arts*, where they absorbed many traditional ideas. At the *École*, they were confronted with the views about the importance of design and technical preparation that had dominated its instruction since the early nineteenth century. They also were made to face the facts of life—professionally speaking. They recognized that official success could only be achieved by subordinating the new ideas that they encountered in the cafés and studios to the rigid discipline of the *École*. This meant the rejection of anything even vaguely new. Impressionism, for example, while scarcely revolutionary, was not totally respectable. No Impressionist taught at the *École*, and

the example of the Impressionists' struggle was still fresh enough to inspire their own dreams of independence.

If we wish to cite individual painters whose work encouraged the young men's experiments, we return again and again to the same names: Seurat, van Gogh, Gauguin, and Cézanne. The study of the development of the Fauvist painters reveals more clearly than that of any other movement the importance of these pioneers and their contributions to modern art. No doubt the Fauves came to know and appreciate van Gogh's work during their early years of training in Paris; but they probably did not grasp the full significance of his style until it was masterfully revealed in the great commemorative exhibition of 1901. The strong interest that the Fauves took in van Gogh is pointed up by the fact that three of them—Matisse, Derain, and Vlaminck—met accidentally at the exhibition on the same day. However much they admired his violent brushwork and swirls of pure color, they were virtually unaffected by the psychological content of his pictures. What interested them was not the painter's confrontation with nature and his subsequent emotional reaction to it, but rather the creation of more abstract color moods.

Perhaps this last factor drew them to the work of Georges Seurat, which was also given a retrospective exhibition in that decisive year, 1905. Ever since his early death, Seurat's color theories had provided the basis

Albert Marquet, *Street in Hamburg*, Brush Drawing

for discussions among the avant-garde painters. The publication of Paul Signac's book *From Eugène Delacroix to Neo-Impressionism*, in 1899, served to promote the legend of Seurat even more, and the young men of Matisse's generation saw his work as a link in the chain that began with the Impressionists and was completed by them. Matisse was the first to read Signac's book and absorb his ideas, although the effect of his reading was not felt until the summer of 1904, when he and Signac met and painted together in St. Tropez. Matisse's "Luxe, calme et volupté" (p. 147), which was painted the following winter and which so astonished visitors to the *Salon des Indépendants*, testifies to the effect of Seurat's theories. It is interesting to note that Signac purchased the picture from the Salon.

The following year, Matisse and Derain visited the artist and collector Georges Daniel de Monfried (1856–1929) at Collioure, in the south of France. There they saw for the first time the last pictures Gauguin had sent from the South Pacific to his friend and patron. These paintings not only gave Matisse the opportunity to study Gauguin's "orchestration of color" at first hand but also, through them, to realize the expressive possibilities inherent in line. We may recall that Gauguin had spoken of his method of composing pictures in the following manner: "By the combination of lines and colors, using the pretext of some motif taken from life or nature, I create symphonies and harmonies...which are intended to give rise to thoughts, as music does, without the aid of ideas or images." Matisse went even further with this concept, stating: "When I have discovered all of the relationships of tones, they must combine to produce

Henri Matisse,
Reclining Nude,
Pen Drawing

Paul Cézanne, *Landscape*, Pencil Drawing

a living chord of color, a harmony analogous to musical composition."

Matisse painted a landscape souvenir of his visit to de Monfried's home (p. 145), and this work embodies some of the principles he was beginning to develop. The intense dots of color so striking in "Luxe, calme et volupté" (p. 147) gave way to a more subtle, exotic palette, and the brush-stroke employed alternatives between crisscrossing slashes of color and swirling lines. The painting presents color harmonies as a symbol of visual reality rather than as an accurate, objective report, and in this we must recognize the effect of Gauguin's views. In retrospect, we can say that the common attitude of Matisse and Derain toward color brought them closer together at this time than any other members of the group.

Matisse began to move further and further away from the violent color and crude or nonexistent drawing of his Fauvist period, in order to concentrate on the realization of a perfect, harmonious design. In his later style, he returned to his roots as a decorative artist, and, in a real sense, he may be considered the decorative artist *par excellence* of the twentieth century. Within six years of "Luxe, calme et volupté," he was to create such masterpieces of line and color as "The Red Studio" and "The Blue Window," the very titles of which betray the painter's interest in achieving a new kind of pictorial unity based on color. Speaking some years later of Impressionism, the great painter seemed to be summarizing his own aims: "Behind the succession of moments ... we may seek a truer, more essential character of things, on which the artist will base himself in order to give a more permanent interpretation of reality."

Henri Matisse, "Landscape at Collioure," p. 145

159

THE DECLINE OF FAUVISM

Today we tend to regard the primary importance of the Fauvist movement as that of a liberating force that enabled painters to develop more fully the wide range of expressive and decorative potentialities inherent in color. The influence of the Fauves outside of France was considerable, especially in Germany, where the contemporaries of Matisse, Derain, and Vlaminck were developing a style known as Expressionism, in which color played a vital part. However, in the development of such individual painters as Matisse, Dufy, or Braque, the Fauvist period was a comparatively brief one, lasting, at best, not more than a few years. We have noted that the *Salon d'Automne* of 1905 marked the peak of Fauvism, in terms of its critical importance, but within two years, a distinctly different force was felt in the art world, which soon overwhelmed the pure color movement. The death of Paul Cézanne in 1906 prompted the charter members of the Salon to organize a large memorial exhibition of his work. Cézanne's reputation was, by this time, almost legendary. From the time of the notable exhibition at Vollard's, in 1895, his artistic importance was increasingly acknowledged. Pissarro had written to his son in a mood of great enthusiasm:

> ... there are such exquisite things: still lifes of unblemished perfection and others, more beautiful still, which are not finished though they have been worked on a great deal; landscapes, nudes, unfinished heads that are really magnificent [p. 159]. ... Strangely enough, as I was admiring this wonderful, astonishing aspect of Cézanne that I had been aware of for so many years, Renoir came along, and my enthusiasm was nothing at all compared to his! Even Degas experienced the charm... and so did Monet. Can we be wrong? I think not. (Camille Pissarro, *Letters to His Son Lucien*, ed. John Rewald, trans. Lionel Abel, New York, Pantheon Books, 1943.)

From the middle of the 1880's until his death in 1906, Cézanne's style had moved away from Impressionism, which had first attracted him, to a concern with the permanent forms of nature—concern that was obviously the antithesis of Impressionism. During this exceptionally prolific period, Cézanne was constantly searching for the correct subject or motif that might allow him to project his perception of nature. In addition to a considerable number of landscapes, he produced famous series of card-players, bathers, and, of course, still lifes. In the latter group, especially in paintings produced between 1895 and 1900 (p. 165), he could arrange the objects in a specific fashion and then concentrate on rendering the essentials of their individual forms. His colors are carefully modulated, so as to bring out the plastic, almost sculptural properties of the objects depicted. No one could describe them as sensual or really eyecatching; instead, they seem to have been chosen for the purely objective purpose of communicating the material sense of the weight of the

Paul Cézanne,
"Still Life," p. 165

160

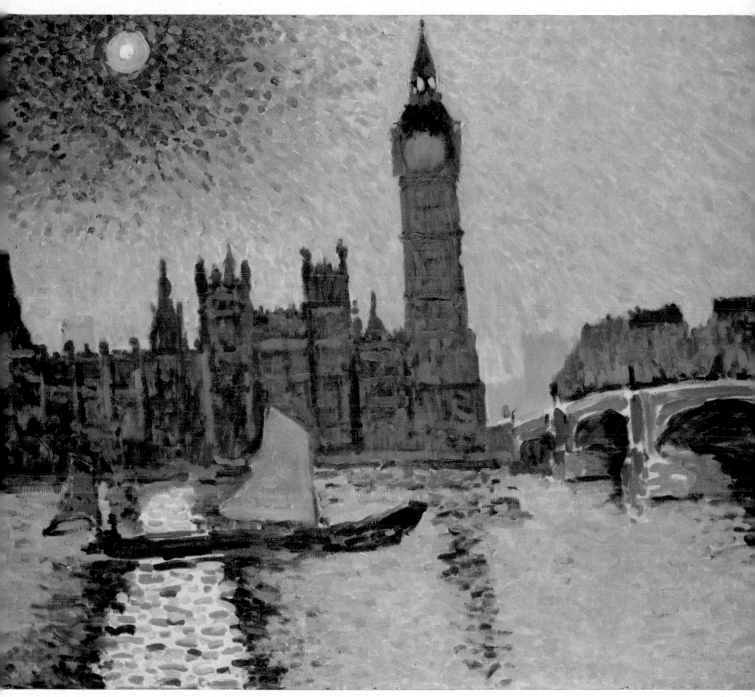

André Derain, *Houses of Parliament, London*

1905.

SUNSET IN LONDON

On the following pages:

Raoul Dufy, *Billboards at Trouville*

Georges Braque, *Harbor with a View of L'Estaque*

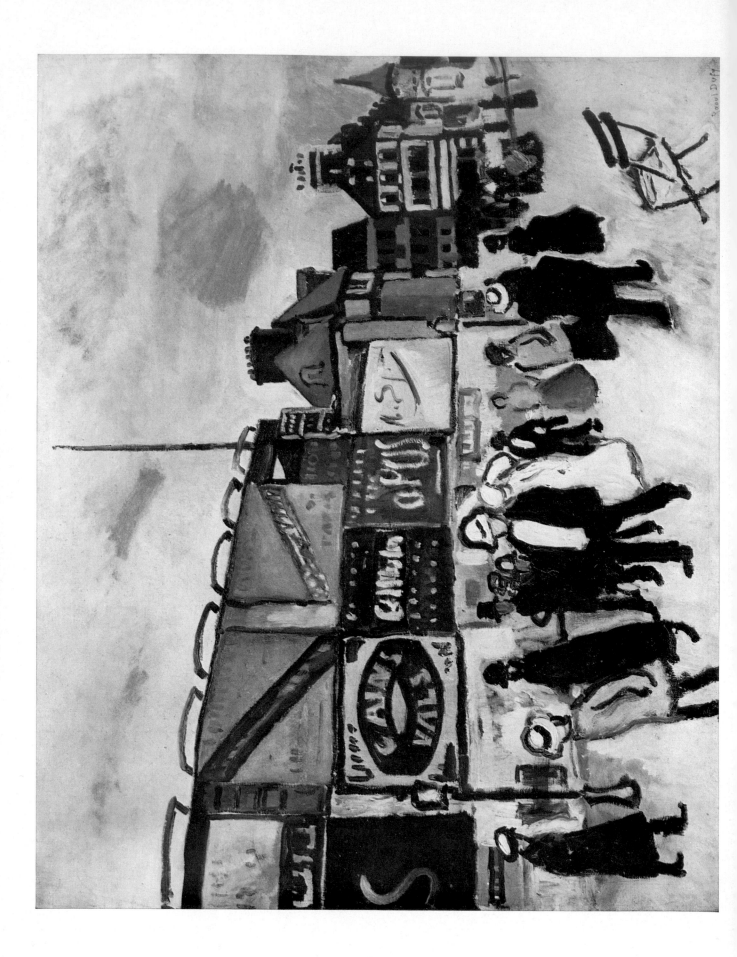

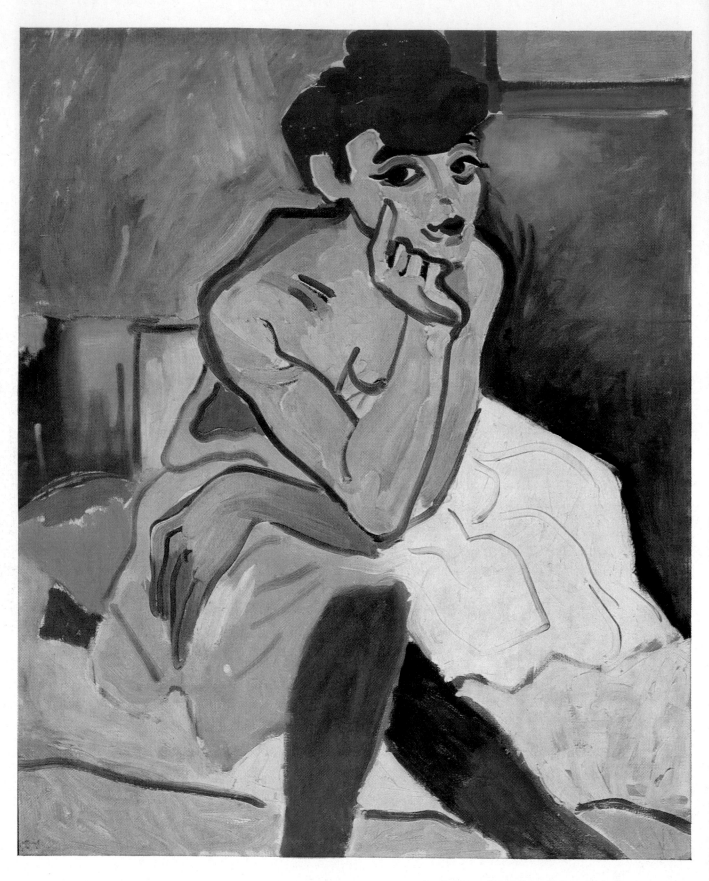

André Derain, *Woman in a Chemise*

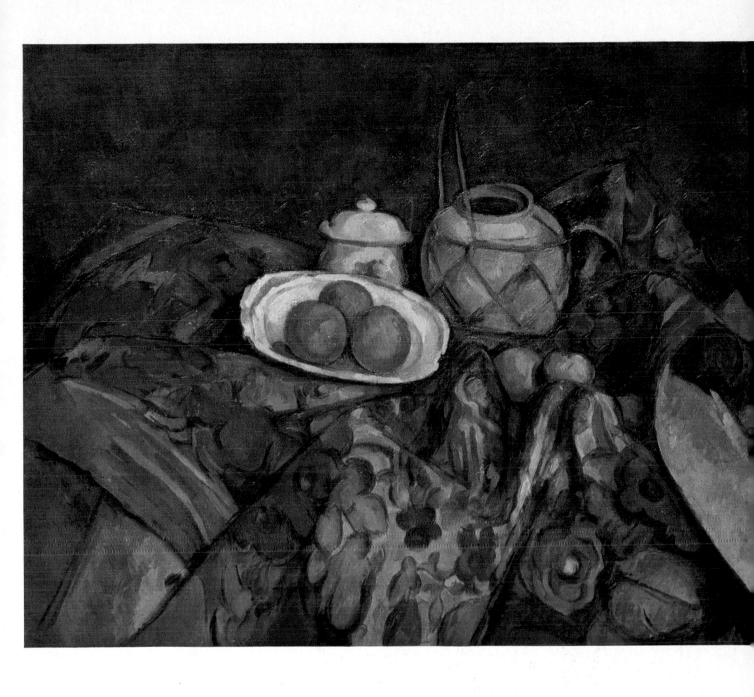

Paul Cézanne, *Still Life*

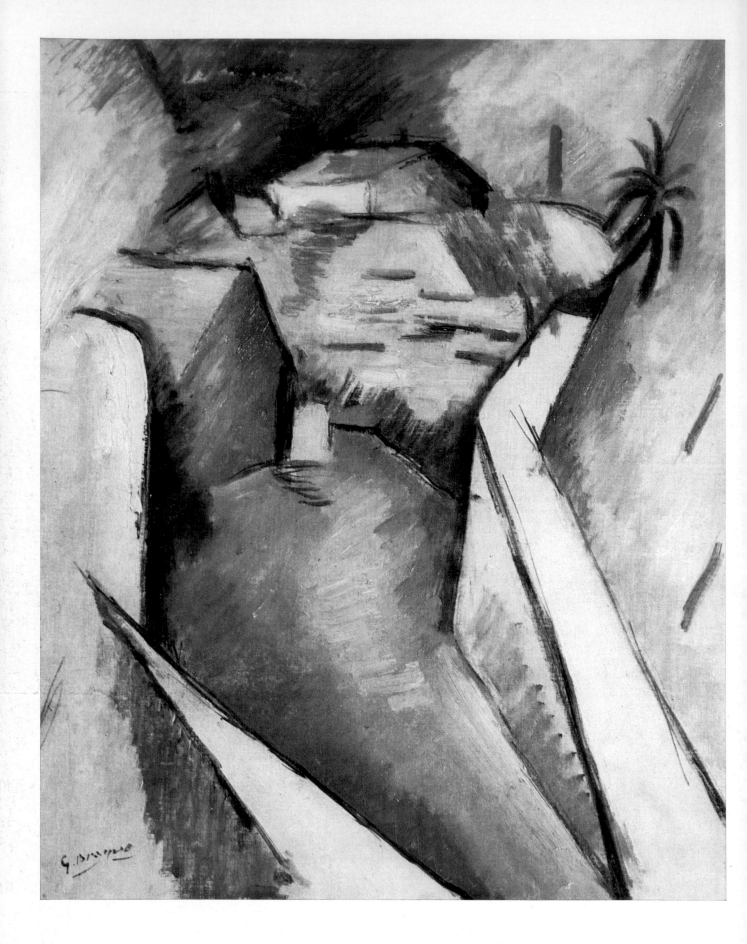

Georges Braque, *Landscape*

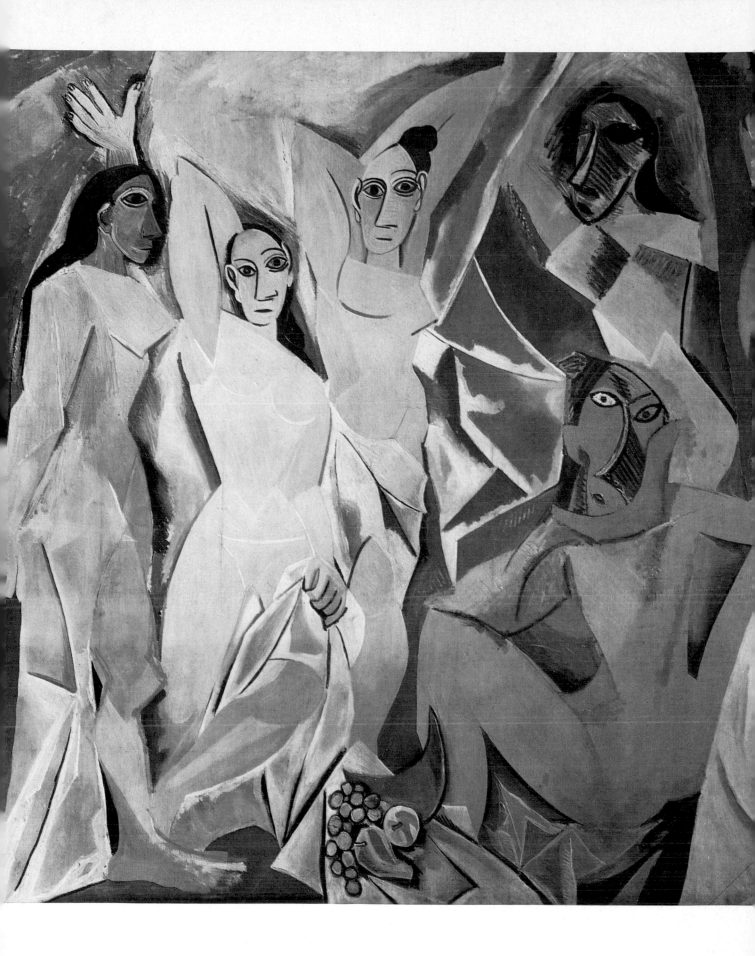

Pablo Picasso, *Demoiselles d'Avignon (Young Ladies of Avignon)*

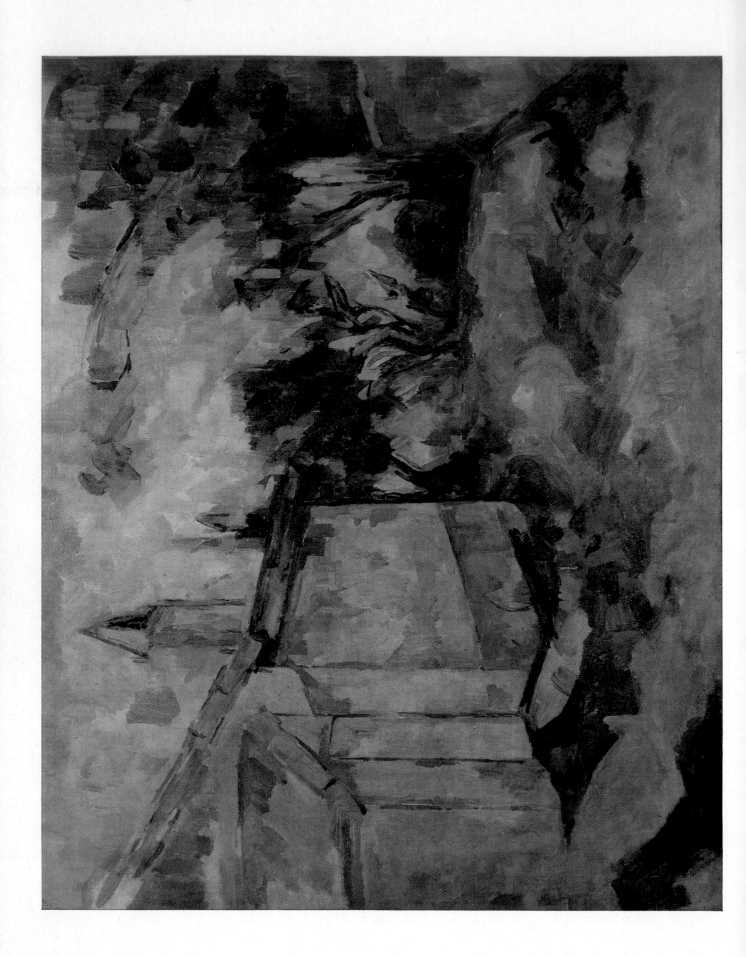

pot or orange and not its tactile quality. Looking at one of these still lifes, the viewer becomes aware of the distinctly geometric properties of the objects, whether they are round bowls of fruit, teapots, or the pyramidal forms of the tablecloth. One can see how Cézanne's search for permanence in nature prompted him to distill a visual experience—cutting away all of the unnecessary details to present the order that existed.

In his last years, his paintings achieved a kind of classic calm similar to that of the great seventeenth-century academician Nicolas Poussin, for whom Cézanne had expressed admiration. While Poussin had created compositions of complete harmony and tranquility, because his model was the highly selective idealized art of the High Renaissance and his subject matter was drawn from ancient history and mythology, Cézanne's achievement was not dependent on literary sources but rested entirely on the painter's study of nature. In his last landscapes, for example, the "Cabanon de Jourdan" ("Cottage of Jourdan") (p. 168), which was still unfinished at the artist's death, he constantly strove to realize or "concretize" his visual experiences. His simplified palette and severe geometric forms come very close to the abstraction that was to Paul Cézanne, "Cabanon de Jourdan," p. 168 mark the work of the painters who took up his advice to "treat nature by the cylinder, the sphere, the cone." While Cézanne did not enjoy discussing his theory of painting, he wrote a number of important letters to artist friends, to collectors, and to his son. Many of his most interesting ideas can be found in the letters to Émile Bernard, who had visited him in Aix-en-Provence in 1904, and who never ceased to prod the old painter to express his views. On one occasion, a year before his death, Cézanne responded to one of Bernard's notes, first thanking him for giving him the opportunity to describe his quest for visual truth and thus clarify it for himself, and then explaining his last works:

> Now being old . . . the sensations of color, which gave light, are the reason for the abstractions which prevent me from either covering my canvas or continuing the delimitation of the objects when their points of contact are fine and delicate; from which it results that my image or picture is incomplete. On the other hand the planes are placed one on top of the other from whence neo-impressionism emerged, which outlines the contours with a black stroke. *Paul Cézanne's Letters*, ed. John Rewald, trans. Marguerite Kay, London, Bruno Cassirer, 1941.)

Looking at Cézanne's pictures and reading his words, one can begin to understand how, virtually overnight, the Fauves came to develop a new respect for form that led them to de-emphasize color almost to the point of denying its existence. Nor were they alone in their enthusiastic assimilation of Cézanne's message. Among the many young painters who made a pilgrimage to the memorial exhibition was one whose work would radically affect the course of twentieth-century art: Pablo Picasso.

Paul Cézanne, *Cabanon de Jourdan (Cottage of Jourdan)*

CUBISM: THE LEGACY OF CÉZANNE

Georges Braque,
"Harbor with a View
of L'Estaque," p. 163,
"Landscape," p. 166

By comparing two paintings by Georges Braque, "Harbor with a View of L'Estaque" (p. 163), from 1906, and a landscape done in the following year (p. 166), we can see how Cézanne's painting affected an artist of the Fauve generation. In the earlier work, executed in an area near Marseilles where Cézanne loved to paint, we see the more willful color and freer brushstroke that characterized the work of other painters in the Matisse circle. In the later landscape, a tremendous change has taken place. The colors in the artist's palette are drastically limited to ochre and green— virtually identical to those which Cézanne employed in his last pictures. Lines are severe, and the entire painting seems to express a new interest in formal and spatial relationships and their reconciliation with the two-dimensional surface of the canvas. While the earlier picture has virtually discarded traditional means of illusionism, the forms depicted in the 1907 landscape approach that essential geometry which Cézanne tried to attain.

When Braque submitted one of the views of L'Estaque that he had painted in 1908 to the *Salon d'Automne* of that year, there was considerable consternation among the members of the jury. Matisse informed the critic Vauxcelles that Braque had offered pictures "made of little cubes," a phrase that the critic recalled later when describing Braque's stylistic development.

All of this had been prefigured in Cézanne's painting. As a natural result of his desire to replace the verisimilitude of traditional perspective and modeling by a more radical system of color patches, Cézanne was led to a closer examination of the physical properties of objects. This, at first, created some confusion. In his view of the "Cabanon de Jourdan" (p. 168), it is difficult to form a clear idea of the spatial relationships of the various parts of the building, for, as Cézanne had stated a year previously, "the planes are placed one on top of the other." Where do the foundations begin, and how is the small, incomplete tower connected to the roof? Apart from its color, does the tower really exist as an independent architectural feature from the complementary blue patches of the sky? The world of unique objects is so completely overwhelmed by the rhythm of the flat patches of color that these questions seem pointless.

Pablo Picasso,
"Demoiselles
d'Avignon," p. 167

In the summer of 1907, scarcely a year after the completion of Cézanne's last painting, the twenty-six-year-old Pablo Picasso painted his epoch-making "Demoiselles d'Avignon" ("Young Ladies of Avignon") (p. 167), and this picture heralded the end of an era. The picture's superficial lack of unity, its harsh, arbitrary coloring, and its total rejection of the formal and spatial ideals that had dominated official painting in France since the seventeenth century, merit for it the designation of "manifesto of modernism." Looking at it, we can see that Picasso tackled the age-old problem that had confronted all great painters: namely, how to resolve the conflict between the three-dimensional world of visual perception and the two-dimensional world of painting. Picasso, along with many

170

of his predecessors, rejected the convention of scientific perspective that had dominated official painting for many years. He tried to capture the impact of the human body in space without attempting to conceal the discrepancy between visual reality and the flat surface of the canvas. His three standing figures are virtual geometric caricatures of classical nudes, and the general integrity of body is denied by the fracturing and shattering

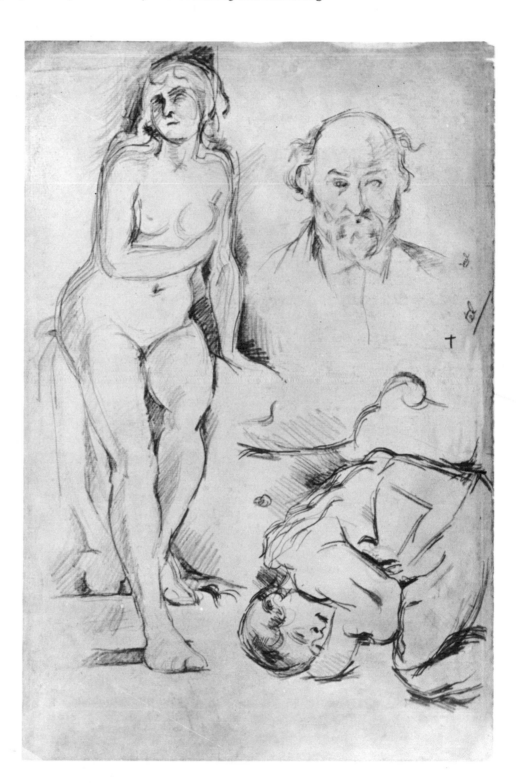

Paul Cézanne,
Figure Studies,
Pencil Drawing

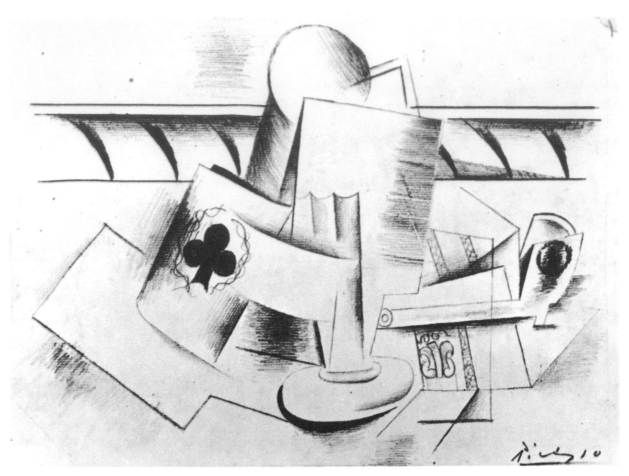

Pablo Picasso, *Still Life With Playing Card*, Pencil Drawing

of forms. So much so, in fact, that a critic likened the canvas to a "field of broken glass." Picasso no longer presents a comfortable world mirroring the visual conventions of our own, but gives us a completely independent, vibrant analysis of the physical that we so easily take for granted.

Picasso's revolutionary picture marks the end of a development that began with the opposition of Ingres and Delacroix. While recognizing the obvious and indisputable influence of Cézanne on Picasso, both in his choice of nude females and in his approach to form (compare the angularity of the drapery in the "Demoiselles" [p. 167] with the late Cézanne still life [p. 165], or the almost crude simplification of a female figure in a Cézanne pencil sketch to the more intensive, studied primitivism of Picasso's nudes), it is difficult to look at the "Demoiselles" without seeing it in terms of the development of nineteenth-century French painting. Trying to place it within a historical context, one must think of such related works as Matisse's "Luxe, calme et volupté" (p. 147) or his "Joy of Life," both partially inspired by Cézanne's studies of bathers, Manet's "Déjeuner sur l'herbe" (p. 50), and, ultimately, Delacroix's "Women of Algiers" and Ingres' odalisques and bathers, wherein the initially opposing doctrines of early nineteenth-century French painting were repeatedly articulated. It seems probable that Picasso's choice of subject matter—a group of nude females—was based on his recognition that this theme still

represented the most perfect expression of an artistic ideal in the eyes of the public, although it must be acknowledged that the young ladies of Avignon referred to in the title are not inhabitants of that French city but of a street in a disreputable part of Barcelona. Picasso's work also reveals the influence of important non-French, non-European sources: Vlaminck had first discovered the art of the African peoples, and Picasso was quick to utilize the geometric distortions of West African sculptures to heighten the expressive quality of his own forms.

In his absorption with the human figure, his analysis of the structural properties of objects, Picasso stands apart from the painters of light and color. With him, Corot's notion of the "first impression" was consigned to oblivion, and art was subsequently dominated by the more analytical and intellectual concerns that marked the rise of Cubism.

Pablo Picasso, *Study of a Head*, Pen Drawing

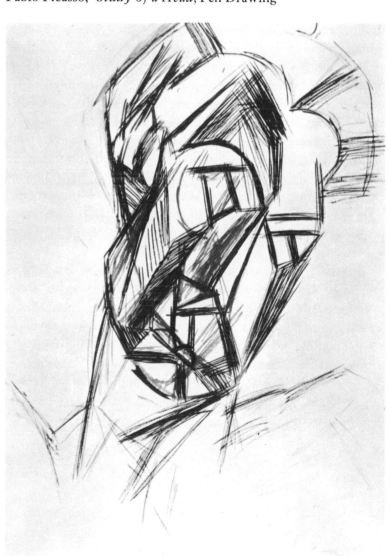

CONCLUSION

This brief survey of the various developments of painting in the nineteenth and early twentieth centuries has attempted to identify and describe the principal sources of what we today call "modernism." In so doing, we have placed considerable emphasis on the painters who worked directly from nature, *en plein air*. We have tried to show how they came to adopt an entirely new attitude toward subject matter and how, by virtue of their gradual liberation from the tyranny of the rules and regulations of the Academy, they developed new techniques and a radically new concept of the nature and function of art in society. While the painters of the Renaissance and Baroque had labored for the greater glory of God or the lesser glory of princes, the men of nineteenth-century France worked primarily for themselves, that is, for the realization of certain artistic principles. Deprived of the security of the age-old patronage system, they were able to break new artistic ground. The arguments that raged in Paris studios were not, for the most part, like those which had dominated the artistic criticism of the past—about the importance of an ennobling, or at least instructive, type of theme—but rather were concerned with the fundamental understanding of the discipline of painting. The systematic study and emancipation of color and line from their traditional function of modeling or describing naturalistic scenes were accomplished only over a period of years, and with the contributions of many artists of extraordinary vision. We have discussed these contributions, especially as they reflected the importance of the great pioneers: Manet, Monet, Seurat, van Gogh, Gauguin, and Cézanne. We have seen how each evolved a personal style as the result of a desire to see nature in a truer or more complete way, and how important a role the study of color and light played in their works.

The journey from Delacroix and Ingres to Picasso is a long one, and the road one follows is by no means straight and narrow; but the pieces begin to fall into place if one views the great artistic controversies of the nineteenth century not in absolute terms but rather as part of a continuing intellectual dialogue, which even today engages painters and all creative people. Such questions as the ever changing nature and functions of art are still as fascinating to the young painters and writers of Paris, New York, or London as they were to the confident upstarts who gathered at the Café Guerbois in the 1860's.

GLOSSARY

Abstract art

Painting or sculpture which depicts forms and colors in compositions of a non-representational or geometric character, and in which the aesthetic value resides in the arrangement of the shapes and colors and not in any literary or other associative context.

Aesthetic

Sensitive or appreciative to art and beauty. The word is generally used to describe a philosophy of beauty.

Complementary colors

Colors that are opposite one another on a color chart or diagram.

Contour

The visible border or edge of a mass in space.

Cool colors

Blue, green, and violet. Their respective opposites— red, orange, and yellow—are called warm colors.

Cubism

An early twentieth-century movement in painting which was concerned with re-examining the picture surface and with analyzing forms and their inter-relationships. In order to provide an account of the structure of an object, Cubists were led to abandon the representation of objects as they appear, thus paving the way for other abstract art movements.

Expressionism

An individual tendency and, later, a group style of painting, in which the artist presents his subject matter in subjective, emotional terms rather than in factual, objective terms.

History painting

Painting whose subject matter is derived from historical or biblical events or from events described in various other types of ancient classical sources. From the Renaissance through the early nineteenth century, this type of painting was more highly regarded than any other kind.

Lithography

A graphic technique in which a design is drawn on a stone with a grease crayon and then the stone is bathed with water. When greasy ink is rolled onto the stone, it will not adhere to the wet parts but only to those portions which have been drawn on with the crayon, thus producing a design. A virtually unlimited number of prints can be made from a good stone.

Neo-Classicism

A painting style popular especially in France, Italy, and England during the late eighteenth and early nineteenth centuries. Its subject matter consisted mainly of ancient history or mythological subjects, and the manner of execution was often severely linear. It differs from other classically inspired movements in that artists were often inspired to imitate directly the ancient artifacts that had been excavated in the southern Italian centers of Pompeii, Herculaneum, and Paestum.

Perspective

A system or formula for representing on one plane the illusion of distance or distant objects. In *aerial* perspective (an older system used throughout the modern era), objects supposedly nearer the viewer are depicted in sharp detail, whereas objects farther away are painted in a blurred or indistinct manner. *Linear* or mathematical perspective employs a horizon and a single vanishing point, toward which parallel lines are drawn to create the illusion of three-dimensional space.

Painterly

A quality of some paintings, in which the paint itself and the gesture of the brushstroke become the main vehicles for the expression of ideas or feelings. Usually, outlines are projected less clearly and the execution seems summary, as if the painter employed a kind of "shorthand," in which one stroke might do the work of many.

Plein air

Literally meaning open air, it refers to those painters who sought to capture effects of light and air not visible in the studio.

Rococo

An airy, bright style of painting that utilizes curvilinear patterns to project essentially artificial situations. The Rococo style developed, especially in France, during the first half of the eighteenth century.

Still life

Paintings of flowers, fruit, vegetables, or other objects, usually arranged on a tabletop or ledge.

Symbolists

A group of writers and painters, prominent especially after about 1880 in France and Belgium, who reacted strongly against naturalism and celebrated the exotic, the mysterious, and the spiritual. They hoped, through their theories and through their participation in group works, to create a universal or all-embracing art form.

Tableau vivant

A representation of a scene showing a person or group of persons appropriately costumed and posing silently, without moving.

Tectonic

This term, or the term architectonic, usually refers to a composition of seemingly monumental grandeur and stability.

Tonal values

An emphasis on contrasts of light and dark values rather than on contrasts of color.

BIBLIOGRAPHY

Holt, Elizabeth. *From the Classicists to the Impressionists. (A Documentary History of Art, Vol. III.)* Garden City: Anchor Books, 1966.

Nochlin, Linda. *Impressionism and Post-Impressionism 1874–1904.* ("Sources and Documents in the History of Art Series.") Englewood Cliffs: Prentice Hall, 1966.

———. *Realism and Tradition in Art 1848–1900.* ("Sources and Documents in the History of Art Series."(Englewood Cliffs: Prentice Hall, 1966.

Rewald, John. *Post-Impressionism, From van Gogh to Gauguin.* New York: Museum of Modern Art, 1956.

———. *The History of Impressionism.* New York: Museum of Modern Art, 1961.

van Gogh, Vincent, *The Complete Letters of Vincent van Gogh,* edited by V. W. van Gogh and J. van Gogh-Bonger, Greenwich, Conn.: New York Graphic Society, 1958.

Baudelaire, Charles
1821—1867

Born in Lyons, died in Paris. Baudelaire came from a well-to-do family and utilized his inheritance to finance a youthful trip to India. The journey left him with a pronounced longing for the bizarre and remote, which permeates much of his poetry. Baudelaire began writing art criticism in the mid-1840's and was one of the first writers to sensitively evaluate the paintings of Eugène Delacroix, whom he likened to a great poet. In his aesthetic writings, Baudelaire addressed himself to such questions as the need to render modern life in a more stirring and pertinent manner, and to the "correspondences" that he believed existed between visual forms, sounds, and other sensations. In 1857, he published his first great poems, *Fleurs du Mal* (*Flowers of Evil*), and promptly was prosecuted for offending public morality. He continued to write poetry and art criticism, and he also produced a brilliant translation of the works of Edgar Allen Poe, which subsequently were to become tremendously popular in France.
Text: 11, 16, 25, 45, 48, 155

Bazille, Frédéric
1841—1870

Born in Montpellier, killed at Beaune-la-Rolande during the Franco-Prussian War. After studying medicine for a short time, Bazille decided to take up painting. He worked in the studio of the landscapist Gleyre and met Renoir, Sisley, and Monet shortly thereafter. He had a painting accepted in the Salon of 1866. Working closely with Monet, he began to develop a relaxed, Impressionist style.
Text: 42, 43, 45, 57

Bernard, Émile
1868—1941

Born in Lille, died in Paris. In the studio of Félix Cormon, Bernard met Vincent van Gogh and Henri de Toulouse-Lautrec. In 1886, he went to Brittany to visit the painter Schuffenecker, who introduced him to Gauguin. Highly interested in artistic and literary theories, he worked closely with the latter at Asnières. Two years later, Bernard again visited Brittany with Gauguin, whom he introduced to Paul Sérusier. Bernard carried on a lively correspondence with Gauguin, van Gogh, Cézanne, and others. In 1890, he organized a memorial exhibition for van Gogh, who had died in July of that year. Subsequently, he exhibited with the Nabis, who shared his interest in literature and philosophy. In addition to being a painter and poet, Bernard was also a sensitive art critic, one of the first to write informatively about Cézanne's work, even though he did not actually meet the latter until 1904.
Text: 109, 110, 112, 125, 169

Bonnard, Pierre
1867—1947

Born in Fontenay-aux-Roses, died in Le Cannet. After studying law briefly, Bonnard enrolled at the *École des Beaux-Arts* and at the private *Académie Julian*, where he met the other members of the group that was to be called the Nabis. In 1890, he shared a studio with Édouard Vuillard and Maurice Denis. Bonnard took part in the first Nabi exhibition and subsequently participated in the *Salon des Indépendants*. His early flat, decorative style was, like that of his friend Lautrec, eminently suited to the poster art that was so popular during the 1890's. Later, his painting became increasingly personal and intimate. In 1925, he settled at Le Cannet, near Cannes, where he worked in seclusion until his death.
Text: 128, 137, 138, 139, 140, 141
Pictures: 130, 133, 138

Boudin, Eugène
1824—1898

Born in Honfleur, died in Deauville. Boudin had an artists' supply shop in Le Havre and literally taught himself to paint. His first attempts were in the style of the landscapist Constant Troyon, and later he was influenced by Millet. In 1851, he won a scholarship and studied in Paris for three years. During this time, he paid frequent visits to the seacoast, where he painted the terrain he loved. In 1863, he painted the beach at Trouville in Normandy, which was to inspire many other works of his and of Claude Monet's. His dominant interest was in open-air effects on the seashore, especially in rapid changes of light. He sometimes noted the day and hour when he made his sketches, and the mood of nature portrayed. His painting style and attitude toward nature made an impression on his fellow townsman Monet who exhibited with him as early as 1856.
Text: 42, 64
Picture: 54

Braque, Georges
1882—1963

Born in Argenteuil, died in Paris. In 1890, the family moved to Le Havre, where Braque's father dealt in artists' supplies. After leaving school, Braque

attended evening classes of the *École des Beaux-Arts* of Le Havre. In 1899, he entered his father's business, but a year later he decided to go to Paris, to continue his training as a decorative artist. For a brief period, he also attended the *École des Beaux-Arts*, where he had encountered his school friend Raoul Dufy. Dufy brought Braque into contact with the Fauves, and the work of Matisse and Derain inspired him to study the expressive effectiveness of color. After 1907, the Fauvist influence in his work gave way to that of Cézanne. Braque painted his first Cubist pictures at L'Estaque in 1908, and he became a friend of Picasso, the other Cubist pioneer. Service in World War I interrupted Braque's career, and he did not resume painting until 1918. Later, his style changed significantly, and he began to design stage sets for Diaghelev's ballet and to produce numerous book illustrations. He remained active as a painter throughout the 1950's, when he was commissioned to paint one of the rooms of the Louvre.

Text: 106, 143, 144, 156, 160, 170

Pictures: 163, 166

Caillebotte, Gustave
1848–1894

Born in Paris, died in Gennevilliers. He studied at the *École des Beaux-Arts* from 1873 on. During the 1870's, he met Renoir, Monet, Pissarro, and Cézanne, and he joined the Impressionists in their second group exhibition. Less important as a painter than as a collector and champion of the Impressionists, his private collection, bequeathed to the state, now constitutes a part of the Louvre.

Text: 76, 77, 78

Camoin, Charles
1879–1965

Born in Marseilles, died in Paris. In 1896, Camoin entered Gustave Moreau's class at the *École des Beaux-Arts*. He met the painters of Matisse's group and was especially close to Marquet. Camoin visited Cézanne in Aix-en-Provence around 1902, and he exhibited three years later in the *Salon d'automne*. In 1912, he visited Morocco with Matisse and Marquet. Later, his style changed, his color softened, and he was much influenced by Bonnard.

Cézanne, Paul
1839–1906

Born in Aix-en-Provence, died there. A close school friend of Émile Zola, who later dedicated a salon criticism to him, Cézanne initially studied law at his father's insistence, but he began to paint in secret during his vacations. In 1861, his father agreed to let him move to Paris to pursue a formal art education. He attended the informal private *Académie Suisse* but was not accepted by the *École des Beaux-Arts*.

He soon returned to Aix, but he revisited Paris, where he met Pissarro and came into contact with other young painters who drew at the *Académie Suisse*. In 1863, he tried unsuccessfully for admission to the *École* and also submitted a number of pictures to the Salon jury, which rejected them. From 1872 to 1874, he worked in Auvers with Pissarro, and he took part in the first Impressionist group show of 1874. By the end of the 1880's, Cézanne was beginning to enjoy a degree of success, but his reputation was not really made until a large exhibition was organized in 1895. During this period, he was working outside of Paris, and many painters and critics journeyed to Aix-en-Provence to view his work and discuss painting with him. The memorial exhibition of his work arranged by the *Salon d'Automne* in 1907 influenced several young artists, particularly Braque and Picasso, the creators of Cubism.

Text: 42, 57, 93, 94, 95, 124–25, 126, 127, 137, 144, 157, 160, 169, 170, 172, 174

Pictures: 125, 159, 165, 168, 171

Chevreul, Michel Eugène
1786–1889

Born in Angers, died in Paris. Chevreul was educated in Paris, where he became a professor of applied chemistry in 1830. As a chemist, he was especially noted for his investigation of animal fats and, later, of the nature of color. In 1839, he wrote *The Principles of Harmony and Contrast of Colors and Their Application to the Arts*, which was to influence decisively some Impressionist and neo-Impressionist painters, notably, Georges Seurat.

Text: 11, 62, 96, 105

Chocquet, Victor
1840–1899

Born in Lille, died in Paris. Despite his modest salary as a customs official, Chocquet managed to acquire a fair number of paintings. He began collecting the work of Delacroix and later bought Renoir and other Impressionists' paintings. In 1899, his widow auctioned the collection, and there was considerable astonishment at the various masterpieces it contained.

Text: 76, 77

Constable, John
1776–1837

Born in East Bergholt, died in London. Constable, the son of a prosperous miller, began studying painting in 1799 at the Royal Academy. At the same time, he began to copy the work of certain old masters, especially the paintings of the seventeenth-century French landscapist Claude Lorrain. Apart from some religious paintings and a few portraits, he con-

centrated mostly on landscape, attempting to bring out the changing moods of nature under different lighting and atmospheric conditions. After 1820, he devoted himself to the study of impressions of nature, which he captured in rapid sketches, as shown in his remarkable series of cloud studies. He also began to employ more vivid color and to use his palette knife as well as his brushes to achieve a maximum degree of spontaneity. In 1824, some of his pictures, includnig the "Hay Wain," were exhibited at the Paris Salon and were much admired by the younger generation of French painters. In 1829, he became a member of the Royal Academy.

Text: 15

Picture: 24

Corot, Camille
1796–1875

Born in Paris, died there. After five years as a draper's apprentice, he became an art student at the *École des Beaux-Arts*. At the same time, he painted nature studies near Fontainebleau and along the Channel coast. From 1825 to 1828, he worked in Rome and painted extensively in the nearby country-side, where Claude Lorrain had worked 200 years before. For two years Corot traveled through various parts of France sketching and painting nature; from the late 1840's on, he became friendly with a group of landscapists who worked at Barbizon near Fontainebleau. Corot was an important figure for the more progressive landscapists, and he was particularly revered by younger artists whom he encouraged and helped.

Text: 26, 28, 30, 32, 41, 45, 57, 58, 59, 60, 62, 64, 78, 89, 173

Pictures: 31, 37, 38, 40, 43

Courbet, Gustave
1819–1877

Born in Ornans, died near Vevey, Switzerland. Courbet's first attempts at painting dated from his early schooldays in Besançon. He persuaded his well-to-do father to let him go to Paris, ostensibly to study law, but he continued his informal art studies by copying old masters in the Louvre. He drew at the *Académie Suisse*, and in 1844, he had a mild success at the Salon. This was repeated in 1849 and 1850. Subsequently, he departed from more traditional painting, and, when certain of his works were refused exhibition in 1855, he installed them in his own "Pavilion of Realism." In the 1860's he painted with Boudin and others along the Normandy coast and traveled to Germany. In 1870, after the Franco-Prussian War had humiliated the government, Courbet sided with the Paris Commune, a revolutionary governing body, and was sentenced to six months' imprisonment for his activities. He later took refuge in Switzerland to avoid further political harassment.

Text: 11, 29–32, 41, 45, 48, 73, 78, 91, 144

Pictures: 33, 34

Couture, Thomas
1815–1879

Born in Senlis, died in Villiers-le-Bel. Couture studied under Gros and Delacroix. In 1847, he received his first award for a painting "Romans of the Decadence," which has since become famous as a model of "academic" painting. Couture was later appointed court painter to Napoleon III. As a teacher, he appears to have been rather important. One of his rebellious pupils was Édouard Manet.

Text: 46

Daubigny, Charles François
1817–1878

Born in Paris, died in Auvers. Daubigny received his first painting lessons from his father. In 1836, he embarked on an extended tour of Italy, where, like Corot, he made many studies from nature. He worked later as a restorer in the Louvre and also submitted paintings to the Salon. In 1843, he stayed for a time near Fontainebleau, where Corot had worked. Settling near Auvers-sur-Oise, he constructed a studio boat (a practice followed by the Impressionists), from which he painted river scenes, seeking to reproduce some of the atmospheric effects he witnessed.

Text: 26, 27, 45, 64

Picture: 36

Daumier, Honoré
1808–1879

Born in Marseilles, died in Valmondois. When his family moved to Paris, Daumier took a job in a bookstore and began to frequent the Louvre. In 1822, he began to take instruction from Lenoir, a pupil of David. Daumier became very interested in lithography, and this led him to a position as a political cartoonist. In 1831, he was sentenced to six months in prison for the sharpness of his political commentaries and, in particular, for a work that indicted the government's role in the abortive revolution of that year. He joined the staff of *Le Caricature*, a satirical review that was banned by the government in 1835. Subsequently, he worked for *Le Charivari*, one of the most popular of the satirical reviews dealing with social and political issues. From time to time, he painted, occasionally doing theatrical or literary themes and then turning to the world of the urban lower classes. Daumier was a good friend of the novelists Victor Hugo and Honoré de Balzac.

Text: 25, 26, 29, 74

Pictures: 21, 27, 28, 35

David, Jacques-Louis
1748–1825

Born in Paris, died in Brussels. As a child, he showed exceptional talent for drawing. With the support of Boucher, a relative, he entered the studio of Joseph-Marie Vien, a painter who subsequently became the director of the French Academy in Rome. In 1774, after competing several times, David won the *Prix de Rome* and remained in that city until 1780. His years in Rome were crucial to the formation of the severely neoclassical style that he carried back to Paris. He was made a member of the Academy in 1781. He scored an enormous success in the Salon four years later with his "Oath of the Horatii," a moralizing ancient history picture he had painted in Rome a year or so before. Other successes followed, notably, his "Death of Socrates," which made him the most influential painter in France on the eve of the French Revolution. David took an active political role in the Revolution, and was briefly imprisoned in the reaction that followed Robespierre's "Reign of Terror." In 1804, he was appointed court painter to the Emperor Napoleon, whom he admired greatly. With the restoration of the Bourbons to power in 1816, David refused to repudiate his Bonapartist sympathies, and he fled to Brussels, remaining there in exile until his death.
Texa: 7, 8, 11, 13, 32, 96
Pictures: 18, 19

Degas, Edgar
1834–1917

Born in Paris, died there. Degas initially trained for a law career but abandoned his studies to work at the *École des Beaux-Arts*. He spent 1856–60 traveling in Italy, where he studied the masters of the Renaissance. On his return to Paris, he made the acquaintance of Manet and became a regular member of the Café Guerbois group. Initially interested in history painting, Degas began to turn more and more to contemporary life for inspiration. Horse racing studies, cabaret and theater scenes were represented with great frequency. In 1874, Degas took part in the first Impressionist exhibition, but he showed also at the Salon. He also produced a considerable number of sculptures of dancers, and one of these was shown in the Salon of 1881. His painting style cannot be categorized as orthodox Impressionism, for, like Manet, Degas was a painter exposed to a wide range of influences who nevertheless managed to cultivate an independent manner.
Text: 11, 13, 45, 48, 57, 73–75, 76, 77, 78, 79, 90, 91, 92, 93, 128, 160
Pictures: 61, 68, 69, 70, 71, 75, 87

Delacroix, Eugène
1798–1863

Born in Charenton, died in Paris. Delacroix was rumored to have been the natural son of Talleyrand, Napoleon's wily minister. Delacroix's family was distinguished, and he grew up in an atmosphere of culture. After briefly studying music, Delacroix entered the studio of Guérin, under whom Géricault had also studied. He enrolled thereafter in the *École des Beaux-Arts*, and he also cultivated independent studies of the paintings of Rubens, the great Flemish colorist. In 1822, he scored a success at the Salon with his picture of "Dante in Charon's Bark," and, two years later, he repeated his success with "The Massacre of Chios," a subject drawn from the contemporary Greek War of Independence. In 1825, encouraged by Géricault, he visited England and came to admire the paintings of Constable and the writings of Lord Byron and Sir Walter Scott. Immensely well read, Delacroix was a friend of many literary lights — Stendhal, Balzac, and Hugo. A trip to southern Spain, Algiers, and Tangier in 1832 was important for Delacroix's stylistic development. He painted many souvenirs of North Africa and described its fascinating sights in his journals.
Text: 10, 12, 13–16, 25, 29, 30, 32, 41, 45, 60, 62, 74, 76, 96, 124, 172, 174
Pictures: 12, 14, 17, 23

Denis, Maurice
1870–1943

Born in Granville, died in Paris. Denis attended the distinguished Lycée Condorcet in Paris, where he first met Vuillard and Roussel, who would later become members of the same painters' group. He was accepted at the *École des Beaux-Arts* in 1888, and studied with Gustave Moreau. At the same time, he met Bonnard and Sérusier, becoming particularly close to the latter. Together they became the principal spokesmen for a group known as the Nabis. In 1890, using a pseudonym, Denis published in the review *Art et Critique* an aesthetic theory that expressed the Nabi point of view. He also exhibited in the *Salon des Indépendants* and became a regular contributor to the *La Revue blanche*, a literary and art magazine much dominated by the Symbolists. Always rather spiritually inclined, Denis took an increasing interest in problems of religious painting.
Text: 13, 123, 128, 137, 138, 139, 140, 144
Picture: 119

Derain, André
1880–1954

Born in Chatou, died in Paris. Derain began to study in a private art school in Paris and made the acquaintance of Matisse in 1899. A year later, he shared a studio with Maurice Vlaminck, an unorthodox figure who became a good friend. Initially influenced by the work of van Gogh, Derain's style was also affected by Matisse, with whom he worked in Saint-Tropez in 1904. He exhibited at the famous *Salon d'Automne* in 1905, and he later fell under the influence of Cézanne, whose work was shown

on a large scale in 1906–7. His subsequent work shows elements of Cubism.

Text: 142, 153, 154, 157, 158, 159, 160

Pictures: 156, 161, 164

van Dongen, Cornelius (Kees)
1877–1968

Born in Delfshaven near Rotterdam, died in Monte Carlo. Van Dongen drew and painted from an early age and was much influenced by the Impressionists. He moved to Paris in 1897, and he made a living there doing various odd jobs while finding some time for painting. Although he was basically an individualist, he became attached to Matisse's circle and attracted the master's attention by his vivid sense of color. Later, he became a member of a German expressionist group in Dresden called *Die Brücke* (The Bridge). After World War I, he returned to Paris and became a fashionable portraitist.

Text: 155

Picture: 150

Dufy, Raoul
1877–1953

Born in Le Havre, died in Forcalquier. Studied at the *École des Beaux-Arts*, Le Havre, and, in 1900, entered the *École des Beaux-Arts*, Paris. Received his first decisive impression in Paris from the van Gogh exhibition of 1901. In 1905, at the *Salon des Indépendants*, he saw Matisse's neo-Impressionistic "Luxe, calme et volupté" and was influenced by it to study the effectiveness of pure color. He went with Marquet to Trouville in 1906, and became attached to the Fauves. After 1907, as were so many others, he became influenced by Cézanne and Cubism. In 1908, he worked with Braque at L'Estaque. From 1911, he designed textile patterns, and, after 1918, tapestries and other decorative objects.

Text: 143, 156, 160

Picture: 162

Durand-Ruel, Paul
1831–1922

Born in Paris, died there. At the time of his birth, what was to become his famous art gallery was nothing but a small stationery store. His father added to it a section for the sale of artists' supplies, where pictures accepted in payment were from time to time exhibited for sale. The son took over the business in 1855. He was a friend of some of the Barbizon painters, and, from 1870 on, became a champion of the Impressionists, who held their second group exhibition at his gallery in 1876. Within a short time, he also organized Impressionist exhibitions abroad: The one held in America in 1887 was a great commercial and critical success. The gallery is now managed by his grandsons.

Text: 75, 76, 78, 80, 105, 126

Fénéon, Félix
1861–1944

Born in Turin, died in Paris. As a critic, he favored new trends in painting and is especially associated with neo-Impressionism and the Nabis. From 1884 on, he defended several painters belonging to the *Salon des Indépendants*. His article "The Impressionists in 1886" excited interest, and it may be regarded as the first official recognition and appreciation of Seurat, Signac, and their followers. He edited the *Revue indépendante* and, in 1886–88, was on the staff on *L'Art moderne*. He wrote for *La Revue blanche* from 1891, and was its editor from 1894 until it ceased publication in 1903. Later, he was one of the first critics to defend and appreciate Cubism.

Text: 79, 106

Gauguin, Paul
1848–1903

Born in Paris, died in Atuana, the Marquesas Islands. In 1851, his father fled from Paris after Louis Napoleon's *coup d'état* but died at sea en route to Peru. His wife and the children remained with friends in Lima for four years. After they returned to France, Gauguin entered the merchant marine as a cabin boy. In 1871, after his mother's death, he gave up the sea and became a bank clerk in Paris. Here he met Émile Schuffenecker, another employee of the bank and an amateur painter. Gauguin took his first steps in painting, and became a passionate art lover and collector, especially of Impressionist works. After meeting Pissarro in 1883, he gave up his bank job in order to devote himself wholly to painting. He worked in Brittany in 1886, and went to Panama the next year. In 1888, he was again in Brittany, where he developed his "new style." He stayed with van Gogh at Arles in the winter of 1888, and made his first visit to Tahiti in 1891. In 1893–96, he was again in Paris and Brittany. In 1896, he returned to the South Pacific, which he never again left.

Text: 12, 13, 78, 93, 94, 95, 109, 110, 111, 112–23, 126, 127, 128, 137, 140, 141, 157, 158, 159, 174

Pictures: 113, 114, 116, 122, 123

Géricault, Théodore
1791–1824

Born in Rouen, died in Paris. The family moved to Paris in 1801. From 1808, he studied painting in Carle Vernet's studio and became a friend of the latter's son Horace. From 1810, he learned classical art theory under Pierre Guérin, copying and studying antique works as well as the pictures of Rubens, Velázquez, Caravaggio, and Van Dyck. After his first public success in 1812, and after a short period of military service, he stayed until 1817 in Italy, studying especially Raphael and Michelangelo. Soon afterward, he met Delacroix in Paris.

In 1820, he went to London, where he painted horses and experimented with lithography. He returned to Paris in 1822, and there he became bedridden by the severe illness that claimed his life.
Text: 15, 16, 30
Picture: 22

van Gogh, Vincent
1853–1890

Born in Groot Zundert, Netherlands, died in Auvers-sur-Oise. At the age of sixteen he was apprenticed to his uncle, an art dealer at The Hague; he later worked at the firm's London branch and, finally, at its main establishment in Paris. He studied at a missionary college in Brussels in 1877, but he soon left there to work as an independent missionary in the Belgian mining district of the Borinage. Van Gogh began to draw in 1880, and in 1882–83, he made his first attempts at oil painting at Mauve's academy in The Hague. In 1885, he went to the Antwerp Academy, and in 1886, he made his definitive journey to Paris, where new impressions shaped his artistic development. In February, 1888, he went to Arles, where Gauguin joined him in the autumn. Their work together was brought to an abrupt and violent end by their quarrels and by van Gogh's subsequent nervous breakdown, after which he voluntarily entered the Hôpital Saint-Paul at Saint-Rémy. He was discharged in 1890 and went to Auvers; he shot himself there on July 27 and died two days later.
Text: 26, 79, 95, 106, 107–11, 112, 121, 126, 127, 137, 140, 143, 155, 157, 174
Pictures: 99, 101, 102, 103, 104, 107, 110

Guys, Constantin
1802–1892

Born in Vlissengen, Netherlands, died in Paris. After taking part in the Greek War of Independence, he served for a number of years in the French army and, in the 1840's, began to teach himself art. After traveling in the Near East and visiting London, he settled in Paris in 1860, becoming a friend to the writer Charles Baudelaire, Daumier, and the photographer Nadar. His witty and fashionable drawings of elegant Parisians were especially admired by Baudelaire, who praised him as a painter of modern life.
Picture: 29

Hamerton, Philip Gilbert
1834–1894

Born in Laneside, Lancashire, died in Boulogne-sur-Mer. A painter and art critic, he settled in France from 1861. He founded The Portfolio, which he edited from 1870, and he wrote various works of art history, including comments on the Impressionists.
Text: 90

Ingres, Jean Auguste Dominique
1780–1867

Born in Montauban, died in Paris. Ingres received his first art lessons from his father, a craftsman, and entered the Toulouse Academy in 1791. He won many prizes while still a student. He entered David's class in Paris in 1796 and, from 1799, studied under him at the École des Beaux-Arts. In 1806, he went to Rome on an Academy scholarship. His first great compositions show the influence of the High Renaissance, especially of Raphael. Ingres exhibited frequently at the Salon and, in 1824, won public success with his "Vow of Louis XIII." In 1825, he became a member of the Academy and thus a juror for the Salon. In 1834, he became director of the French Academy in Rome, settled finally in Paris, in 1841, and, in 1850, became president of the École des Beaux-Arts. At the world exhibition of 1855, he exihibited sixty-eight paintings, a testimony that enshrined his reputation.
Text: 10, 12, 13–14, 16, 26, 28, 44, 45, 73, 74, 96, 153, 172, 174
Pictures: 9, 10, 20

Jongkind, Johan Barthold
1819–1891

Born in Lattrop, Netherlands, died in La Cote-Saint-André. He entered the Academy at The Hague after a period of home study and, from 1846 to 1853, was a pupil at Isabey's studio in Paris. Returning to Holland in 1855, he was again in Paris from 1860 to 1870. He was a friend of Boudin, with whom he made various trips in Normandy. Under the influence of Boudin, Corot, and Bonington, he became more and more of an open-air painter.
Text: 42
Picture: 51

Lehmann, Heinrich (generally known as Henri)
1814–1882

Born in Kiel, died in Paris. He began his art studies with his father in Hamburg and went to Paris in 1831 to study under Ingres; he exhibited his first picture at the Salon in 1835, after which he made numerous trips, especially to Italy. He became a member of the Institut in 1864. Considered one of Ingres' best pupils, he became one of the most successful painters of his time, having some influence as a teacher.

Mallarmé, Stéphane
1842–1898

Born in Paris, died in Valvins. Because of financial difficulties, Mallarmé was forced to teach English in French high schools for many years. Initially influenced by Baudelaire, his poems began to attract public attention by the 1870's. During the last fifteen years of his life, his Tuesday evening gatherings of writers and artists were celebrated for their intel-

lectual character. A friend of Manet's, Mallarmé was associated with artists throughout much of his lifetime and became identified with the group of painters who gathered at the office of *La Revue blanche*, an avant-garde literary and art review of the 1890's. Among his best known poems is *L'Après-midi d'un faune (Afternoon of a Faun)*.
Text: 11, 121, 128—29, 138, 140

Manet, Édouard
1832—1883

Born in Paris, died there. He embraced the career of a naval officer after his father opposed his plans to become a painter. Manet sailed to South America in 1848 on a training ship, but the voyage only confirmed his belief in his destiny as an artist. In 1850, he entered Thomas Couture's studio in Paris. While a student, he met Suzanne Leenhof, who bore him a son in 1852; his father concealed the child's parentage, and it was passed off as Suzanne's brother. After the death of Manet's father, the couple married in 1863. In 1861, Manet's "Spanish Guitar Player" received an honorable mention at the Salon; two years later, his "Déjeuner sur l'herbe" caused a scandal at the *Salon des Refusés*. In 1865, his controversial "Olympia" was rejected by the Salon. He visited Spain and studied the Spanish masters, who had a strong influence on his work. In 1867, at his own expense, he organized an exhibition of his work near the hall of the world exhibition. Although not participating in the first Impressionist exhibition, he became increasingly close to the young revolutionaries. He was made a Chevalier of the Legion of Honor in 1881, and his art reputation began to grow. After 1880, he was afflicted with a disease of the spinal marrow, from which his work increasingly suffered.
Text: 11, 32, 42, 43, 45, 46—48, 57, 58, 64, 74, 78, 80, 90, 93, 124, 128, 144, 153, 172, 174
Pictures: 44, 50, 52, 53

Manguin, Henri-Charles
1874—1943

Born in Paris, died in Saint-Tropez. He joined Moreau's class at the *École des Beaux-Arts* in 1894, and there he met Rouault, Matisse, Marquet, and Camoin. From 1899, his studio in the rue Boursault became a meeting-place for the painters from Moreau's studio who were later known as the Fauves. He exhibited at the famous Salon of 1905. His later work was influenced by Cézanne, and he befriended Signac at Saint-Tropez, where he settled.
Text: 142, 153, 154
Picture: 151

Marquet, Albert
1875—1947

Born in Bordeaux, died in Paris. In 1890, he studied at the *École des Arts Decoratifs* in Paris. He entered

Gustave Moreau's class at the *École des Beaux-Arts* in 1897, and there he met Rouault, Matisse, and the other future Fauves. His friendship with Matisse provided the core of the Fauvist movement. Marquet took part in the famous *Salon d'Automne* in 1905. Previously, he had exhibited at the *Salon des Indépendants*, and, he had his first one-man exhibition at Berthe Weill's gallery in 1902. In 1915—19, he lived in Marseilles, visiting Matisse in Nice. He traveled all over Europe, and in Asia and Africa, between the wars, living in Algiers 1940—45 and returning to Paris after World War II.
Text: 142, 144, 153, 154, 156
Pictures: 134, 148, 149, 154, 155, 157

Matisse, Henri
1869—1954

Born in Le Cateau-Cambrésis, died in Nice. He began painting after three years as a law student, studying at the *Académie Julian* in 1891—92 and entering Moreau's class at the *École des Beaux-Arts* in 1893. He became a friend of Marquet in 1892, and he met Rouault, Manguin, and Camoin at Moreau's studio. In 1898, after Moreau's death, he visited Corsica and Toulouse. A cofounder of the *Salon d'Automne* in 1903, he held his first one-man show at Vollard's in 1904. Staying with Signac at Saint-Tropez in the summer of 1904, he became influenced significantly by neo-Impressionism, which can be seen in his "Luxe, calme et volupté." Matisse participated in the famous *Salon d'Automne* of 1905, becoming the leading personality of Fauvism. He was influenced by Gauguin's later pictures from the South Seas, which he came to know in 1906 through the painter Georges Daniel de Monfreid. He traveled extensively in Europe, the South Pacific, and the United States, but from 1938 on, he worked exclusively in the area near Nice.
Text: 12, 106, 142—43, 144, 153, 154, 155, 156, 157, 158—59, 160, 170
Pictures: 135, 136, 143, 145, 147, 158

Millet, Jean François
1814—1875

Born in Gruchy, near Gréville, died in Barbizon. The son of a peasant, Millet studied painting in Cherbourg, 1834—36, then moved to Paris and entered Delaroche's studio. He exhibited at the Salon for the first time in 1840. In 1849, he moved to the village of Barbizon, on the edge of the Forest of Fontainebleau, where he became a friend of Théodore Rousseau, Daumier, and Constant Troyon. His simple figure-paintings of peasant life and, above all, his drawings were not without influence on some painters of the younger generation, notably van Gogh.
Text: 26, 108
Picture: 42

Monet, Claude
1840–1926

Born in Paris, died in Giverny. As a schoolboy in Le Havre, where his family had moved in 1845, he attracted notice with his caricatures. After a decisive meeting with Boudin in 1858, he went to Paris the next year, beginning to study seriously; soon afterward, he became a pupil of Gleyre's at the *École des Beaux-Arts*, until the latter's studio closed in 1863. Here Monet met Bazille, Sisley, and Renoir, and during the same period, he made the acquaintance of Courbet and Jongkind. Depressed by a lack of recognition and abject poverty, he attempted suicide in 1868. He was in London 1870–71, during the Franco-Prussian War. Through Daubigny, he met Durand-Ruel, who gave him much encouragement. From 1883, he lived in his own house in Giverny, spending much time on the Normandy coast. He visited Holland in 1872 and 1886 and went several times to London, where he painted scenes of the Thames. The great picture series establishing his fame as a painter dates from 1890, and he achieved success thanks to a large exhibition organized by Durand-Ruel in 1891. Monet retired more and more to his house at Giverny after the turn of the century. His water-lilies series was executed as a state commission.
Text: 15, 27, 42, 43, 45, 48, 57, 58, 59, 60, 62, 63–64, 73, 74, 76, 77, 78, 79, 80, 89, 90, 92, 93, 109, 160, 174
Pictures: 55, 56, 60, 63, 65, 85

Monfreid, Georges Daniel de
1856–1929

Born in Paris, died on his estate near Collioure. A friend of Gauguin, with whom he corresponded actively until Gauguin's death and who influenced his sculpture, engravings, and pottery.
Text: 158

Moore, George
1852–1933

Born in Moore Hall, Co. Mayo, Ireland, died in London. He came into contact with the Impressionists, many of whom he knew personally, while a young art student in Paris. His book *Reminiscences of the Impressionist Painters* is an important source.
Text: 91

Moreau, Gustave
1826–1898

Born in Paris, died there. He studied at the *École des Beaux-Arts* and exhibited at the Salon for the first time in 1852. As an artist, he led a quiet life and cared little about selling his pictures. He succeeded Élie Delaunay as a teacher at the *École des Beaux-Arts* in 1891. His liberal methods mo-tivated a number of the younger generation of painters who worked with him, especially Georges Rouault and Henri Matisse.
Text: 142

Morisot, Berthe
1841–1895

Born in Bourges, died in Paris. She first studied painting in the early 1860's and was taught by Corot, among others. She met Daubigny and Daumier at Pontoise in 1863. She traveled in France and England, and exhibited at the Salon between 1864 and 1873. She met Manet in 1868 and married his brother Eugène in 1874. Participating in the first and later Impressionist exhibitions, she stood somewhat closer as an artist to the painters of this school than to her brother-in-law.
Text: 46, 48, 77

Nadar (real name Félix Tournachon)
1836–1910

Born in Paris, died there. Nadar was a celebrated photographer and a friend of the Impressionists in the decisive years: Their first exhibition, in 1874, was held in his studio. Throughout his life, he defended revolutionary tendencies in painting. His surviving photographical work includes portraits of well-known contemporaries.
Text: 48, 57, 73

Picasso, Pablo
1881–

Born in Málaga. Picasso first studied art at the Barcelona Academy. He came to Paris in 1900 and stayed there briefly in 1901 and 1902, finally making his home there from 1904. Works of these years—his so-called blue period—thematically deal with despair, poverty, and loneliness. In 1905 came his friendship with the poet Apollinaire and, subsequently, his "rose" period. He met Matisse, Braque, and the art dealer Henri Kahnweiler in 1906, and, at this time, under the influence of African Negro sculpture, he turned to the problem of "deformation." Picasso began the great composition "Les Demoiselles d'Avignon," which signaled the beginning of his Cubist style, in the winter of 1906–7.
Text: 106, 144, 169, 170–73, 174
Pictures: 167, 172, 173

Pissarro, Camille
1830–1903

Born in St. Thomas, Virgin Islands, died in Paris. At an early age, he received drawing instruction in Paris, returning to St. Thomas, at his father's wish, to work in the latter's general store. Pissarro met the Danish artist Melbye in 1852 and returned to Paris in 1855, having decided to become a painter. Melbye's

teaching had no visible effect on his development, but he profitably studied the old masters and the work of Corot and Courbet. He painted at Pontoise and at Louveciennes, where he lived. He fled to England at the outbreak of the Franco-Prussian War in 1870, and at this time, he met Durand-Ruel. As a result of the war, the whole of his early work was destroyed in his studio at Louveciennes. He settled at Pontoise and worked with Cézanne in 1872. Pissarro participated in the first Impressionist exhibition, 1874, and in all the subsequent ones—the only painter to do so. He spent his last years in his home at Éragny, where he painted a series of Paris scenes that were shown with great success by Durand-Ruel in 1898.

Text: 41, 42, 45, 57, 58, 60, 62, 76, 77, 78, 79, 80, 90, 91–94, 96, 105, 106, 109, 112, 124, 160
Pictures: 39, 66, 83, 84, 88, 89, 92

Ranson, Paul
1884–1909

Born in Limoges, died in Paris. He attended the École des Beaux-Arts in Limoges, and in 1888 entered the Académie Julian in Paris, where he met Sérusier, Denis, Bonnard, Vuillard, and Ibels. He took part in the Nabis' first exhibition, 1892, at Le Barc de Boutteville gallery. He was on the staff of La Revue blanche in 1893–94 and again in later years. He founded the Académie Ranson.

Redon, Odilon
1840–1916

Born in Bordeaux, died in Paris. In 1863, he became a pupil of the draughtsman Bresdin, and later entered Gérome's class at the École des Beaux-Arts in Bordeaux. In 1868, he met Corot in Barbizon, and he visited Belgium and Holland in 1878. He became a friend of the poet Stéphane Mallarmé in the early 1880's, and was a cofounder of the Salon des Indépendants in 1884. His imaginative, often fantastic work shows close ties with the symbolist poets.
Text: 144
Picture: 115

Renoir, Auguste
1841–1919

Born in Limoges, died in Cagnes, near Nice. His family moved to Paris in 1845. Renoir worked at china-painting, then entered Gleyre's studio in 1862, meeting Bazille, Monet, and Sisley. He visited Chailly with his friends, and there he met Narcisse Diaz, who influenced him considerably. He was rejected by the Salon jury in 1866, the year of Zola's articles. In the late 1860's, he realized his style, partly as a result of close collaboration with Monet, Sisley, and Bazille. He was called up during the Franco-Prussian War of 1870–71 and in 1873 was introduced to Durand-Ruel, who bought a number of his pictures. He exhibited in 1874 with the Impressionists, and soon afterwards was befriended by the patron and collector Chocquet. In 1881, he visited Italy where he studied and admired Raphael and the Italian primitives. He undertook trips to Algeria in 1881 and 1882, and to Spain in 1891 and 1892. From 1906 on, he lived mostly in retirement at Cagnes, his work increasingly hampered by his condition of severe gout.

Text: 43, 48, 57, 60, 62, 77, 78, 79, 80, 90, 105, 144, 160
Pictures: 49, 77, 81, 82, 86, jacket

Rouault, Georges
1871–1958

Born in Paris, died there. Rouault was apprenticed to a stained-glass painter in 1885, following evening courses at the École des Arts Decoratifs. He was accepted by Moreau at the École des Beaux-Arts in 1891, and met Matisse, Marquet, Manquin, and Camoin. After Moreau's death in 1898, Rouault painted in the open air and became, as well, a painter of night life. He took part in the Salon d'Automne of 1905, and in 1910 held his first one-man show, at the Galerie Druet. In 1917, he began work on "Miserere," a series inspired by the horrors of World War I. A large retrospective show was held at the Museum of Modern Art, New York, in 1945. In 1948, he burned 315 unfinished pictures returned to him by Vollard's heirs. He became a Commander of the Legion of Honor in 1951.
Text: 142, 144

Rousseau, Henri
1844–1910

Born in Laval, died in Paris. He fought in the Franco-Prussian War of 1870–71, and afterward entered the customs service in Paris. He retired in 1885 and was active as a painter and musician. The year of his retirement, he exhibited at the Salon des Indépendants, and later he met Gauguin, Seurat, and Picasso. He took part in the Salon d'Automne of 1905.

Rousseau, Théodore
1812–1867

Born in Paris, died in Barbizon. He began his art studies in 1827, while carefully absorbing the work of the Dutch landscapists. He painted out of doors in the environs of Paris. He first exhibited at the Salon in 1831; from 1836 on, he spent every summer in Barbizon and was a friend of the other painters who collected there. He won his first medal at the Salon of 1849 and exhibited thirteen works at the world exhibition of 1855.
Text: 26

Roussel, Ker Xavier
1867–1944

Born in Lorry-les-Metz, died in Étang-la-Ville. He met Vuillard at the Lycée Condorcet, Paris, and in 1888, they both entered the *Académie Julian*, where they met the future Nabis. Roussel took part in 1892 in the first Nabis exhibition, at Le Barc de Bouteville gallery. He married Vuillard's sister in 1893, and worked for *La Revue blanche*. In 1913, he designed sets for the Théâtre des Champs-Elysées and, 1914–18, executed murals for the staircase of the Fine Arts Museum at Winterthur, Switzerland.

Text: 128, 137, 138, 140

Schuffenecker, Émile
1851–1934

Born in Fresne-Saint-Mamés, died in Paris. A clerk and Sunday painter in Paris, he was employed at the same bank as Gauguin, whom he met there. From 1884, he exhibited at the *Salon des Indépendants*. His art was influenced by Gauguin.

Text: 112

Sérusier, Paul
1863–1927

Born in Paris, died in Morlaix. In 1886, he entered the *Académie Julian* in Paris; in 1888, he went to Brittany; there he met Bernard, who introduced him to Gauguin. With the latter's help, he painted the small landscape of the "Bois d'Amour" at Pont Aven, which became revered by the Nabis as a "talisman." He returned to Gauguin in Brittany in 1889 and 1890. Together with Denis, he became the Nabis' chief theoretician. He met the Dutch painter Verkade in 1891, and he took part in the Nabis' first exhibition at Le Barc de Boutteville gallery. Sérusier went to Italy in 1893, revisiting that country a number of times. In 1908, he became a teacher at the *Académie Ranson* in Paris. His essay *ABC de la peinture* appeared in 1921.

Text: 128, 137, 138, 139, 140
Picture: 120

Seurat, Georges
1859–1891

Born in Paris, died there. In 1875, he entered a municipal school of drawing and copied works by Poussin, Raphael, Holbein, and, especially, Ingres. In 1878–80, he studied at the *École des Beaux-Arts* under Ingres' pupil Henri Lehmann, and he began his intensive study of the nineteenth-century theoreticians of color, especially Chevreul. In 1881–83, he devoted himself almost entirely to drawing with precise tone values and gradations in black and white. In 1883–84, he worked on his first big composition, "La Baignade" ("Bathers at Asnières"), which was rejected by the Salon. With others, he founded the

Salon des Indépendants, and also met Signac. He began the composition "Sunday Afternoon on the Island of La Grande Jatte," which exemplified his theory of color analysis and which aroused public and critical indignation at the last group exhibition of the Impressionists in 1886. In the next five years, Seurat developed his theory still further, seeking symbolic values of color and line.

Text: 12, 79, 80, 91, 94, 95–106, 108, 109, 124, 126, 127, 137, 144, 155, 157, 158, 174
Pictures: 94, 95, 97, 98, 100

Signac, Paul
1883–1935

Born in Paris, died there. Self-taught, Signac sought out Monet, whose work had profoundly impressed him. He took part in the foundation of the *Salon des Indépendants* in 1884. He met Seurat, became an enthusiast of the latter's developing color theory, and subsequently became the theoretician of divisionism. He published *De Delacroix au néo-impressionisme* in 1899, and in 1908 became president of the *Société des artistes indépendants*. He made many study trips in Europe and the Near East.

Text: 79, 94, 96, 105, 106, 108, 158

Sisley, Alfred
1839–1899

Born in Paris, died in Moret-sur-Loing. Of English parentage, he studied for a commercial career in London from 1857–1861, not relinquishing his interest in painting, especially that of Constable and Turner. He returned to Paris in 1862 and entered Gleyre's studio, where he met Monet, Renoir, and Bazille. He attached great importance to open-air painting, especially after Gleyre's studio closed in 1863, working in the Forest of Fontainebleau. He traveled in England in 1871 and 1874 and stayed on the Isle of Wight in 1881. In 1871, in London, he met Durand-Ruel, who organized a comprehensive exhibition of his work in 1883. From 1882, Sisley lived and worked in Moret, a lone figure in straitened circumstances, making no attempt to see Monet, the friend of his youth, until 1899, shortly before his death.

Text: 42, 43, 45, 57, 60, 62, 76, 77, 78, 79, 80, 89, 105
Pictures: 59, 67, 72

Toulouse-Lautrec, Henri de
1864–1901

Born in Albi, died in the Chateau de Malromé. Born to one of the noblest families of France, Lautrec became a cripple as a result of two childhood accidents. After his first attempts at drawing, he studied under Bonnat in 1882–83 and under Cormon until 1885, meeting van Gogh and other

young painters. He discovered Montmartre and made its life the theme of his art. He exhibited with the *Indépendants* from 1889 to 1892. In 1895, he visited London and met Aubrey Beardsley; he also made trips to Holland, Spain, and Portugal.

van de Velde, Henri
1863–1957

Born in Antwerp, died in Oberägeri, Switzerland. He began as a neo-Impressionist painter but began to design furniture as early as 1892. Director of the *Kunstgewerbliches Seminar* in Weimar from 1902 to 1914, he founded the Arts and Crafts School in Ghent in 1926. He became one of the principal *Jugendstil* (*Art Nouveau*) architects.

Vlaminck, Maurice de
1876–1958

Born in Paris, died in Rueil-la-Gadelière. A racing cyclist, amateur musician, and self-taught Sunday painter, Vlaminck met Derain and the group of painters around Matisse in 1900. He shared a studio with Derain in Chatou, near Paris. He was greatly impressed by the van Gogh memorial exhibition in 1901, and he participated in the famous *Salon d'Automne* in 1905. He met Picasso and Apollinaire and was directly influenced by Cézanne after 1908.

Vollard, Ambroise
1865–1939

Born in St. Denis, Reunion Island, died in Paris. He came to Paris as a young man and apprenticed himself to an art dealer. He opened his own gallery in 1893, handling, at first, only established painters. He organized the celebrated Cézanne exhibition of 1895 and began to deal more and more in the works of revolutionary young artists, including Picasso.

Many well-known painters did portraits of him. He also became known for publishing de luxe illustrated editions and series of engravings and drawings.

Vuillard, Édouard
1868–1940

Born in Cuiseaux, died in La Baule. His family moved to Paris in 1877, and he met Roussel and Denis at the *Lycée Condorcet* in 1884, Bonnard, Ranson, and Sérusier at the *Académie Julian* in 1888. He took part in the first Nabi exhibition in 1891. With Lugné-Poe, he founded the *Théâtre de l'Œuvre*. In 1894, he received his first big commission, to decorate the home of Thadée Natanson, publisher of *La Revue blanche*. He was a cofounder of the *Salon des Indépendants* in 1903, and in that same year, he visited Hamburg with Bonnard. He traveled to Holland and England, and also to Switzerland with Felix Vallotton. In 1938–39, he decorated the Palais de Chaillot and the League of Nations building in Geneva.

Zola, Émile
1840–1902

Born in Paris, died there. He was a school friend of Cézanne at the Aix-en-Provence lycée. In Paris, he took a strong interest in painting, becoming one of Manet's first admirers; he was also a friend of the Impressionists. In 1866, his revolutionary articles on the Salon appeared; he also soon began to doubt the value of Impressionist painting. In his literary work, he was a realist; his *l'Œuvre* of 1886 is to some extent a *roman à clef* depicting artistic circles of that time—the character of Claude Lantier is said to have been modeled on Cézanne. In any case, it prompted the latter's break with Zola. Among Zola's greatest works in his stirring indictment of official corruption: *J'Accuse*, the revelations of the Dreyfus trial.

LIST OF PLATES

189

Picture Credits:

Conzett & Huber, Zurich: p. 86; W. Dräyer, Zurich: p. 101; Giraudon, Paris: pp. 19, 20, 22, 23, 34, 35, 37, 50, 56, 65, 67, 68, 70, 71, 85, 103, 115, 119, 131, 146; H. Hinz, Basel: p. 168; R. Kleinhempel, Hamburg: p. 33; New York Graphic Society, Greenwich, Connecticut: pp. 69, 104; Propyläen-Verlag, Darmstadt: pp. 36, 54; J. Remmer, Munich: pp. 52, 72; I. Sello, Hamburg: pp. 88, 134; A. Somogy, Paris: p. 53; Thames and Hudson, Ltd., London: pp. 24, 97, 100, 113; Three Lions, Inc., New York: p. 129; L. Witzel, Essen: p. 66; Westermann-Foto H. Buresch: pp. 17, 21, 40, 49, 81, 116, 117, 120, 132, 148, 149, 152, 161, 162; Hans Platte: pp. 55, 135, 147, 150, 151, 163, 166; archives of the museums indicated: pp. 18, 38, 39, 51, 82, 83, 84, 87, 98, 99, 102, 114, 118, 130, 133, 136, 145, 164, 165, 167.
Grateful acknowledgment is extended to all museums, collections, and private individuals involved, and also to SPADEM, Paris/Cosmopress, Geneva, for pp. 49, 55, 56, 65, 68, 69, 70, 71, 81, 82, 85, 86, 87, 115, 119, 120, 129, 131, 132, 135, 136, 145, 146, 147, 150, 151, 152, 162, 163, 166, 167, and jacket, and to ADAGP, Paris/Cosmopress, Geneva for pp. 130, 133, 134, 148, 149, 161, 164.